Caught

Karl Gernot Kuehn

CAUGHT

The Art of Photography in the
German Democratic Republic

University of
California Press
Berkeley
Los Angeles
London

University of California Press
Berkeley and Los Angeles, California

University of California Press, Ltd.
London, England

Library of Congress Cataloging-in-Publication Data

Kuehn, Karl Gernot, 1940–
 Caught : the art of photography in the German Democratic
Republic / Karl Gernot Kuehn.
 p. cm.
 Includes bibliographical references and index.
 ISBN 0-520-20436-0 (cloth : alk. paper)
 1. Photography—Germany (East)—History—20th century.
 2. Germany (East)—History—Pictorial works. I. Title.
 TR73.1.K84 1997
770'.943'109045—dc21 97-174

The epigraphs to chapters 1, 2, 4, 5, and 6 are quoted from
Lothar Klimter and Just Wagner, eds., *Prominente Fotogedanken*
(Leipzig: VEB Fotokinoverlag, 1969). The epigraph to chapter 7
is translated from *Der geteilte Himmel* (Munich: Deutscher Ta-
schenbuch Verlag, 1973), 113, and used by permission of Christa
Wolf; those to chapters 9 and 10 are translated from Christa
Wolf's *Störfall* (Munich: Luchterhand Literaturverlag, 1987),
118, and *Nachdenken über Christa T* (Munich: Luchterhand
Literaturverlag, 1971), 5, respectively, and used by permission
of the publisher. The epigraph to chapter 11 is quoted from
Marjorie Gerber et al., eds., *Studies in GDR Culture and Society* 5
(Lanham, Md.: University Press of America, 1985), 133. Those to
chapters 12 and 13 are quoted from *Niemandsland* 2, no. 7 (1988):
130, and *reiterin,* July 1991, 5, respectively.

Printed in Singapore
9 8 7 6 5 4 3 2 1
This book is printed on acid-free paper.

*The publisher gratefully
acknowledges the
contribution provided by
the Art Book Endowment
Fund of the Associates
of the University of
California Press,
which is supported by a
major gift from the
Ahmanson Foundation.*

Contents

When the German Democratic Republic was created from the Soviet-occupied sector of east Germany, in 1949, it not only became the first Communist country in the West but also brought to fruition the vision of Karl Marx, whose *Communist Manifesto* was specifically tailored to Germany. As a model of the socialist state, the new nation was closely watched by the Soviet Union. There more than in any other East bloc country, ideology was put to the challenge of wrenching the people away from the abyss of so-called capitalist greed and bourgeois decadence, supplanting these, presumably, with social solidarity and peaceful work. It was only logical that photography, by virtue of its immediacy and its unique ability to appear factual, be harnessed to foment this radical human transformation—that it serve as a didactic tool for imaging the utopian collective.

Exactly why this grandest of all social experiments failed remains a matter of debate, but when other socialist countries discarded Marxism-Leninism as a way of life, the GDR ceased to exist altogether. In 1990, after forty years of perilous isolation, the territory was absorbed by West Germany.

Although it may never be known why human nature has eluded revision, the photographs that the GDR left behind constitute a compelling case history of human

aspiration. They show how the two consecutive leaders, Walter Ulbricht and Erich Honecker, manipulated the medium's special relationship with "reality" in order to imprison individualism, and how they surreptitiously used—and abused—the various definitions of photographic "truth" to build up their personal power. At the same time, these East German photographs depict the ongoing struggle of a people hoping to break their cycle of national tragedy and get on the right side of history.

In Chapters 1 through 7 of the present work, I examine the years between 1945 and 1978—a time regarded in the GDR as the "socialist formation period," when a number of political and cultural edicts defined appropriate methods of photographic representation. This period thus provides a standard against which we may measure later developments. In Chapters 8 through 14, I consider more specifically the causes and effects of the peculiar artistic liberation that took place, against all odds, in the 1980s, when it was discovered that creativity could be suppressed but not eradicated. Because government censorship in the GDR prevented not only true analysis of art but also the free dissemination of photography and all literature pertaining to it, a meaningful examination of the topic could only begin after the country had ceased to exist.

I offer my sincere gratitude to all the East German photographers who allowed me to reproduce their work and to the many historians, curators, librarians, archivists, gallery owners, and photography teachers in the GDR who shared their knowledge of the complex sociopolitical conditions and offered assistance. I am particularly indebted to Ulrich Domröse, curator at Berlinische Galerie, who helped locate many of the artists who had dispersed since reunification; to Theo Immisch, curator at Staatliche Galerie Moritzburg Halle, who loaned prints from his archive; to the historian Thomas Kumlehn, who provided his entire private collection of mostly out-of-print exhibition guides, catalogues, and underground publications; and to Wolfgang E. Schröter, teacher at the Hochschule für Grafik und Buchkunst in Leipzig, who offered guidance during my initial research. Unless otherwise credited, all photographs appear by courtesy of the artists.

The manuscript benefited from thorough critiques by Birgitta Wohl, professor at California State University at Northridge; Peter Baldwin, professor at the University

of California at Los Angeles; and Weston Naef, head of the photography department at the Getty Institute in Los Angeles. I am also grateful to Annegreth T. Nil of the Columbus Museum of Art, Ohio, for her insights, and to Thomas Hines, professor at the University of California at Los Angeles, whose untiring involvement and unwavering faith in the project provided the guiding light during its long and often problematic evolution. Last but not least, I would like to thank Jean Quataert and Jonathan Spaulding for their valuable comments in reviewing this manuscript for the University of California Press, Stanley Holwitz for directing the manuscript into the Press, and Rose Vekony for her sensitive editing.

In 1839, when the Englishman William Henry Fox Talbot dazzled the world with his first photographic images, he already spoke of the camera's special aptitude for recording "the injuries of time."[1] He was referring to the deterioration of architecture, but his words would soon have broader implications. Shortly after midcentury, when the new mechanical medium was firmly established, its social potential was unequivocally recognized and explored. Somber recordings from the battlefields by Roger Fenton, Mathew Brady, Alexander Gardner, and George Barnard shattered the glamorous fantasies of warfare that painters had painstakingly perpetuated through the centuries. Photographs of majestic nature by Henry Jackson, Timothy O'Sullivan, and Carleton Watkins inspired an almost religious awe of the American West, prompting the preservation of vast tracts of virgin land as national parks.

As technical advances in photography seduced an ever wider stratum of the population, photographers increasingly used their art to better society: Adam Clark Vroman and Edward Curtis focused on the plight of indigenous Americans herded into reservations; John Thomson exposed the glossed-over misery of London's disenfranchised; Jacob Riis and Lewis Hine highlighted the exploitation of New York's immigrant population. Much social redress in Great Britain and the United States—from

the enactment of laws banning child labor or providing wilderness preservation and public sanitation to the creation of labor unions—sprung from the awareness that photography had kindled.

After 1918, the transformative potential of the medium was put to an especially daunting task in Germany, as an age-old insecurity about political and territorial identity had forged a perplexing social crisis. In the sobering aftermath of the "Great War," the saber-rattling aggrandizement of the Prussian House of Hohenzollern having given way to the cultural pessimism of the Weimar Republic, Germany was suddenly a lost country, sullied and shunned by all respectable nations. The Prussian dynasty had been ushered out during the October revolution of 1918—forcing Kaiser Wilhelm II into exile—but the new heads of state were still members of the prewar aristocratic ruling class, a coterie hardly deemed qualified to analyze the unresolved political and social legacy. Intellectuals and artists almost unanimously opposed the government from the start. Hope for recovery, meanwhile, was thwarted by the pernicious conditions of the Versailles peace treaty, which severely truncated German land and dealt a fatal blow to German wealth and self-esteem. As production plummeted and inflation skyrocketed, opposing factions—democrats, monarchists, nationalists and Marxists of various stripes, fascists, and even pacifists—fought each other in the streets, often to the death. As the historian Peter Gay explained, "Everybody was armed, everybody was irritable and unwilling to accept frustration . . . ready to kill."[2]

Many Weimar photographers responded to this overwhelming sense of chaos by looking to the camera as a mechanical arbiter—a modernist tool for analyzing the meaning of "reality" and "truth." They wanted science to give them an impartial, distilled excerpt of the world that would enable them to transcend the quagmire of human error. Almost pathologically, they came to believe that the camera would usher in a future thoroughly liberated from the curse of human memory and the senseless human passion that dominated the older, tragic world.

Weimar photographers were the heirs of positivist intellectuals from the early years of the industrial revolution—Pierre-Joseph Proudhon, Auguste Comte, Karl Marx, and Friedrich Engels, among others—who had viewed machines as symbols of an unencumbered egalitarianism. A similar technological utopianism had also been advanced at the Bauhaus school of design in Weimar since 1919, and later—after

2

1925—in Dessau, under the aegis of Walter Gropius.[3] Many Weimar photographers taught at the famous school or were inspired by the functional techno-geometric Bauhaus design, regarded as the aesthetic essence of the new unadorned, practical spirit of the mechanical age.

One noted proponent of this Neue Sachlichkeit (literally, "new matter-of-factness" or "new practicality," usually mistranslated as "New Objectivity") was the photographer Albert Renger-Patzsch. By isolating the clean, sculptural form of both natural and human-made objects as well as the industrial landscape, he wanted to show the world as an ordered and harmoniously interconnected system, countering the confusing and often violent irrationality of the new romanticism that had emerged since World War I. Another photographer, August Sander, painstakingly recorded people from all classes and walks of life with a scientific sense of detachment, inscribing what might be called the collective face of society. Erich Salomon, meanwhile, used the new smaller, handheld cameras to capture the behind-the-scenes ambience of public events, introducing an unmistakable "you-are-there" candor to photojournalism that became the hallmark of the leading periodical, *Berliner Illustrirte Zeitung.* But while these photographers contributed to the artistic appreciation of the medium, they often shied away from calling themselves artists. Renger-Patzsch felt the label stifling; he simply wanted to follow the form wherever it led him. Sander, too, preferred the term "photographer," and Salomon saw himself as a photojournalist, recording the news.

Others, however, used this mechanical medium to produce work that was deliberate in its artistic subjectivity, intended less as a window on the world than as a mirror of an inner reality. The dadaists Raoul Hausmann and Hanna Höch, for instance, made complex photomontages densely packed with personal innuendo, and the multitalented Hungarian-born László Moholy-Nagy experimented with the effects of modernist light and speed; he painted over appropriated photographs, made photograms and solarizations, and even used the negative for its own sake. By mapping its seemingly limitless possibilities, he helped liberate photography from the restraints and obligations imposed by society while asserting its autonomy as a medium.[4] Moholy-Nagy taught at the Bauhaus, where the objective and subjective definitions of the medium coincided.

There existed another distinctive school of photography in Weimar Germany, one

equally bent on exploiting the camera's mechanical nature to comprehend and redefine reality; its proponents, however, scoffed at the formal, intellectual, and aesthetic concerns of the others. These were the so-called worker photographers (*Arbeiter Fotografen*), whose ethical stance of engagement drew loosely on that of earlier socially concerned artists, such as Jacob Riis, Lewis Hine, and—closer to home—Heinrich Zille, who had produced an eye-opening oeuvre of the crime-ridden working-class neighborhoods of Berlin under the Kaiser.[5] But worker photographers—Erich Rinka, Lilly Becher, George Hanson, Eugen Heilig, Ernst Thormann, Walter Ballhause, and others— were not content to improve the existing society; they wanted to fuel social unrest and build a new world order founded on the proletariat, as envisioned by Marx.

Eagerly they embraced new technology: the unobtrusive 35-mm Leica with film in a roll, which eliminated the need for reloading after every shot; the magnesium flash-bulb, which allowed them to get in the thick of the action, in spite of the often dim lighting. They emulated Salomon's voyeuristic style in their effort to expose the exploitation of the poor, the backbone of society. They also infiltrated underground right-wing meetings, lootings, and beatings. They worked fast, surreptitiously, in the night, in partisan fashion. They disappeared. They reappeared elsewhere, training their eye on yet another visceral inequity. A treatise on Weimar's unsavory underbelly, their pictures appeared with inflammatory captions in *Arbeiter Illustrierte Zeitung*, a worker magazine published in Berlin between 1921 and 1933.

Worker photographers shared with Neue Sachlichkeit an uncompromising desire for hard-edged, clinical realism; with subjective photography they shared a desire to transform reality. But they never strayed from their sociopolitical and ideological objective. They never concerned themselves with beauty, print quality, or composition. They valued only the message. They saw themselves as educators of the underprivileged.

Some consider August Sander a proto–worker photographer, because he often focused on ordinary people and trade workers. But Sander photographed with cultivated deliberation, devoid of social criticism or class preference. He simply wanted to create, as he put it, a piece of history, a family album of the human species. He was a cataloguer. Worker photographers, on the other hand, were camera-wielding revo-

lutionaries. The camera was their weapon in what they saw as a worldwide class struggle. They forged an articulated opposition to the modernist art movement, even though they too were inspired by modernist utopianism.

But many of the ordinary Germans from the heartland, whose lives were provincial in the extreme, embraced neither modernism nor bloody revolution. Quite to the contrary, they longed for a romanticist purification built on Johann Gottfried von Herder's notion of "cultural nationalism." The eighteenth-century philosopher offered a spiritual antidote to Germany's political fragmentation, which by the early nineteenth century had culminated in a bewildering hodgepodge of nearly three hundred autonomous quasi-feudal principalities, autocratic duchies, absolutist monarchies, and free city-states. Herder had argued the merits of a natural indigenous culture, unaffected by arbitrary political division—a union that derives its strength from the familiarity shaped over time by common experience, social solidarity, language, education, geography, and climate.[6] To him no culture was better than another, but all were different.

The Enlightenment had fizzled out in Germany by the early nineteenth century, but artists, the intelligentsia, and certain members of the aristocracy continued to welcome the cosmopolitanism it had advanced. It granted them an intellectual world-citizenship—a sense of belonging to a free society governed by reason—that diminished both the need and desire for national unity. The security-minded bourgeoisie, on the other hand, transmuted Herder's more emotional solution into an unbridled blood-and-earth romanticism (*Blut und Boden Romantik*), defined by the historian George L. Mosse as "volkish" (German *völkisch,* an adjective derived from *Volk,* or the people).[7] The *völkisch* movement became an indicator of Germany's growing preoccupation with "rootedness" in the native soil as an escape from political division and subjugation as well as modernist alienation. Promulgating pantheistic concepts as a unifying emotional essence, a "higher reality" that would link the individual with other members of society, the movement sought to create a unique cultural expression that has been described as national destiny.

This sentiment gained momentum after the botched liberal revolution for unity in

5

1848, about which Engels remarked, "All people make progress. . . . Only the forty million Germans do not budge."[8] Although certain historians, such as David Blackbourn and Geoff Eley, argue that the bourgeoisie still predominated to some extent after 1871, when Germany was finally united under Prussia,[9] the general consensus is that reactionary Prussianism—the control of the people by the aristocratic elite—was merely stamped on all German lands and all German peoples. This process—often dubbed "the nineteenth-century feudalization of the bourgeoisie"—can be seen as the inevitable prelude to the cataclysm in the twentieth century. Certainly, while the second German Reich was not exactly a dictatorship, no freedoms—whether of speech, of moral choice, of the press, of assembly, or of artistic expression—were taken for granted by the public.

The rush toward spiritual renewal was not limited to Germany, of course. In England, William Morris gave birth to the Arts and Crafts Movement, championing a return to manual production in an attempt to recapture the bond between the individual and what he thought of as a distinctly medieval English environment. Almost everywhere in the Western world, the nineteenth century was an age in search of new meaning to counteract loss of identity and estrangement in the wake of rapid mechanization. But in Germany, where it proved impossible even to establish a clearly defined environment, this search spurred the strongest preoccupation with cultural mysticism—a phenomenon which, taken to an extreme, led to the rejection of all foreign influence, lest it dilute indigenous identity and sully German "purity."

This attitude was nourished by the fact that Germany's political weakness had frequently made it the battleground for the chronic conflicts of foreign nations. But now the definition of "foreigners" broadened to include German Jews. Non-Christians, had, of course, been routinely singled out and persecuted as "pagans" in other European countries as well, but in Germany the often liberal, cosmopolitan orientation of Jews became specifically associated with being "rootless," as Herder's positivism was twisted to foment ideological xenophobia.

This is where the *völkisch* movement, in its darkest manifestation, had finally arrived when it regained momentum during the Weimar years after World War I; it stymied any real chance for spirituality. But while the bourgeoisie retreated into their

6

neoromanticist *Sehnsucht*—which can be described as a lugubrious addiction to un-requited longing as an escape from the dilemma of powerlessness—some of the pho-tography that came out of that mood was intriguing.

Erna Lendvai-Dircksen, for instance, depicted the eternal peasants, weathered like the ancient stone in their walls, deeply entrenched in the rhythms of nature, in the regional tradition, lore, food, wine, song, and dress. But these images also brought to light Germany's idiosyncratic and often incompatible particularism, which persisted in the face of both the *völkisch* movement and democratic unity. As Thomas Mann wrote, "The Germans are the really problematic people. . . . Whoever should strive to transform Germany . . . in the sense of the West would be trying to rob her of her best and weightiest quality, of her problematic endowment, which is the essence of her nationality."[10]

By 1925, the notorious inflation had been brought under control, and—precariously propped up by foreign investment—Germany entered a period of relative calm. With over 120 newspapers, forty-some theaters, and a climate of sexual liberation, the en-ergetic capital of Berlin became an ebullient haven for a consummate class of radical artists that included George Grosz, Max Beckmann, Lyonel Feininger, Bertolt Brecht, Kurt Weill, Alban Berg, Paul Hindemith, Arnold Schönberg, Max Reinhardt, Fritz Lang, Ernst Lubitsch, Elisabeth Bergner, Greta Garbo, and, last but not least, Marlene Dietrich, whose lesbian duet from *It's in the Air* was the biggest hit of 1928—until Brecht and Weill's *Threepenny Opera* took the city by storm.

But when the artificial economy totally collapsed after the New York stock market crash of 1929, National Socialism, as Adolf Hitler presented it, not only seemed to of-fer a viable alternative to both failing capitalism and the threat of communism but also promised finally to bring the *völkisch* movement to fruition. In his "idealism of deeds," Hitler beguiled many Germans as a new Parsifal who had come to heal their spiritual wounds. Although the aristocratic elite, who had the most to fear from communism, financed his ascent, Mosse points out that ordinary men and women "fell into the arms of the new Reich like ripe fruit from a tree."[11] Neither objective nor subjective photographers had enlightened the German public; nor had worker photographers

roused the proletariat from apathy. The latter had succeeded only in alerting the bourgeoisie to the fact that their world was going up in flames. Indirectly, worker photographers thus helped clear the stage for the extreme political right.

When Hitler came to power in 1933—ending Germany's tentative encounter with liberty—"reality" took on a new meaning for photography. Now it was "reality monumentalized." Wedding *völkisch* aspirations with the modernist concept of a mechanized utopia, Hitler took advantage of new sound amplification and large-screen projection to bring about an unprecedented mass consciousness. Never before had so many people been able to witness the same photographed events simultaneously. As evidenced by the breathtaking films of Leni Riefenstahl, the audience could be hypnotized into a state of spurious unity, an effect calculated to justify the exclusion and persecution, and finally the systematic annihilation, of those who, for one reason or another, failed to conform. Dissent was eliminated by eliminating dissenters, as fascism became the self-appointed interpreter and adjudicator of the collective *völkisch* experience.[12]

Not all art produced in Germany during the Third Reich was political, but censorship was stringent. Worker photography was immediately suppressed, as was *Arbeiter Illustrierte Zeitung,* the left-wing magazine that published it. Some of the artists regrouped in various countries, but the spell of the movement—at least in the West—was broken. August Sander, meanwhile, was accused of being "antisocial" for departing from the official norm of positivist Aryan physiognomy. The printing plates and remaining copies of his first volume of photographs, *The Face of Time* (intended as part of a larger body of work titled *People of the Twentieth Century*), were seized and destroyed, but in the late 1930s he secretly managed to complete another series, titled *Persecuted Jews*. After that he went into seclusion in the Westerwald mountains. Although he lived until 1964, he never regained his vigor.

László Moholy-Nagy was denounced for his association with "decadent" abstraction. He escaped to Holland in 1934 and moved to England in 1935. In 1937 he founded the New Bauhaus School of Design in Chicago. Erich Salomon was not so lucky. It was not just the candor of his work but also the fact that he was Jewish that caused him to be labeled "enemy of the Reich." He was captured in Holland. In 1944, together with his wife and his youngest son, he was murdered in Auschwitz.

Meanwhile, Erna Lendvai-Dircksen, whose rather nineteenth-century pictur-esqueness resonated with Hitler's personal taste, joined the Nazi party. Her series of books—*German Volk Faces, Danish Volk Faces, Flemish Volk Faces,* and so on—inevitably came to be regarded as a glorification of the Nordic race, a stigma from which the artist never recovered.[13]

The realism of Albert Renger-Patzsch—which in spite of its purported objectivity also exhibited a somewhat glossy idealization—lent itself to the new dogma as well. His style, intended as an expression of natural harmony, came to serve as a prototype for the propaganda about ethnic superiority, inspiring a photography in which "real-ity" was systematically imbued with subliminal (and often not so subliminal) mytho-logical grandeur, rationalizing the unconditional surrender to an inevitable fate. From Renger-Patzsch's innocent perception of the world, as seen in his 1928 book, *The World Is Beautiful,* now issued a sinister scale of rigid norms. Fascist tableaux, such as *Kraft durch Freude* (strength through joy), *Arbeit macht frei* (work liberates), and *Jedem das Seine* (everybody gets what they deserve), were consciously based on tradi-tional *völkisch* virtues but given a new meaning that would strike terror into the hearts of those who did not conform. The words of G. W. F. Hegel now rang true: the state, formed as the embodiment of the collective, was not to be directed by those who composed and served it. It needed to fulfill its destiny through the power that was its essence.[14]

Indeed, by the mid 1930s, with the German economy miraculously revived, the new state was rushing over the land like a giant tidal wave. Those who were not swept up in it—or could not pretend to be—were swiftly swept under. While pho-tography officially followed the crest of this wave, it inevitably also exposed the abyss. Images of corpses from Dachau to Buchenwald endure as the evidence by which all other atrocities are measured.

Much has been written on the end of World War II, but it is still difficult to assess what Germans really felt. It was a time when, as Willy Brandt recalled in his mem-oirs, every little garden had become a graveyard. Certainly, the tragic disillusionment experienced after World War I, twenty-seven years earlier, paled in comparison to the

overwhelming sense of confusion and shame experienced in 1945—the year "zero," as it is called in German history.

The country was divided again, and in the eastern, Soviet-occupied, zone,[15] which would later become the socialist German Democratic Republic, many early vanguard photographers—Klaus Wittkugel, Edmund Kesting, Hajo Rose, and Oskar Nerlinger and Alice Nex-Nerlinger, among others—had survived. But they were not allowed to pick up where they had been forced to leave off under Hitler. New censorship for yet another fundamental revolution of the soul was already waiting in the wings.[16]

Some of these artists, however, were also devout Communists. Such was the case with the Nerlingers, who had vaunted the machinelike geometric abstractions of constructivism as the spiritual art of communism. Once that cerebral naïveté had soured, an art that could demonstrate tangible conversion was needed. Having recanted his earlier photographic abstraction and photograms—which he now saw as misguided excursions into error—Nerlinger wrote, "We wish to build a road that will lead to a new, valid state of mind and to enlist all active artistic powers that can work with us on the cultural construction of our country." Carl Hofer put it more metaphorically: "We find ourselves before the difficult task of clearing the field and cleansing it," he wrote, "before we sow and plant."[17]

At all costs, the Soviet-appointed authorities wanted to avoid repeating what they saw as the fatal blow to Weimar's worker photography, namely, the movement's having to compete with other, nonpolitical, currents. Why else, they rationalized, did the worker movement fail in Germany? Had it not been stronger there than in any other Western country? Like Hitler, they blamed certain artists, such as Moholy-Nagy, for attempting to promote anarchy, but whereas Hitler believed this tendency would engender communism, they now saw it as paving the way for fascism. Thus disparaging the entire modernist art movement as the enemy of all enlightened peoples, they ceremoniously endowed worker photography—both of and for the new humanity—with a singular status. Photography would show the workers how they should see and how they should be, how to emerge from their protracted period of lethargy and become revolutionaries. Programmed to both direct and commemorate culture, photography would instill, as Susan Sontag once put it, "a form of knowing without knowing."[18]

Of course, the ordinary German citizen, east or west—the baker, the mailman, the innkeeper—surely viewed all modernist art with great suspicion anyway. It threatened traditional Gemütlichkeit. Many East Germans were probably relieved when Wittkugel's early shadowgrams were held up for ridicule as an example of the "distorted decadence" responsible for all past problems. But now even John Heartfield's acerbic antifascist photomontages, which had often appeared on the cover of *Arbeiter Illustrierte Zeitung,* were lambasted as "experimentation." Although he moved to East Germany out of political conviction after it was declared a socialist nation, until his death in 1968 he primarily worked as a typesetter and set designer.

But while there was general consensus in the politburo as to which artists should be suppressed, officials disagreed on how the socialist worker should be portrayed. Should workers be seen as they actually were—as they lived and breathed—or should they be idealized into archetypes? Should they be shown in their struggle to overcome doubt and evil or at their moment of victory? Some believed the socialist consciousness was innate to the human psyche and needed only to be brought to the surface; others insisted that first all traditional thinking and behavior had to be exorcised through a lengthy process of fundamental reimaging of human nature, human need, and human value. But on one point the leaders agreed: the people themselves were not qualified to make these decisions.

Their debate was open-ended, continuing, in essence, until the GDR ceased to be, in 1989. But the most critical moment was in 1945, when, burned to the ground, Germany presented a unique opportunity to be rebuilt from scratch according to socialist principles. For communism, East Germany represented a foot in the door to the Western world. To the East Germans themselves, it must have seemed appropriate to give communism a chance, as it promised to put them above the seemingly self-perpetuating engine of capitalist greed and destruction. They had nothing to lose.

Thus, as West Germany embarked on its perilous journey to join the free nations of the world, leaving behind both mythological longings and Hegelian concepts of the perfect state, East Germany remained under the dominion of utopian totalitarianism —caught between ideological conformity and basic human desire. Although it was not yet a separate nation, at this juncture the history of GDR photography began.

Tired and without hope were those who crawled out of the rubble when the Fascist war-fury was finally silenced. They did not see the red flag over their heads. But already it was blowing in the wind, the flag with the insignia of peaceful work, the symbol of socialism and friendship among nations. . . . Here began our good life.

MARIANNE LANGE, professor of Kulturpolitik at the Parteihochschule Karl Marx, East Berlin

Chapter One

AFTER "ZERO"

14 The first photograph of the Soviet flag in Berlin, atop the burned-out dome of the German Reichstag, was taken from a military plane in 1945 while the furious battle was still raging. It was published in *Pravda*.[1] But when the city surrendered on May 2, a more heroic reenactment of the raising of the flag provided the Russian photographer Yevgeny Khaldei with the opportunity to help legitimize the Soviets' role as "peaceful liberators" (fig. 1).[2]

A number of slightly different versions of this official photograph have survived, all showing the Soviet flag emblazoned in the foreground, forming a series of dynamic diagonals with the flagpole and the figure of the Soviet soldier performing the ritual. His name was Meliton Kantarija, and he was called the "courageous son" of the Soviet Union—"the first to bring the banner of freedom."[3] He wields the flag like a symbolic weapon, in the grand tradition of baroque historical painting, yet he also crouches before it in reverence. Empowered by the various elements of the composition—the tanks and the shadowy procession of people below, the statues on the roof—the hammer and sickle form a central, easily understood insignia of the new pursuit.

Having thus assumed his "moral duty," Stalin immediately placed Berlin in the hands of one of his favored Communists, Walter Ulbricht, a tailor's son living in exile in Moscow since 1933. Within a week after the unconditional capitulation on May

Reichstag, Berlin,
1945 (Galerie Voller
Ernst, Berlin)

YEVGENY KHALDEI

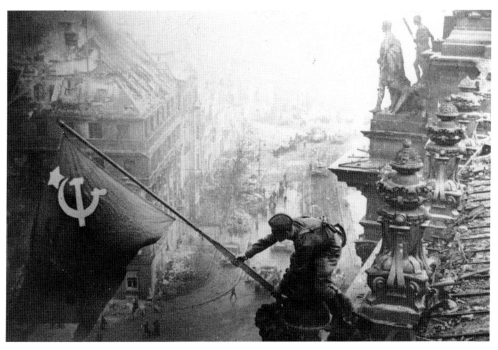

1

7, Radio RIAS Berlin was back on the air under new management; another week later the *Berliner Zeitung* resumed publication, equally "cleansed." Within a few weeks, the new leadership had brought epidemics under control and restored most basic urban services.

Art returned as well. By the time the Western allies had settled into their respective administrative sectors, a new phase of antifascist literature, film, and theater had sprung to life. But nonpolitical works by Jean Anouilh and Thornton Wilder were also appreciated, as were German classics from Goethe to Kleist. Even Gerhart Hauptmann, the humanist playwright who had compromised himself by remaining in Germany under Hitler, was not excluded.[4]

During the First Cultural Symposium, in February 1946—sponsored by the Communist party, or KPD (Kommunistische Partei Deutschlands)—Chairman Wilhelm Pieck offered unconditional artistic freedom and government stipends to artists. The response was enthusiastic. Even when he went on to say that in return, "the most urgent and distinguished duty" of artists was to create conditions that would prevent "this newly awakened cultural life from sinking back into reactionary, chauvinistic and militaristic debauchery," suspicion was not appreciably roused.[5] This duty seemed a privilege, hardly a limitation. Exiled artists and liberal intellectuals were still returning to Berlin from all over the world, eager to be part of what they believed to be a glorious new epoch of peace.[6] True liberty, it seemed, had dawned in Germany at last. And hope, once again, sprang eternal.

In his 1985 article "In Search of Ourselves," Peter Pachnicke, who taught photography at the prestigious Hochschule für Grafik und Buchkunst (hereafter HGB),[7] provides an official insider's view of East Germany's photography from this early postwar phase. Reiterating how, under Soviet influence, the medium was allowed to resume the "proletariat revolutionary" style of the *Berliner Illustrirte Zeitung* and *Arbeiter Illustrierte Zeitung,* he commends surviving prewar worker photographers, such as Walter Heilig, Horst Sturm, Richard Peter Sr., and Erich Höhne, for focusing poignantly on the "reality" and "truth" of ordinary people—now amid the ubiquitous ruins and refugee camps.[8] Already under the strict supervision of the Kulturbund,[9] the supreme cultural agency in charge of artistic affairs, their work appeared in the

official East German photo magazine, *Fotografie*—which replaced all other existing photography magazines—and the official magazine for all the visual arts, *Bildende Kunst,* both founded in 1947.

Pachnicke praises these artists not only for bearing the burden of history but also for "taking history into their own hands" by exposing the evils of war. The unflinching verism of their images distinguishes them as "symbols of conviction, expectation, search, resurrection, help, sharing, responsibility, and activity."[10] Still, a photograph by Abraham Pisarek of an aged woman refugee dressed in black, facing backwards as she rides through the rueful decimation that national arrogance has wrought, somehow makes fate seem irremediable (fig. 2). How many wars could she count? And what did she have left in the end to fill the purse on her lap? The triumph of evil appears hopelessly perpetuated from generation to generation, offering no reassurance that yet another political system could make a difference.

Pachnicke's goals for photography were not limited to East Germany. In West Germany, having spent the war years in seclusion, August Sander returned at age seventy to photograph among the ashes of his beloved Cologne. Friedrich Seidenstücker attempted to chronicle the ghost of Berlin. On an international level this desperate urge to sort out the overwhelming chaos breathed new life into a documentary style reminiscent of the Farm Security Administration photography under Roosevelt. In this climate, Magnum Photos was founded in Paris by Henri Cartier-Bresson, Robert Capa, Ernst Haas, and others from six countries in all, laying the groundwork for the human-interest photojournalism of the 1950s and 1960s.

But in East Germany all other photographic subjects—the landscape, the intimate portrait, the still life, the nude—were already viewed with disdain.[11] While beauty and hedonism were perhaps needed more than ever, they were seen as trivializing the postwar experience and thus negating a meaningful recovery. Photographs inspired by the old avant-garde—from Renger-Patzsch to Moholy-Nagy—were still a staple in *Fotografie,* but officially all experimentation, all expression of subjectivity, formalism, or anything that evoked *l'art pour l'art,* was dismissed as "bourgeois decadence," which in turn was blamed for just about everything that had gone wrong in the past.[12]

For the time being, artists took this argument with a grain of salt. It was, after all,

ABRAHAM PISAREK

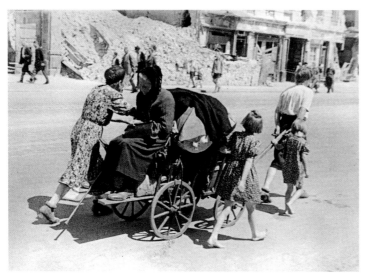

2

Refugees, Berlin,
1945 (Sächsische
Landesbibliothek,
Deutsche Fotothek,
Dresden)

EDMUND KESTING

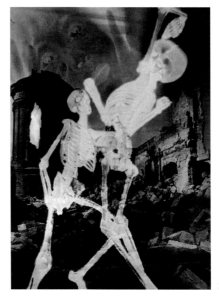

Untitled, from
Dance of Death,
Dresden, 1945
(Technische
Sammlung der
Stadt Dresden)

3

almost as old as photography itself—a seemingly quaint echo of nineteenth-century morality, in which art was rhetorically admonished to reflect the conscience of society and thus avoid being reduced, as Proudhon had put it, "to nothing more than an excitement of fancy and the senses."[13] As creativity continued to flourish, little did anyone imagine the radical artistic oppression in the making.

Edmund Kesting's allegorical photomontage from his series *Dance of Death,* for example, is a direct continuation of his expressionist style from the 1920s (fig. 3).[14] And highly subjective, if factual, is Richard Peter Sr.'s image from his series *A Camera Accuses,* where a solitary baroque angel solemnly presents the viewer with the aftermath of Dresden's inferno,[15] initiating a Faustian dialogue between celestial beauty and human perversity (fig. 4). Equally filled with interpretive innuendo is his chilling photograph of the decomposed body of a Nazi soldier as a personification of tortured agony in the manner of Hieronymus Bosch (fig. 5).

But while the future for photographers seemed bright, the political situation took a more overtly ominous turn. When the first local elections in 1946 brought defeat for the Communists (KPD) and overwhelming victory for the Social Democrats (Sozialdemokratische Partei Deutschlands, or SPD),[16] Stalin simply joined the two to create the Social Solidarity Party (Sozialistische Einheitspartei Deutschlands, or SED). One at a time the Social Democrats were then ousted, leaving the remaining Communists under the ever-growing power of Ulbricht. As a Soviet-directed Marxist-Leninist tool, the SED moved quickly toward dominating every minute phase of political, economic, social, and cultural life. For democratic appearances other parties were tolerated, but they had no voice and unwittingly served as a means for keeping track of dissidents. It was the beginning of the end for bourgeois institutions as they had been advocated before the war by the popular front of Communists, Socialists, Liberals, and Conservatives against Fascism.[17] A long string of disappointments was to follow, as "democracy" turned out to be a euphemism for universal agreement with the self-perpetuating SED.

In Marxist philosophy, of course, democracy is not associated with freedom of individual expression; it is rather a state in which all societal difference, all opposition and all privilege, has been erased by whatever means necessary and replaced by the collective. Although presented as a scientific solution to the problem of human self-

19

Untitled, from
A Camera Accuses,
Dresden, 1945
(Sächsische
Landesbibliothek,
Deutsche Fotothek,
Dresden)

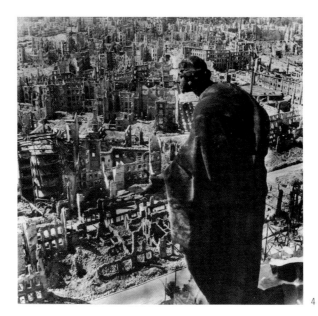

4

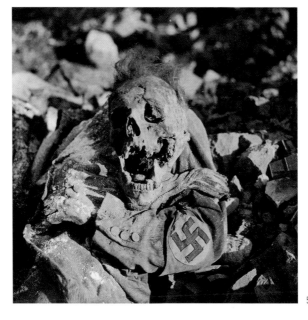

5

ishness and greed, in terms of government-regulated mind control, communism was identical to fascism. Politics remained an expression of ideological conformity, promoted by liturgical rituals, mass rallies, and public demonstrations of loyalty. The goal was still a total culture where "truth" was a given. Whoever would not accept the official status quo was labeled a "reactionary hindrance to progress" and could, in the name of the workers, be purged by the newly appointed State Security Service (Staatssicherheitsdienst), commonly referred to as the Stasi.

For whatever reason, whether fear or opportunism, eventually close to one out of every thirty East Germans became an informer for this organization. Many of them were photographers. The much-heralded German revolutionary spirit had failed to be roused once again. Instead, old methods of oppression had merely resurfaced under a new insignia. A growing sense of desperation began to darken the pale shimmer of hope.

Subtly, but with implicit urgency, those who wrote on photography began to rationalize artistic control to clarify "ideological confusion" and promote "democratic and anti-imperialistic thought patterns."[18] What precise form censorship should take was still unclear, but it was evident that only an ironfisted effort could break the relentless cycle of chaos, war, and destruction seeded by capitalism. Everyone needed to be engaged in the process of proliferating the "socialist world inheritance" if the movement was to succeed. Both the old, who had longed for a return to stability, and the young, who had never known anything but war, were thus inducted into another, even greater, campaign. This time it was for everlasting peace.

The Western allies, meanwhile, had not yet firmed their ideas about the future of Germany, and in the afterglow of Hitler's defeat they wanted to see Stalin as an ally. But lingering suspicions were finally confirmed on June 30, 1946, when the SED introduced an inimical measure preventing East Germans from crossing freely into the Western zones. Local airwaves then began to resound with slogans about the great Soviet Union as the most inventive, progressive, and democratic society, destined to change the world. Communists were given high ci ii and administrative positions, private land was expropriated, private bank accounts were seized, and entire industries—such as Zeiss optics or the Allgemeine Elektricitäts-Gesellschaft—were

confiscated, sometimes including the personnel that had run them. Perverting ideal-istic ideology for personal gain, Stalin had East Germany systematically looted and stripped. He turned the tables on Frederick the Great, the eighteenth-century founder of Prussian militarism, who had boasted that a defeated people should be left with nothing but their eyes to weep with.

While Western allies were still celebrating on the Rhine, Stalin was busy building his domain along the Oder and the Neisse, rearranging both German and Polish bor-ders at will. And as the ubiquitous East German *Trümmerfrauen* (women of the ruins) were copiously photographed clearing the rubble in their ghostly cities (figs. 6 and 7), loudspeakers mounted on slow-moving cars announced that only learning from the Soviet Union meant learning to be victorious. Once more the idea of liberty had fallen by the wayside. A peaceful and parliamentary path to a unique brand of Ger-man socialism—as the Communist theoretician and party official Anton Ackermann had suggested in 1946[19]—was no longer even an option.

The iron curtain, which was about to come down, would eventually take the form of a three-mile-wide death zone, severing families and friends as it slashed arbitrar-ily through the heart of the nation. What had been the center would become the shad-owy fringe, ostensibly studded with watchtowers, searchlights, antitank mines, booby traps, and endless coils of barbed wire stretching over hills and valleys into the Baltic Sea. After seventy-five years of perilous unity, Germany would be more deeply riven than ever before.

An article by Heinz Lüdecke from 1948 reveals the difference that began to crystal-lize between acceptable and nonacceptable photographic treatment of postwar dev-astation.[20] An image by Fritz Eschen, *Destroyed Facade,* was deemed "worthy" by Lüdecke, because it supposedly presented destruction in an objective and straight-forward, almost cartographical, manner (fig. 8). The solitary bronze figure attached to the ruined facade, he wrote, suggested nothing beyond its immediate context, as no technical tricks were used to visually isolate or emphasize the figure for unfounded symbolic innuendoes. But he criticized *Castle Ruin in Potsdam,* by Max Baur, for compromising "absolute truth" and manipulating the emotions of the viewer (fig. 9).

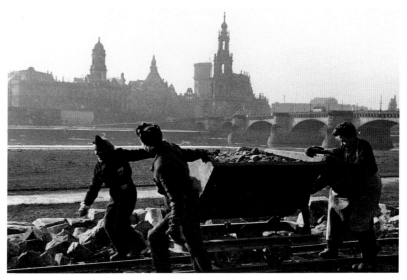

6

Untitled, Dresden,
1946 (Sächsische
Landesbibliothek,
Deutsche Fotothek,
Dresden)

Untitled, Dresden,
1947 (Sächsische
Landesbibliothek,
Deutsche Fotothek,
Dresden)

7

Destroyed Facade,
Berlin, 1947 (*Bildende*
Kunst, July 1948)

FRITZ ESCHEN

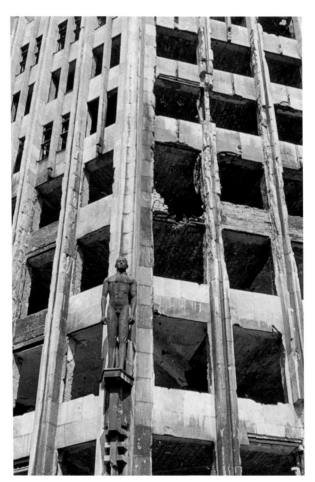

8

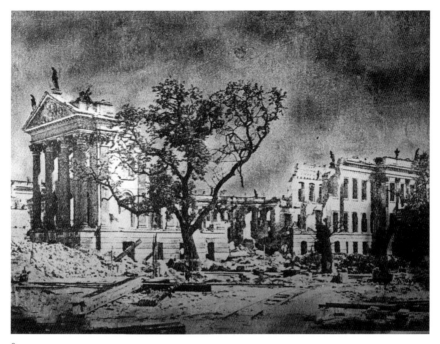

9

*Castle Ruin in
Potsdam,* ca. 1947
(*Bildende Kunst,*
July 1948)

Although the image itself was utterly factual, the ruin appears somewhat transfigured by dramatic lighting, as well as by the printing. The result, Lüdecke felt, negated the real horror of war. "What is truth?" he asked. "The river is truth; a drop from it can be a lie." He accused the artist of conjuring up a sentimental lie—a cheap imitation of romanticist landscape painting. "Attitude is everything," he concluded, "for both the artist and the photographer."[21]

For Lüdecke, art criticism was removed from the realm of intimate judgment; rather, it was a uniform, politically motivated response. Because Baur's personal interpretation of reality evoked a romanticist analogy between recent events in history and a universal existential frailty, he was admonished to be single-minded, like the audience he was to inspire. The line was drawn in the sand.

While Lüdecke disseminated official policy, two writers aptly summed up the paradigm: Edith Lohmann believed that the picture as document and the picture as artistic expression coexisted as equals; Wolfgang Watteyne, on the other hand, thought that photography became an art when it was dedicated with "body and soul" to creating something in which "the whole" was "more than the sum of all parts."[22] Here the traditional argument for the superiority of humanistic over naturalistic photography serves as an introduction to the new didactic photography. Already "the whole" was synonymous with socialism.

In spite of persistent rumors to the contrary, hope was still nurtured that the dread Soviet occupation was a temporary inconvenience, bound to be lifted once a peace treaty was signed. Berlin, well within the Soviet zone, was ruled jointly with the three other Allied forces—Great Britain, France, and the United States—and communication among the four sectors was virtually unimpeded. Therefore, cans of American Spam—bartered for family heirlooms on the black market at the Potsdamer Platz, where the four sectors converged—still found their way to the far corners of East Germany. The honeycombed ruins of what had once been the busiest traffic hub in Europe apparently enabled the vendors to escape effortlessly into adjoining sectors whenever authorities approached.

Times were harsh, and people could afford only the barest necessities. But after the nonstop bombing of earlier years, this seemed a heavenly period, not without its own

special humor. Jokes about open-air bedrooms or dark back-alley houses that had ac-
quired a view were making the rounds. Then in 1948 came the Soviet blockade of
West Berlin, cutting off all land routes to the former capital within the Russian sector.
It was a blow that shattered the frail and peculiar sense of almost playful normality
that had emerged against all odds. Berlin now stood in the path of Soviet control over
Europe, giving a new twist to Hitler's old slogan, "First Germany, then the world."
The cold war had begun in earnest. Although West Berlin was saved by the now-leg-
endary Allied airlift, the future, in spite of intermittent improvements, grew dimmer
with each passing year.

An exhibition of contemporary German photography from all four sectors, orga-
nized by Adolf Lazi in the ruins of the Landesgewerbemuseum in Stuttgart in 1948,
provided a brief moment of hope.[23] For the first time east and west were united, but
for all practical purposes it was also the last. October 7, 1949, two months after the
Federal Republic of Germany was created in the west—as a precaution against an all-
socialist Germany—the portion of East Germany that had not been assigned to
Poland became the German Democratic Republic. Stalin sent a telegram of congrat-
ulation, but he neglected to grant diplomatic recognition.[24]

The new GDR retained a multiparty system for the world to see, with a constitu-
tion, actually based on that of the Weimar Republic, that guaranteed traditional lib-
erties.[25] But in reality, only the self-perpetuating SED—described in a membership
booklet as the "highest form of social and political organization"—continued to rule;
its power, increasingly in the hands of Ulbricht, was absolute.[26] The SED was now a
party that had acquired a state, one in which all accountability went from the bottom
to the top.

The issue of unification remained a subject of passionate debate, both in the east
and in the west,[27] but the ideological wedge was now firmly positioned in the battered
body of the country, splitting all of Europe into opposing camps—one claiming to be
"idealistic," the other "realistic." Although each German state viewed itself as the
rightful heir to the German nation, the GDR rejected all responsibility for the atroc-
ities committed in the name of nationalism, blaming them instead on capitalist im-
perialism. Thus, while the idea of nationalism had become distasteful in the west, in
the GDR it continued to be promoted without qualm.

Scientific socialism promised deliverance from the "chains" of the past. It would empower the human spirit to conquer both the gnawing evil without and the intimate, flagrantly inventive evil within the soul. A panacea, it granted a perpetual state of grace to the worker as both deity and worshiper in the temple of Marx and Lenin. Meanwhile, Martin Luther, who represented the old religion, was disavowed as the "first in a long succession of reactionary, militarist/imperialist leaders to whom the people had become subjugated and addicted."[28] From that lineage came centuries of bloodshed, pain, and tears.

Such fundamentalism soon squelched almost all artistic impulses. Even Brecht—who had moved from Los Angeles to East Berlin in 1948, after being investigated by the House Un-American Activities Committee—came under attack. The party feared that his sardonic humor and proclivity for parody might put the audience in too critical a mood.[29]

After 1950, photography was denied what little artistic freedom it had during the early postwar years. While in West Germany, Otto Steinert's *Subjektive Fotografie* introduced a new generation to an artistic commitment inspired by the Bauhaus,[30] in the GDR, subject matter and technique were ever more narrowly tailored to the purpose of illustrating the "progress" of the "new forward-moving revolutionary worker society in its historical transition from capitalism to socialism."[31]

Although many recognized this restriction as an erosion of individual rights, it was difficult to escape the effects of such an intense campaign. The restless cycle of human destruction indeed appeared to be driven by personal greed and desire; certainly the world could not go on as it had been going. Perhaps it was easier to temporize, to fall into step once again, than be tortured by constant doubt and fear. After all, did not the ubiquitous success of the Soviet Union validate the scientific nature of Marxism and the inevitability of its worldwide application?

That deduction seemed reasonable enough in western Europe and even the United States, where the McCarthy campaign from that period is a testament to the degree of hysteria it generated. But in the GDR, where all had already been lost, it was more practical to surrender. Ulbricht was a cogent orator with an affable air, and he be-

stowed importance on the masses as the bearers of culture. Happiness was no longer getting what one wanted but learning to want what one could get.

Photography clearly reflects this imperative. *Beautiful German Homeland (Schöne deutsche Heimat),* a juried exhibition of amateur photography in Berlin in 1953, was advertised as an "all-German" show, but submissions were to illustrate how "all up-right patriots . . . cultivate national, humanistic traditions, while ceaselessly fighting for unification of a democratic, independent, and peace-loving Germany."[32] Specific guidelines listed, first, a typical homeland photo; second, the revolutionary national tradition and cultural inheritance; and third, the present societal conditions in the fatherland, west and east.

As they could easily imagine what kind of imagery would be awarded, the tired citizens of East Germany acquiesced. Once again they chose the traditional path of least resistance and hoped for the best. Of course, they had no other choice. In return they were absolved from both their Nazi and their Prussian past. They abandoned their *Sehnsucht,* the romanticist malaise of undefinable longing, and instead were given the role of "pioneers of humanity." They would be remembered as the people who changed human fate. This consolation prize undoubtedly made life more bearable on some level, but in photography it largely produced a generation with very little to express. Photographers learned to fill quotas like factory workers, but they forgot how to think. With the rest of the nation they fell into a long, deep sleep.

29

And the face of our audience is the face of our art. Beware,
enemies of humanity! We shall protect and defend our
artistic creation! It is the prerequisite for peace.
Humanism must be armed—to protect humanity.

HANNS ANSELM PERTEN,
superintendent of the Volkstheater, Rostock

Chapter Two

PHOTOGRAPHY AS
POLITICAL ICON

Ulbricht's campaign to cleanse life and art of all remaining "imperialistic residue" during the official socialist building phase (*sozialistische Aufbauperiode*) amounted to an ideological eugenics, weeding out those who refused to surrender body and soul.[1] The lucky ones were expelled; the less fortunate were imprisoned or simply disappeared. Sometimes relatives were later notified of the victim's fate, but more often they were left to wonder.

Ulbricht was Stalin's most reliable scion, with little patience for ideological debate. He had been a member of the Communist party since 1919, when he was described as "reticent and friendless, with few ideas and conspicuous talents."[2] Nevertheless, he became personally involved in transforming the SED into a Bolshevist party, which he virtually ran after 1953.

Political intrigue was nonetheless rampant, and it added to the general aura of paranoia and fear. Jews were once again singled out for persecution, this time because "Zionist" doctors were suspected of attempting to poison the Soviet party leaders. Official anti-Semitism became so alarming that by 1953 all chairmen of the small Jewish communities had fled to the West.[3] Christian church leaders were not spared either; their ration cards were routinely withheld, and often their children were denied access to higher education. Even former soldiers who had been prisoners of war in

Western countries came to be regarded as traitors. Those in the politburo who advocated a more temperate course were quickly ousted or destroyed. In 1951 the Marxist writer Horst Bienek, for example, was sentenced to twenty-five years of hard labor in Siberia for handing out leaflets. He was pardoned only after the visit of West German Chancellor Konrad Adenauer to Moscow in 1955.[4]

One of the most absurd manifestations of this mania was the fate of the resplendent Royal Palace, in the heart of old Berlin, which miraculously had avoided major damage from the air raids. In 1952, Ulbricht had it dynamited as a symbolic gesture of renewal, leaving the site vacant for military parades and May Day spectacles. In his effort to redefine so-called progressive German culture, Ulbricht now also execrated socially conscious worker photography, whose often gritty portrayal of the human condition undermined the optimism deemed necessary for the triumph of socialism.[5] Photography had to be positive, he effused in 1953, shortly after the unsuccessful uprising of workers on June 16 and 17; it needed to create harmony and enthusiasm and transmit an appreciation for life.

The uprising began as a general strike of construction workers in Berlin in response to the government's failure to reduce the unrealistic work quotas, which helped pay for the growing government apparatus. Unrest spread to other industrial centers, culminating in a demand for unions and free elections. Soviet intervention led to considerable bloodshed, and participants were severely punished.[6]

Brecht publicly endorsed the suppression of the uprising, but privately he wrote:

After the uprising of the 17th of June
The secretary of the Writer's Union
Had leaflets distributed in the Stalinallee
In which one could read that the people
Had forfeited the confidence of the government
Which it could only retrieve
By redoubled effort.
Would it then not really be simpler
If the Government dissolved the people
And elected another?[7]

33

Ulbricht's socialist zeal was undoubtedly fueled by the uprising, which, after all, was his first taste of failure. Rebellion—that fickle igniter of history—was provoked precisely by those whom socialism had deified. It was a slap in the face, and most likely the Soviets would have deposed him, once the insurrection was put down, had they not become so preoccupied with their own accelerating power struggle in the wake of Stalin's death three months before.

The brief lull in strict Soviet supervision created the faint illusion of new liberties for artists. Some historians have called this period the Great Thaw; on the whole, however, it was more of a new chill, bringing to the forefront Ulbricht's own authority, which squelched all hopes that had been stirred by news of Stalin's death. Soon Ulbricht demanded that artists concern themselves solely with the victory of socialism over capitalism, and the Kulturbund echoed: "As the artist shapes the new progressive element—the evolution of humanity—he is educating millions of others to become progressive. Therefore, at the center of artistic creation must be the new human being—the activist, the hero of socialist construction."[8]

Photography—the astonishingly libertine medium that had finally fulfilled the Renaissance aspiration of rendering images true windows to the world—was thus imprisoned by the political grandiloquence of social realism. As imitation of nature gave way to the fixation on an idea, culture ceased to be a dialogue or even an argument. It became a Marxist monologue about the happiness of unconditional conformity as the solution to the individual experience.

But could the Marxist concept of democracy—the erasure of all societal and cultural differences—be applied to the creative process? Ulbricht believed so. He denounced all subjective interpretation of reality in art as "bourgeois debauchery," which was bound to pass with capitalism. To him, artistic individualism was not only superficial and frivolous but also dangerous, bringing an irresolvable chaos of conflicting opinions.

The official definition of formalism was now broadened to include any recognizable concern with composition. The conscious structuring of images, like all concerns with aesthetics, supposedly detracted from the "higher reality" of the content; it negated the "democratic" struggle as it caused artists to squander invaluable oppor-

tunities to improve the human condition.[9] The "formalist debate," as it came to be called, continued over several years, culminating in an outright ban of all tendencies that might betray a sensitivity toward form. But since the debate itself was censored, it was little more than a tautological soliloquy justifying prohibition. "The working class," wrote the historian Ernst Hoffmann, "learned to use . . . science and culture as important weapons in class struggle, as they created the foundation for a profound cultural revolution. They liberated art from the terror of formalism by waging a consistent war against its ideological roots, cosmopolitanism."[10]

In spite of the official ban, the issue of formalism could never fully be resolved. It was simply impossible to agree on when a compositional form detracted from the message and when it actually enhanced it. On the one hand, a photograph of a plow—the quintessential symbol of work—was lambasted as an expression of the "crassest" formalism and "cultural decay," because its sharp silhouette was thought to create too strong a design.[11] On the other hand, Helmut Dattermusch's high-elevation shot of a lone street sweeper dwarfed by a curving sidewalk (fig. 10) flirts unabashedly with formal abstraction, yet it was displayed in 1954 at the *First Regional Photography Exhibition (1. Bezirksfotoausstellung)* of amateurs and workers in Leipzig.

35

Occasionally, of course, one could also stumble upon photographs that more overtly conformed to the subject matter of the working person without sacrificing artistic integrity. In Günter Rössler's *Engrossed in Work,* for instance, a boy folds sheets of white paper in a factory assembly line (fig. 11). On the surface he denotes a well-functioning small unit within a larger productive whole, or—as Marx had put it—a small stone in the large socialist mosaic. The message, it seems, is that material needs are met by serving the needs of others. But at the core there is a conundrum. In an aesthetic manner that harks back to Lewis Hine and even the early gum-bichromate prints of Edward Steichen, the light tones seem to float against the dark background, etherealizing the boy's face above the faint contour of his body. He takes on a gossamer hue. Half dreaming, he seems to be watching over the empty sheet like a guardian angel, as though it were his own yet unwritten life.

When this photograph was taken, about 1953, the boy would have been thirteen or fourteen, the age at which children of German workers left school to learn a trade. Although he would probably not have known much of the Nazi era firsthand, he was

The Day Begins, n.p.,
ca. 1954 (*Fotografie,*
December 1954)

HELMUT DATTERMUSCH

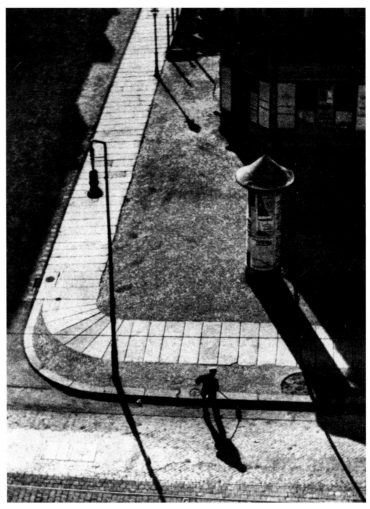

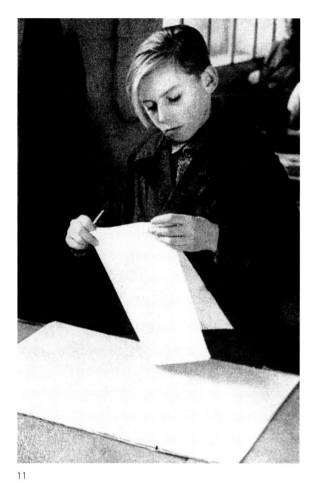

11

Engrossed in Work,
n.p., ca. 1953
(*Fotografie,*
May 1953)

born during the war and remembered its end. Now, with all of that behind him, he finds himself folding a white sheet—one of many white sheets—as if to seal in its pure emptiness, in a room where the window has bars.

Without knowing what was intentional and what accidental, it is impossible to know what the photographer was really attempting to convey.[12] For this reason the interpretation of photographic images inevitably remained a vexing source of confusion. It was easier, however, to theorize about why social realism—then simply called "realism"—was the only valid criterion. The historian Ernst Nitsche put it quite bluntly when he wrote that "in order to develop a realistic art, the social conditions in the GDR must be considered; our life must be properly portrayed in its progression. . . . Realism, therefore, is the laughing, happy life; it is our proud youth; it is our workers; it is our beautiful German homeland. Abstract, formal visualization in which nothing can be recognized only invokes false emotionality, the kitsch photography of old; it means isolation from the people, a furthering of imperialism."[13]

Kurt Eggert approached the subject with greater aplomb. "Realistic art," he noted, "is not a historical style; it is truthfulness. . . . That does not, however, make it a slavish copy of reality. The essential, general quality, the idea that the artist wants to bring to the viewer in order to awaken his thoughts and feelings and motivate him to action . . . must be based on truth."[14] Since "truth" was routinely equated with socialism, everybody knew what kind of thoughts, feelings, and actions the artist was to inspire. In fact, what Eggert wrote came directly from Marx, who had said that artists needed to do more than understand the world; they needed to help change it. Everybody knew what kind of change was required, hence what kind of realistic photography qualified as art. In the name of art the two opposing tendencies in photography— idealization and truth-telling—were made simply synonymous to forge a tangible expression of wishful political thinking.

The objective, socially conscious documentary style of earlier years was not banned outright at first; it was merely demoted to the nonartistic, technical sector of photography and labeled *naturalistic,* in the sense of a mechanical record of nature—a soulless reflection of appearances, devoid of all higher creative significance. Naturalism was disparaged for failing to take advantage of the artistic prerogative of "imaginative and intelligent choice."[15] Photographers were thus told to make a critical and creative

38

selection of reality, but at the same time Ulbricht insisted that all subjectivity in art was a threat to Marxist principles of equality. Artists were asked to think—but to think alike.

To rationalize this total political surrender, writers cited respected premodern authorities, from Plato to Delacroix, twisting their definitions of realism into an endorsement of social realism. Werner Lachmann, for example, quoted Goethe's assertion that "artists are not to bring forth something that is easy or superficial; their duty is, rather, to use exacting yet sensuous fantasy in competition with nature, to bring out something at once spiritual and organic, to give the work of art a form and content that make it appear both realistic and supernatural."[16]

But most frequently quoted was Lenin's credo that "a work of art must be subjected to the process of human understanding: from living contemplation to abstract thinking and then practical application." With these words, Lenin simply reformulated Marx's own pronouncement that artists needed to change the world. (Marx also reprimanded philosophers for only trying to understand the world instead of changing it.) Those who wrote on photography likewise adapted that statement, giving the impression that they all agreed, when in fact they were only reciting Marx. By whatever means necessary, social realism was endowed with "artistic truth" to justify falsifying reality.

What made art "progressive" was not the artistic vision, form, color, or concept but rather a singular preoccupation with ideological and technological advance geared to the "real needs" of the "new humanity." Progressive art, the photographer Jaro Koupil wrote, should take all people of goodwill by the hand to fight for progress and peace for the worker, regardless of language, nationality, or race.[17]

While the requirements were sufficiently clear, rendering progress on a two-dimensional plane still remained problematic. Painters could at least take their time. They could imagine or observe different models; they could add and remove various elements until the idea became convincingly isolated and clarified. Photographers, meanwhile, had to work backward: they were forced to find this elusive socialist essence among the great number of moments that life randomly presents. The most practical solution was to bypass reality altogether and simply stage the situation to be

39

photographed. Those who wanted to play it safe took this option. The most blatantly obvious images—those accessible to the lowest common denominator—were the ones most likely to be published and applauded by the censors, who were, after all, bureaucrats with no appreciation of art. Anything that transcended the cliché or displayed a sense of flair or originality was viewed with suspicion.

A cultural ordinance passed in 1951 offered stipends for artists to produce politically correct work. While this support certainly provided an incentive, Ernst Hoffmann's glowing assessment—that "most artists in the GDR have seriously begun to fulfill their obligation" and that "they are siding with their new art patron, the leading power of the state, the working class"—merely reflected the mood the government wanted to impose, not anything the people actually felt. Like social realism itself, this mood was fictitiously hopeful. "Only in socialist countries," Hoffmann concluded, "is the exploitation of humans by humans brought to an end—permitting true liberation of the artistic personality. Only in socialist countries can free people live and work according to the laws of beauty."[18]

While social realism in the Soviet Union and China often hinged on mass rallies, marches, and shows of military empowerment, in the GDR great care was taken not to stir up memories of Germany's irksome past. Emphasis instead was on the rewards that come from sharing and working together. "Pointing out the worth of the working man," wrote R. Tzschaschel, "is a rightful imperative of our time. . . . Every step we take, we meet this man in his manifold manifestations: the worker on the machine, the scientist in the laboratory, the child at play."[19]

Heading the list of safe and acceptable subjects was the leader Ulbricht himself (fig. 12), shown as a personification of positivist truth, presiding over symposia or interacting with the youth, and always poised like a Lenin monument: confident, paternal, benevolently domineering and imbued with mystical splendor. Even a Lenin-style goatee sprouted on his chin. In reality Ulbricht remained a staunch Stalinist and was hardly a man of the people; photographers needed to take care not to reveal his arrogance or his isolation.

Popular subjects also included group sports, as long as the emphasis was on winning, to symbolize collective achievement. Industrial themes were a given, since they

40

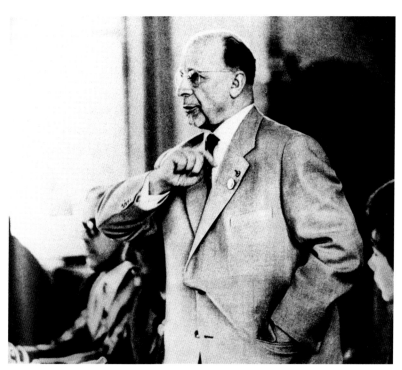

Walter Ulbricht,
n.d. (*Fotografie,*
June 1968)

THOMAS BILLHARDT

contributed to a positive image of national productivity and expansion. But although machines were still worshiped in a somewhat naive, early modernist way, they could not be given more importance than the workers who operated them. (Renger-Patzsch's failure to observe this rule was one of the reasons he was declared persona non grata.) Socialism was purportedly a humanistic movement, in which machines were an important means but never an end.

Perhaps this is why most public praise was bestowed on photographs of farmers: sowing and reaping in unison, dominating their tractors and threshing machines like thrones—always jubilant, strong, and productive. They were the most basic unit of humanity, the salt of the earth, liberated after centuries of abuse. Photographers, explained Jaro Koupil, must show how ordinary humans have taken possession of nature in spite of all natural obstacles. "Only man can triumph over nature and be victorious in the fight for his daily bread."[20] Humanity was not a product of nature, but rather, in this somewhat unabashed Wild West mentality, nature was a limitless commodity to be harnessed and molded into an expression of an indomitable human will. The vast plain filled with rustling wheat, the August sky, the sun setting on the harvest—such picturesqueness could certainly be addressed in a photograph, but only if it clearly transcended "romanticist bourgeois values" and clarified "the real achievements of the workers."[21]

Amateur photographers were likewise recruited for the political cause, albeit under the auspices of the Kulturbund's benign-sounding "Friends of Nature and Homeland." Like the professionals, they were admonished to shun the pure landscape and concentrate instead on the effects of work on the land—large-scale farming, mining, the building of roads or dams—or illustrate, in some form or fashion, abstract socialist ideas such as land reform.[22] Only through conquest, it seems, could nature become a "friend" and a "homeland." "More and more people recognize that man holds and shapes progress," said a certain Kulturbund member, identified only as Böhle, in his welcoming address at a 1954 conference of amateur photographers in Dresden. "The more consciously man works at the existing conditions, the more he devotes himself to a progressive cultural development, the more beautiful life will become."[23] Agreement, mandated by the state, became a public mask that could be taken off only in the tentative sanctuary of the home, or among a few trusted friends.

*One can be a communist only when one's mind has been
enriched by all the treasures recovered by humanity.*

V. I. LENIN, "The Tasks of the Youth Leagues"

Chapter Three

PIONEERS
AND BACKLASH

Despite the official stance on art, some historians managed to interject their personal opinions. Wolfgang Hütt, for instance, appealed to photographers to be versatile, to address everything that "moves and captivates," including the contradictions.[1] And his unconcealed enthusiasm for form, which surfaced in his analysis of Tadeusz Wilkans's image of abstracted shadows of legs projected on a beach, was downright bold (fig. 13). "The placement of the horizontal shadows, as they intersect with the slightly curvilinear waves of the sand, is immediately enticing. . . . How well the feet are positioned within the frame of the image! The man's right foot is cut off. Only the big toe is visible. But [the toe] is all that is needed to receive the powerful lines of the formal arrangement, anchoring the picture firmly within its space."[2]

Hütt's formalist revelry, though exceptional, gives evidence that the limits continued to be tested. Still, in the end he thought it wise to back down. "There at the vacation spot," he concluded, "without any covering, simple humanity is stripped bare. Because only their feet are seen and their shadows, [the subjects] are not individuals. . . . Standing before us are not two specific human beings but humanity at large. From individual truth, the artist leads us to a general and deeper sense of humanity."[3]

It is to Hütt's credit that he found a way to rationalize a thoroughly playful photograph within the framework of Marxist sensibilities. In other socialist countries, such as Czechoslovakia, where similar battles were being waged, the government eventu-

Untitled, n.p.,
1950s (*Fotografie,*
January 1958)

TADEUSZ WILKANS

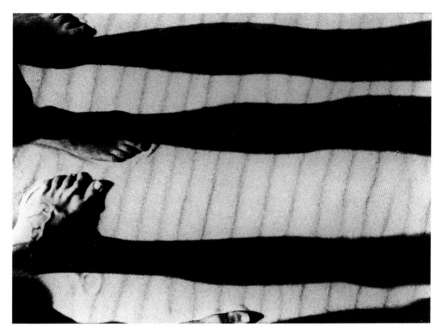

ally gave in and photography was rescued. But in the extreme climate of Ulbricht's Germany, that was not to be. Those gently pushing for change got nowhere. At least not yet.

There were other attempts at tempering the system from within. The publishing house Sachsenverlag in Dresden came out with a series of nonpolitical architectural photo books on various cities, including some in the forbidden zone, West Germany. Helmar Lerski's *Man, My Brother* (1957), published by Verlag der Kunst, also in Dresden, lacked the expressionist quality of his early work, but it was a cut above social realism. Certainly Kurt Liebermann's monograph on Oskar Nerlinger, published in 1956 by Verlag der Kunst, defied the current scope of acceptable art, although it focused only on his realistic work.

In 1957 a promising new photo magazine hit the newsstands: *Fotografik,* published by Fotokinoverlag, Halle. In the first issue the editors announced that "for photographic creation there are no rigid, limiting rules, because life is manifold and everchanging." They recanted, however, in the second issue: photographic translation now meant "grasping a theme through sharp observation from the perspective of the party . . . , recognizing and recording it in such a way as to make a concentrated, typifying visual statement." Although this new position complemented Engels's view that art should be "a faithful rendering of typical character under typical circumstances," it did not save *Fotografik*.[4] Less than a year later—by May 1958—the magazine was dead.

A similar fate befell an independent group of young photographers from Leipzig who had come together in the spring of 1956 under the name *action fotografie*.[5] Defying the mandated themes, they were even more determined to bring movement to photography, to make it as versatile and pulsating as life itself. They reasoned that if socialism was indeed built on truth and forward movement, then photography should not be held back.[6] For a while their tactic seemed to work, and based on the written comments left by viewers, their exhibitions were regarded as "liberating and inspiring."[7] "The courage to experiment!" read the headline in a Saxony daily.[8] International developments could still be monitored via West Berlin, and that is undoubtedly where the group found inspiration.

46

The problems began when they were required to admit a certain number of amateur photographers, purportedly for reasons of social equity. They were the watchdogs, and their participation in the exhibitions was a token gesture. Before the first opening, in the lobby of the Capitol cinema in July 1956, the censors removed sixteen prints because of "experimental transgressions." Eventually—and miraculously—those prints were allowed to be seen separately, in another room; in the catalogue they were labeled "D," meaning "for discussion."[9]

There was nothing overtly controversial about the work of these artists. A rather timeless image by Ursula Arnold captures two pensive children in Leipzig being secretly adored through the store window of a bakery (fig. 14). Another of her photos, portraying a dilapidated street corner in Leipzig, tenderly details a neighborhood where these children may have lived (fig. 15). In both these photos, the only transgression was a vague sense of melancholy obfuscating pure optimism. The ruckus over Günter Rössler's solarized nude (fig. 16), on the other hand, was caused by both the "experimental" technique and the overt nudity, which was associated with "bourgeois decadence" and escapism.

But Volkmar Jäger's interview with *Fotografie* gave a better sense of the group's defiance. He clearly flirted with danger when he quoted Romain Rolland saying that "those who walk behind others never get ahead." Then, rejecting what passed for "truth" in the GDR, he announced that the real call for truth was only now being sounded. "Why only smooth, happy pictures?" he asked. "Everybody knows all too well that this perpetual self-satisfied smiling, this happy face, has never existed in any country or in any family. I ask: Are folk songs only happy? They come from the people, and they show all their moods."[10]

Jäger was one of the first to leave the group. As their second exhibition neared, in December 1957, the censors came prepared. The catalogue, meanwhile, emphasized that the new direction of *action fotografie* "is not aesthetics; it is not experimentation with form and technique; it is also not flight into the idyll. It is life."[11] Given what was allowed to remain of the show, the artists grew listless. They managed one more exhibition, in the autumn of 1958, but it was heavily constrained by socialist "truth."

47

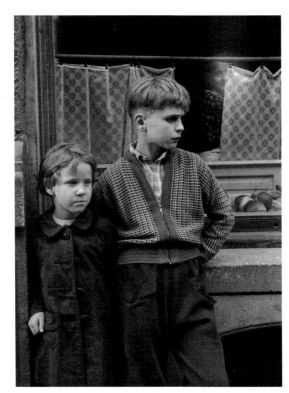

Untitled,
Leipzig, 1956

14

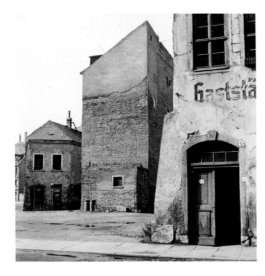

Untitled,
Leipzig, 1956

15

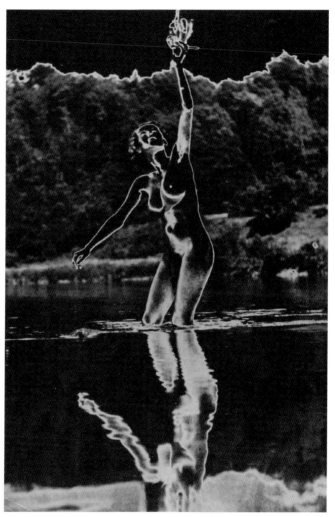

16

Solarized nude,
ca. 1956

That was the end. Some of the members—Evelyn Richter, Günter Rössler, and Wolfgang Schröter, in particular—later redeemed themselves and pursued lucrative careers, but on the whole the group was forgotten.

None of these efforts was truly revolutionary or even subversive. Far from the insurrectional spirit that ignited in Hungary in 1956, contemporaneous events in the GDR were an expression of normalization. As the war years receded, a new energy was felt, and with it a desire for relief from the abject boredom of relentless sincerity. Artists sought to make life not necessarily frivolous but just a little more surprising.

But Ulbricht was not willing to take chances and lengthen the artistic leash. Despite the never-ending accolades, marches, and flag-wavings, he could not be sure that socialism had won the hearts and minds of the people. The workers acted compliantly, but they failed to be convincing in their enthusiasm. In an attempt to force the issue, he demanded ever greater predictability in photographic subjects: perspiring, energetic steelworkers to symbolize determination; cigarette-smoking, soot-covered coal miners to embody a rugged joy for life; pensive politicians to denote a sense of responsibility; teachers guiding their students to show concern for youth; interracial embraces to stand for class equality and socialist solidarity.

Images were shamelessly altered and retouched to achieve the proper effect, but care was taken that the deception not show. As Berthold Beiler—one of the most influential GDR authorities on photography—justified it, by "interfering with a gentle hand," one could "turn the possibility into reality. The only rule is that of all good directing: it must not be visible in the finished work." For support he quoted Brecht, who had said that "realism is not how 'real' things are but how things 'really' are."[12]

A number of competent photographers rose to the occasion, among them Erich Schutt and Carla Arnold. Schutt's *Help for the Buddies* and Arnold's *Getting the Weeds* (figs. 17 and 18) present a male and female allegory of socialist cooperation, productivity, and optimism.[13] They are interchangeable and complementary: one helps build the future, the other helps eradicate the enemy. Both images look as if they were culled from the flow of life, but they were probably carefully composed and relieved of any extraneous visual detail that might be suspected of diluting the central impact. Photography was made to surrender to a premodernist aesthetic of history painting with

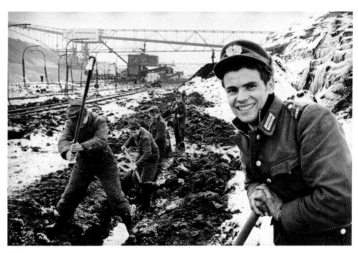

17

Help for the Buddies,
n.p., ca. 1960

CARLA ARNOLD

18

Getting the Weeds,
n.p., ca. 1960

a political agenda, where the individual—in spite of all the emphasis on humanism—was replaced by generic symbols.

But how did the older surviving avant-garde artists feel about these limitations—those dreamers who used to fight for personal vision and artistic autonomy? And what about the worker photographers with a true social consciousness who wanted to look at life honestly? In other socialist countries, such as China—where deliberate reiteration of "correct" views was deeply ingrained in art—social realism could perhaps be experienced as a logical extension of tradition, but how could it supplant the diverse and often contradictory modernist efflorescence that had once thrived under Weimar democracy?

Among the avant-garde artists, Klaus Wittkugel became known for a series of photographic worker posters with titles such as *I Am a Miner, Who Can Be More?*, and Edmund Kesting found himself making heroic portraits of the politburo members.[14] Some of the older worker photographers who had excelled during the early postwar years with their cultured objectivity, such as Horst Sturm, went right on working as photojournalists, making no artistic claims. They simply took pictures on assignments and let the censors decide which ones to publish or exhibit.

While social realism was mandatory for all the arts, the immediacy of photography and its persuasive historical authenticity made it the most critical tool of visual propaganda. Painters and sculptors thus had greater freedom to choose neutral subject matter, but for photographers, acceptance into the Verband Bildender Künstler (Association of Visual Artists), which was a virtual prerequisite for employment, demanded more posturing. Even portraiture was regarded as too personal to serve didactic goals. Though taught at the HGB, mostly with old plate cameras, it fell under the lowly rubric of "amateur" or "family souvenir" photography, along with the pure landscape. Theater and fashion photography were only one rank higher. It remains to be seen what hidden treasures from the unofficial sector will be unearthed in time, but the limited supply of photographic materials—combined with the harsh economic, social, and political environment—certainly failed to provide a fertile ground.

While the limitations imposed on photographers were devastating, escaping from the GDR via Berlin was still a viable alternative, especially for the young and the talented.

Flight was a more productive solution than jeering at Soviet newsreels, apparently a favorite pastime of movie audiences.[15] Although the exodus was bleeding the country, Ulbricht at first almost encouraged it, believing it would eliminate troublemakers—which of course it did. But in 1954 alone close to half a million defected, most of them under twenty-five years old. About seventeen million remained, and the birthrate was declining. Who would be left in the end to celebrate? These figures were another slap in the face for Ulbricht and the enviable image of the GDR he sought to conjure through photography.

The relentless depiction of an even-tempered proletariat whose only concerns were class struggle and work quotas not only drove away artists and intellectuals, but it also threatened the middle class of small factory owners and merchants who had managed to hold on to their property. Their fears were well founded: in spite of the new course that was announced after Stalin's death, expropriation intensified during the second half of the 1950s, and the military was resurrected to protect the production of the proletariat from so-called imperialist thieves. Pacifism was unacceptable. Those who had already lived through two consecutive rearmaments felt increasingly trapped by historical circumstance.

Meanwhile, the drive for a prescriptive photography was accelerated to counter the supposedly rampant censorship in the West. Peter Pachnicke pointed to McCarthyism as hastening the demise of the socially conscious Farm Security Administration photography in the United States, and he recalled Paul Strand's famous 1947 rebuttal to the blacklisting of the New York–based Photo League. He argued that censorship had reduced American art to "self-centered, pointless exercises . . . reflecting a pathological preoccupation with fear, form, and aggressiveness for the sake of artistic status."[16] Social realism, he insisted, was needed as a balance, to suggest a better world.

Ernst Hoffmann went further. Filled with rage, he alleged all Western art to be the vicious product of American imperialism, consciously directed to incite another world war by propagating antihumanistic, ignoble values, attempting to "make the repugnant appealing, the absurd rational, decay attractive, and true beauty irrelevant."[17] For him, art had to be surmounted by ideology, with the artist bound by a sort of medieval loyalty to a patron whose allegorical iconography served the mystical transformation of the people.

53

Similar principles were at work in most socialist countries, but in the GDR the situation was more critical and extreme, for several reasons. First, its leaders were well aware that the world was watching: as the only Western socialist country, the GDR was a guinea pig for all of Europe. Second, the proximity of the other half of Germany and the prosperous island of West Berlin required vigilant measures of overcompensation. Third, even within the East bloc, diplomatic recognition was thwarted by West Germany's threat of trade sanctions. Last, there was Ulbricht himself—more determined as a dictator than most.

These combined factors not only abetted the GDR's cultural, political, and geographical truncation, but they also created a rather dangerous moral isolation. Photography, already stagnating under the routine idealism imposed upon it, furthermore became totally inbred. It was a bad omen for the future. A temporary solution, however, came inadvertently—not from Ulbricht but from Stalin's successor, Nikita Khrushchev.

The law of the struggle in which we are engaged contains
the joy and celebration of today . . . the questioning and
worry of tomorrow . . . and then the happiness of the victor
is transformed once more into the happiness of the fighter.

HANS PETER MINETTI, actor

Chapter Four

REVISIONISM
AND REFORM

Khrushchev's radical departure from Stalinism and Stalinist concepts of social realism had a profound ripple effect throughout the East bloc. Ulbricht, although he remained a staunch Stalinist, was obliged to follow suit. In 1958, after a long and heated debate, the SED thus initiated a new tactical approach to art: reality would no longer be idealized; the new mandate was objectivity. For photographers, this meant exploring the ordinary, everyday socialist environs in a thoroughly factual manner.[1]

The inevitable failure of social realism was never officially acknowledged. Rather, the new photography was presented as a progressive evolution from the "socialist building phase" (*sozialistische Aufbauperiode*), when socialist ideals still needed to be inspired, to what was called the "arrival in day-to-day socialism" (*Ankunft im sozialistischen Alltag*). Ulbricht simply declared the success of socialism.

The famous *Family of Man* exhibition, organized by Edward Steichen at the Museum of Modern Art in New York, became a critical model for the new photography. It traveled to West Berlin in the fall of 1955 and was popular throughout West Germany, where it inspired Karl Pawek to launch four consecutive exhibitions in a similar vein.[2] Although for the GDR it fell short of endorsing the "arrival in day-to-day socialism," the compassionate and egalitarian depiction of humanity from all over the world brought it well within the new parameters of socialist acceptability.[3] Even the

installation of *The Family of Man* intrigued Ulbricht, for it was an object lesson in Steichen's uncompromising view of photography as a persuasive mass medium for a mass audience. The prints were purposely flush-mounted, unmatted, and displayed without protective glass, presented not so much as precious art objects but as tools for proliferating ideas with speed and efficiency. The grainy images themselves, shot with inexpensive small-format cameras, further enhanced the immediacy of the witnessed event.

Because the exhibition blurred the distinction between photography as art and photography as a technical means of communication, greater freedom for the medium seemed inevitable. No longer limited to "artistic" rendering of a "higher truth," it could approach life more on its own terms. Indeed, some improvements quickly followed: the experimental work of John Heartfield was reinstated for the sake of its powerful mass appeal, and Weimar worker photography was brought back as a "truly innovative expression," dedicated to the "beauty, strength, and solidarity" of the real people.[4]

57

But the excitement spreading in the photography community was short-lived. On May 26, 1958, a specialized subagency of the Kulturbund was created, the Zentrale Kommission Fotografie (Central Commission for Photography), for the explicit purpose of monitoring subject matter and "ideological clarity." The vice president and public spokesman for the agency, Friedrich Herneck, quickly let it be known that the commission would be responsible for coordinating all photographic activities in the GDR, would provide artistic and political "guidance," and would determine both what was shown abroad and what was published in *Fotografie*.[5] It was the certain end of the magazine as an occasional platform for subtle defiance, and soon ever more stringent guidelines reinforced photography's earlier commitment to its didactic mission as a mirror of socialist positivism. "Objectivity," it was discovered, meant recording the factual, ordinary, uneventful socialist workday in a seemingly straightforward, nonaesthetic manner that left no doubt in the viewer's mind that it was the best of all possible worlds. Whereas social realism had simply been called "realism," this new direction was referred to as "socialist realism."

To add to the confusion, photography continued to be extolled as art. In an article from December 1959, Herneck himself proclaimed that it "must prove itself an equal

to the classical arts."[6] On the whole, however, during the following two decades the medium became defined more as a documentary tool for recording, as the writer and photographer Klaus Fischer put it, "the struggle of opposites" and "how obstacles are overcome."[7] No longer thinly veiled as artistic impressions of a Platonic socialism, images came to serve as the tangible "evidence." Having barely learned to fictionalize proletariat aspiration, photographers were now asked to make it real.

Ulbricht remained unfazed by this new dilemma. He had a plan. As Steichen had blurred the boundary between art and mass medium, he believed he could eliminate the deep divide between artists and the masses. At a now infamous art conference, held in Bitterfeld in April 1959, he announced his plan for merging the two. It was simple: workers would participate in the process of making art, and artists would satisfy work quotas in factories. All segments of the population would re-create themselves through a combination of art and work, inspiring one another for the common cause.

In theory, at least, the idea recalled the "pure reality" imagined by Piet Mondrian— a state of reality in which all of life is sustained and propelled through the power of art. But here the intent was to forge a true proletariat art and dilute whatever power had been left to the artists. As Ulbricht put it, "building socialism is first and foremost a matter of education," and "the question of ideological clarity must be the most important question of them all."[8]

The Bitterfeld Path (Bitterfelder Weg), as it came to be called, remained on the books even through the 1980s. It specifically called upon photography to clarify "the inevitable forward-moving march of the masses," freed from the "clutches of selfish greed." According to a survey of 1959, most workers already owned cameras or were involved in the medium in one form or another.[9] Ulbricht believed he needed only to provide them with a direction. Thus, in the very same year that Western pop culture was born in Great Britain, photography was pronounced the art of the masses in the GDR.

The tenth anniversary of the GDR was approaching in November of that year, and Ulbricht was eager to put the Bitterfeld Path to the test. As part of the official celebrations, an exhibition, appropriately titled *Socialism Is Victorious (Der Sozialismus*

siegt), was scheduled at Alexanderplatz in Berlin, with a jury comprising prominent artists and functionaries, including several from other socialist countries. Supervising the jury was Herneck, the Zentrale Kommission Fotografie representative, who also subsequently penned the "review."

"The images," he wrote, "selected for this show from a vast and exciting body of work, honor the dignity of mankind. . . . The jury . . . promoted the simple, the clear, and the noble . . . the progressive and the new. They rejected anything that was vague in expression. . . . They especially appreciated those artists who had discovered the new human psyche—thus demonstrating an intimate contact between photography and life."[10]

Among the most touted images was Jo Gerberth's *Sports for the Masses* (fig. 19), a Riefenstahlian bird's-eye view of myriad female bodies moving in gymnastic unison, each one an interconnected part of the whole, filling and spilling out of the frame to suggest an infinite continuation. Another highlight was an installation of worker posters by the early avant-garde photographer Klaus Wittkugel, who was also a member of the jury.

59

Although the show was considered a unanimous success, Herneck wished more emphasis had been given to specific themes of the "new" socialist life. He mentioned, among others, fighter groups from state-owned enterprises,[11] socialist marriage ceremonies, and youth initiation rites (*Jugendweihe*). He regretted that not a single image had been taken at the new "glamorous" press balls, held annually by the leading socialist newspaper, *Neues Deutschland.* He chided photographers for failing to recognize the social potential offered by these themes and for lacking the necessary insight and courage to advance the visual frontier.[12]

He did, however, concede that the dispute about the proper application of Marxist-Leninist aesthetic continued, but he insisted that it could be resolved at once if dialectical materialism were consistently applied to all forms of artistic creation. This tautological vagueness was typical; it served to keep artists on their toes. Not surprisingly, when another representative of the Zentrale Kommission Fotografie, Gerhard Henniger, also wrote on the exhibition, his text was virtually identical to Herneck's.[13]

To some extent, political correctness furthers artistic success everywhere, but in the

*Sports for the
Masses,* n.p., 1959
(Staatliche Galerie
Moritzburg,
Halle/Saale)

JO GERBETH

GDR it remained a prerequisite for all artistic expression. Like athletes, photographers were prodded to the limits of their capacity in order to expedite the ideological goal. The attitude of the historian Günter Blutke was characteristic: first he urged photographers to portray truth based on knowledge, feeling, and skill; then he shamelessly suggested that for knowledge they should look to the front page of *Neues Deutschland* and for feeling and skill they should nurture an enthusiasm for the socialist lifestyle. He specifically recommended Klaus Fischer as a role model, who, as he explained, "never depicted a human being as small, helpless, or subordinate to the environment." Blutke took this as evidence of how thoroughly the photographer had examined life. Pessimism, he insisted, was the product of a sick mind: "Life is optimistic (even without the radiant smile of victory!), and to represent it any other way is untypical. Photographers have no right to write under a photo, 'A Man from Our Socialist Experience,' when the only thing seen is Herr M., who has a liver ailment. Klaus Fischer . . . avoids such superficiality . . . ; his photos are almost consistently the result of his close contact with our reality. This is why they are genuine and true."[14]

61

Beginning in 1958, the government published a yearly photo anthology, or *Fotojahrbuch* (called *Fotojahrbuch International* after 1966), summarizing for the general public the "best" of the Bitterfeld Path. The proper ideological posture could thus be synthesized in a single volume. And where the pictures left off, the text took over.

The *Fotojahrbuch* from 1959, for instance, includes an industrial scene by an anonymous photographer, centered on a silvery-glowing reactor spewing white smoke (fig. 20). Scattered around it are regulation worker tenements, silhouetted smokestacks, and industrial tubing. The air looks foul. The accompanying text reads:

Here, the consciously creative photographer seizes life. He shows the industrial giants of socialism and the new housing, where tomorrow is already alive today. . . . These are the photographic documents of our time that will tell later generations, See, this is how it was when we moved into our new housing. Everywhere the new is growing powerfully. New works come into being, stronger than those that were destroyed. The clear composition validates our attitude. The workers are proud of their common work, which belongs to them, and this is how they celebrate it. And they will also defend it against all who should dare to question our

[Anonymous],
industrial landscape,
n.p., ca. 1959
(Zentrale
Kommission
Fotografie, ed.,
Fotojahrbuch 1959)

achievements! Those who have created industry and living quarters and those who have tilled the soil will protect the fruits of their labor . . . a single front of one determined will. Working sons, be on guard, ready to protect our land and our peace from all attacks.[15]

While such rapture must surely have made all but the most naive readers roll their eyes and quickly turn the page, as a wishful projection it undoubtedly had an effect— just as advertising in Western countries has an effect without necessarily being taken seriously. And given that all conflicting points of view were eliminated, attention was focused in a single direction.

Another development after 1959 were the many regional, national, and "international" exhibitions (i.e., among socialist countries), often held in conjunction with the popular worker festivals, where the classless society was featured as both partaker and creator of culture. One such worker festival exhibition, staged in Chemnitz (then called Karl-Marx-Stadt) in 1960, was titled *On Becoming a Socialist Person (Vom Werden des sozialistischen Menschen),* and literary comments were provided, once again, by Gerhard Henniger. "For our photography," he wrote, "as for all art, the main concern has become the human aspect of socialism, creating an image of the new human being . . . on the road from *me* to *we,* struggling to embrace socialist morality in order to become a well-rounded, educated person. The images of the new, the shapers of our ordinary workday who are setting a new standard, reveal both the beauty and the dignity of human beings who have been freed from exploitation."[16]

In addition to the traditional parade of grimy, soot-covered coal miners, factory workers, and crane operators—the unequivocal builders and wreckers—this show included images of mothers planting flowers, fathers and sons watching Soviet fighter planes or playing chess, grandfathers splitting wood, and old women feeding pigeons in the park, with amiable Soviet soldiers lending a helping hand (even though fraternizing between military and civilians was forbidden). There were also photographs of competent doctors, cheerful secretaries, and gorgeous fashion models, as well as dog trainers, acrobats, dancers, and clowns—the possibilities seemed endless—in an earnest attempt to depict socialist life as an exuberant bouquet of delicious individual moments held together by a sense of the shared. But in the end, obeisance to a rigid

63

positivist standard stymied this effort. To be different in the GDR still meant to be of one prescribed mind. Despite the ever-ready slogans about the new forward-moving, changing humanity, nothing ever moved or changed. Photography reflected a languishing culture that was not driven by artists or intellectuals. It was a culture in which "truth" remained a lie.

Ulbricht's insistence that the GDR would surpass West Germany economically within less than a decade—that the chronic shortages and restrictions would soon be over—completely lacked credibility. Sacrificing for socialism was supposed to make everybody live better. But when? The temptation to escape intensified after 1960, setting off a domino effect as those who had already fled passed on their dreams of exotic places: Venice, Rome, Paris. Even West German cities such as Heidelberg or Munich took on a romantic air.

"What kind of doctor would abandon his patients?" lamented Ulbricht; "What kind of teacher would forsake his students?" He pleaded in vain. West Berlin, which had become a center for Western ideas, styles, and comforts, was like an open wound, draining the lifeblood of the country. The GDR was quickly becoming a no-man's-land—a provisional middle station caught somewhere between the last war and an elusive future. To run away and start over from scratch was getting to be a national obsession.

In an effort to control the situation, after September 1960 West Germans were no longer permitted to enter East Berlin,[17] and Khrushchev and Ulbricht took turns delivering ultimatums to get the Western allies to leave West Berlin. But since the GDR was virtually dependent on West German imports, their threats could be ignored. In a desperate attempt to bail out the economy, Ulbricht decided to follow Stalin's ill-fated precedent and nationalize agriculture, with more than 90 percent of all arable land to be removed from the private sector by the end of 1960.[18] "Ulbricht takes from the capitalist Junkers and gives to the free farmers," blasted the newsreel headlines, but it was not so much the former landowners who were prompted to depart as the small shop owners and trade workers, who knew they would be next. Of particular concern was the renewed exodus of intellectuals, who realized that no German unification was on the horizon. Ominous events, such as Ulbricht restoring Stalin to a place of honor, heightened their fears.

In photography, formalism continued to be repudiated, but now even naturalism came under attack. "Naturalism," wrote Herneck, "unlike formalism, is not based on class; still, it has a similar negative effect on society inasmuch as it creates an obstacle for a 'realistic' typifying photography, thus giving new impetus to old photographic prejudices. For this reason naturalism, as an uninspired imitation of nature, must be fought with the same determination as formalism, which deliberately distorts and belies reality."[19] To assure a correct portrayal of "reality" and—as it was explained—to protect citizens from the enemy both within and without, a list of forbidden subjects and locations was published. It was now illegal to photograph policemen, archaeological sites, and visiting relatives at train stations; even the popular factory themes were off limits without a special permit.[20]

The most influential and prolific writer on photography from this period—with more than two hundred pieces published in his lifetime—was Berthold Beiler, a senior member of the Zentrale Kommission Fotografie and head of the prestigious photography department at the HGB. His 1959 book about partiality in photography (*Probleme über Fotografie: Parteilichkeit im Foto*) became the definitive work on the subject, a presumably analytical explication of Marxist-Leninist art theory with regard to photography. It was declared a first in the German language.[21] The word *Parteilichkeit* literally means "to be partial to a cause," but it was also used to describe party solidarity. To rationalize unquestioning loyalty to the SED as a prerequisite for good art, Beiler freely quoted historical figures who apparently had viewed *Parteilichkeit* as a sign of character. His attitude toward *action fotografie* from the late 1950s typifies his stance: "It is not enough to be in *action*; one should rather ask, action for what? And this *for what* is never the self-serving, technically superior photo . . . but the photo that helps to form in its place the worldview of socialist mankind."[22]

Beiler never wavered from his conviction that photography could be understood only in terms of its political-philosophical content, and he refused to see this as a limitation. "*Parteilichkeit,*" he explained, "is . . . not the end but the beginning of an aesthetic/artistic quality in photography."[23] Photography, he insisted, was not about themes but about personal artistic vision. And personal artistic vision required an in-

65

sight into the meaning of "reality," which in turn required dialectical materialism as a worldview. "Representational methods that deform human beings or are nonfigurative find no resonance in our circles," he concluded, "not because of any prohibition, but simply because our photographing worker does not hold an image of humanity that would warrant such alienation."[24] But Beiler could also be poetic. *Parteilichkeit,* he once wrote, "is like the sun for photography: it puts light and shadow in the right places; it is the living heart of every truthful shot."[25] With great eloquence he addressed an astounding number of issues in photography, and his texts were peppered with persuasive historical references. He was applauded as a visionary.

One of Beiler's bêtes noires was Otto Steinert's Subjektive Fotografie movement, which dominated the photography scene in West Germany throughout the 1950s.

Naturally, many photographers from the bourgeois world know, just as we do, that photographs can be more than mere copies, that they make a subjective statement about objective reality if one moves beyond merely documenting the surface. But only a few bourgeois photographers and theoreticians at this terminal stage of their epoch are able to draw the single plausible conclusion from this: the need to tell the truth about their society. . . . We condemn Subjektive Fotografie because it misuses the prerogative of photography to be truly judgmental, encouraging the photographer to discard the truth of reality for the sake of personal petty bourgeois emotionality translated into photographic hieroglyphics. One has only to look at the results of such subjectivity to realize that their source is the well of decadence: a dead, tattered chicken against a mysteriously glowing background; rotten pears on a crumbling wall; three images, one printed over the other: a wire noose, a round lamp, small light spots—the whole titled "Tortured Soul." . . . There is no attempt even to make a statement about mere objects; the only thing expressed is a worldview of emptiness . . . and existential fear.[26]

Beiler was unwilling or unable to recognize that West German photography was indeed a tacit reflection on the twentieth century, where the democratizing effects of the camera—its ability to record all things with equal ease and to give them equal importance—render traditional priorities of perception obsolete. Had he earnestly attempted to explore this dilemma, he might have been far along in building a critical and perhaps workable socialism. But like most so-called intellectual leaders in the

66

GDR, he was mired in dogma: the function of photography was not to reflect or examine but to mold. Art had very little to do with it. Merely ambitious photographers could live with that, but for those with talent, the situation was desperate.

The demand to cull ideological statements from real life finally did engender a more sophisticated and subtle propaganda. Because images were no longer so obviously manipulated, they became more credible. They seemed specific. Diane Arbus's teacher, Lisette Model, once told her, "The more specific you are, the more general you'll be."[27] So it was with the new photography. It acquired an authentic edge, a "you are there" quality, without sacrificing its tunnel vision. And those who complied did not have a bad life: unlike the rest of the population, they were allowed to travel to the West, and since the pay was good, compared to what one earned threading bolts in a steel mill, it was not so hard for them to adopt an optimistic outlook on what appeared to be an unalterable fate. Instead of posing and retouching the positive socialist life, they simply edited it skillfully. To monitor progress or failure the Kulturbund routinely scheduled symposia, and the various speeches were then either printed in the current *Fotojahrbuch* or issue of *Fotografie* or published as collected essays in commemorative books that became required reading for photography students.

67

The new favorite subjects were scientific laboratories and classroom situations, both palpably illustrating the diversity of socialist progress. Naturally, sports events continued to be appreciated; they appealed to a large sector of the population and illustrated success in a most elementary way.[28] But agricultural themes, which had played such an important role before the land reform, had become somewhat delicate and cliched. Artists who still pursued the subject would approach it more from a documentary angle: rather than make sweeping statements about the domination of earth, they might focus on the daily routine of a given family in a given location. But if the GDR was to succeed and surpass others, it clearly had to be through science and technology, not by making hay. Socialist positivism in 1960 was no longer unconditional happiness but concerted specialization.

Industrial themes remained the safest, assured of exposure and accolades. They filled the ubiquitous *Fotojahrbücher* as well as the proliferating regional, national,

Mechanics Brigade,
Lübbenau, ca. 1965

21

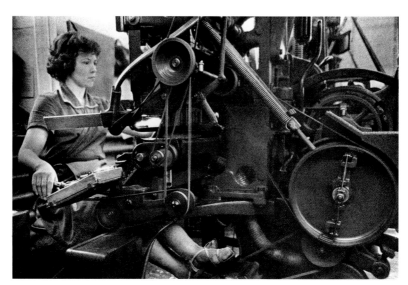

22

On the Linotype, ND
Printing Company,
East Berlin, 1960

and so-called international exhibitions. Strongly centered on the worker, industrial themes, as explored by photographers such as Erich Schutt (fig. 21), presented the human being as a productive and well-functioning part of the societal machinery without having to confront societal contradictions; they captured the workday aspect of vibrant collectivity without controversy. These pictures were not meant to be exciting or novel; instead, they capitalized on familiarity to promote stable thought patterns.

In 1960 the former *action fotografie* member Evelyn Richter was earning a living with precisely the kind of industrial photography that was encouraged and rewarded. One of her images, *On the Linotype* (fig. 22), shows a pretty young woman concentrating on running an enormous printing press. It seems ordinary enough in its functional composition, but while the frame is filled with soothing patterns of predictable repetition—attesting to human control through mechanical power—a subtle departure shifts that emphasis. In such images the worker usually dominates the composition. Here, however, the engine parts extend beyond the frame, creating a Kafkaesque sense of limitless machinery poised against a single human being. The metal parts seem to be wrapped around the worker like a harness of torture, and only her face, hands, and feet—impractically shod in sandals and protruding from under the heavy equipment—remain incongruously human.

69

The small, seemingly incidental detail of the sandals is what Roland Barthes would have called the *punctum* of the image.[29] He explained that because such a detail is usually unplanned, it can fill the entire photograph with new meaning, in spite of the deliberate content or subject, which he called the *studium*. The *studium* of Richter's photograph conveys progress through machines, but the *punctum* betrays the incompatibility between the rigid application of an idea and the unpredictability of human nature.

If Richter was commenting on the passivity of her people who allowed themselves to be controlled once again, she could not have timed the statement any better. The Berlin Wall—conceived by Ulbricht but executed under the command of an ambitious new party favorite, Erich Honecker—was about to become a reality. The number of escapees had reached close to two thousand a day when, shortly after 2:00 A.M. on August 13, 1961, Berliners who had spent the night in the opposite sector found

they could no longer return to their homes: coils of barbed wire (to be augmented by concrete and minefields) were already slicing the city in half; anyone trying to cross the barricade was shot on sight. The mayor of West Berlin, Willy Brandt, is said to have run to the Potsdamer Platz, screaming excitedly at the workers and demanding to know what was going on,[30] but the people on the whole remained remarkably calm. There was no uprising, no violence, only quiet shock and disbelief. The key was already in the lock; now it was turned. East Germans were gripped by a new fear—and they did nothing.

Although walling-in cities is as old as history, none has ever been walled out. Even in East bloc countries the news was received with dismay. But Ulbricht remained nonplused. When reality finally set in, thousands attempted to jump from buildings over the wall—many missing the sheets stretched out for them on the other side. Those who lacked the courage or strength to jump found themselves torn from their families without so much as a goodbye—elderly mothers from their children, young wives from their husbands. Ulbricht proudly justified the barrier as his "antifascist protection wall," a symbol of socialist strength and solidarity that prevented the West from effecting its imperialist claim over the GDR. "It is common knowledge," he explained, "that drug addicts are isolated from addictive drugs for their own good and their recovery. Likewise, we have separated from West Berlin many of those citizens who had become confused by the swamp. . . . This sickness will prove curable. In the clean air of the GDR, they will come to their senses."[31] With television not yet commonplace, Radio Free Europe remained the only fragile bridge to the West as the thirty-year Babylonian captivity of the GDR was about to begin. On the new city map that was hastily issued, West Berlin was a blank. It no longer existed.

Although Richter's work seemed routine at the time, she came to subtly reflect the unique oppression of the 1960s, and in so doing she laid an important part of the foundation for the evolution of photography in the 1980s. Richter found a way to work within the parameters of censorship to express her privileged perception: she photographed the veneer but managed to show what she saw lurking beneath it. As hope for a rescue from the outside was abandoned, learning to express one's inner reality became a strategy for survival.

*To make oneself continuously useful for socialist society is
the most beautiful duty and the highest form of happiness.*

ADOLF HENNECKE, coal miner

Chapter Five | **JUNCTURE**

72 The Berlin Wall was a watershed in the history of the GDR. Not only did it squelch the lingering aspiration for German unity and contact with the outside, but it also provided the first semblance of stability. With the attention firmly focused inward, Marxism-Leninism could be more thoroughly implemented, since now a steady labor force could be relied upon. If a worker failed to show up on a Monday, he or she was probably only ill, not gone forever. Economic growth was feasible for the first time.

Ulbricht proclaimed the GDR the only legal German state, "the German republic of peace and freedom," obviating any further talk of unification until the day when "imperialist forces in the West were exhausted."[1] And as East Berliners were desperately jostling for the exit, he spoke of "a life full of trust, of readiness to help one another, of common work and of common joy. . . . The more deeply we can convince our citizens of this," he said, "the more profound their consciousness of freedom will be."[2]

Of course, the wall not only stemmed the exodus of the labor force, it also filtered out undesirable influences that had been coming in. At the top of that critical list was pop art, which was speedily gaining momentum in the West. Pop art, with its irreverent, hedonistic glorification of consumerism and individual gratification, was a constant reminder of how bland the menu of Ulbricht's own popular culture really was. Even though East Germans had not directly experienced the steps leading up to

pop art, Ulbricht knew all too well that his carefully constructed rationale for obedience remained an artificial and fragile web, which at best kept the country suspended in a quasi-perpetual state of tolerable discontent. He also knew that Western "decadence," in spite of its public repudiation, was secretly yearned for.

The desire was heightened with news of the first transatlantic television broadcast, by Telstar satellite in 1962, which ushered in a future of global simultaneity. For better or for worse, it was the beginning of the end for culture-proof barriers, including the Berlin Wall. Ulbricht knew that too. He understood that in a future of instantaneous mass communication socialism could not be commanded; he was left with but a few years to complete his mission of conversion. But how could he succeed?

In his wranglings Ulbricht may have remembered Lenin, who had written that "the strictest loyalty to Communist ideas must be combined with the ability to make necessary compromises, to scheme, to sign agreements, to zigzag, to retreat . . . anything to hasten the coming to power of Communism."[3] Ulbricht lacked Lenin's brilliance, but he was equally determined. And he was also becoming more willing to take chances.

The Bitterfeld Path had not been very successful so far. While artists working in factories were perhaps no less enthusiastic than career factory workers, the art that the factory workers produced was no consolation. From the start the whole experiment was doomed to contrivance, even though that fact was painstakingly ignored. How could Ulbricht persuade the people to do more than merely go through the motions of socialism day by day? How could he teach them to enjoy it?

Eventually Ulbricht came up with another grand scheme. He decided to exploit art—and specifically photography, among the visual arts—to package socialism as a truly competitive product, thereby beating capitalism at its own game. As he had fused workers and artists at Bitterfeld, he now planned to fuse carefully selected Western methods and styles in art with Marxist ideology, to make socialism entertaining and hence irresistible. He hoped to produce a wholly unique and spellbinding national culture as a "popular" method for denouncing "decadence."

Absent from the selection were the interdisciplinary and conceptual tendencies that began to emerge in Western photography after 1960. That work simply did not exist; it was a hallucination arising from the "swamp fever" that raged behind the wall.

73

Berthold Beiler penned a series of articles titled "Western Photography at the Dead End of Late Bourgeois Philosophy," published in *Fotografie* throughout 1962, but the "evidence" presented went no further than Bill Brandt's distorted nudes.[4] Certain Western traditionalists, however, such as Lewis Hine, Walker Evans, Dorothea Lange, and Henri Cartier-Bresson, were held up for their satisfying, realistic focus on life.[5] Paul Strand, who had spoken of social morality as the highest measure of art, was perhaps the most revered, for the time being. His association with Alfred Stieglitz and the vanguard New York Photo Secession in the early twentieth century was glossed over, as was his preoccupation with visual rhythms and repetitive form.

To what extent the work of these artists could actually be seen is not entirely clear, but it appears that viewers had to content themselves with furtive glimpses. Even in the 1970s, when diplomatic recognition of the GDR necessitated foreign embassies in East Berlin, visitors who attended exhibitions there were routinely detained for questioning.[6] One book was published in 1969 on the work of Paul Strand (*Land der Gräser,* by Erich Frommhold), but for the most part it seems that foreign photographers were known indirectly, through teachers. For example, Berthold Beiler's second book, *The Power of the Moment* (*Die Gewalt des Augenblicks*, published in 1967), was an elaboration on Cartier-Bresson's "decisive moment," yet not a single image by the French master was included.

Of course, it was difficult to obtain the material. There was no regulated import of Western art or art books, and who would loan original prints to a country that did not exist on the international map? Still, the flurry of officious acknowledgments helped local photographers feel less insulated; it gave them a semblance of artistic internationalism. The quantity and quality of their work was improved by what was probably the most calculated method yet for molding the human character through art, bringing life that much more in line with party policy.

The work of amateur and emerging photographers was easier to obtain from abroad for exhibitions. Through contests a truly international, albeit selective, forum was established, comprising young artists from capitalist countries such as Norway, France, and Holland that were otherwise dismissed as the "enemy camp." These Western artists not only stimulated the local scene, but they were also courted for the

socialist cause. Their depictions of Western atrocities—manmade famines, urban vi-
olence, widespread poverty, and the general misery of "the late bourgeois capitalist
epoch"—were skillfully contrasted with images by photographers from socialist coun-
tries to show the "logical" alternative.

A case in point was the third *bifota,* an international photography exhibition held
in Berlin in May 1962. In an official review of the event, Gerhard Henniger dis-
cussed two images: one from Holland, depicting strikers, and one from the Soviet
Union, showing a brigade of Communist workers.

In both photographs, people are seen fighting for a beautiful and happy life: in one, under cap-
italist conditions, marked by the oppression of monopolists and imperialists, and in the other,
as masters of their own destiny for new and ever-greater success in production for the benefit
of the people. . . .

. . . Not only does the dark shadow of the capitalist order dissolve in socialist countries, but
here the creativity of the people can develop unimpeded toward a goal-oriented, real, system-
atic, continuous improvement of life. That is the source of the true, deep optimism of socialist
photographic art. It offers the opportunity for more and more people to re-create their lives
based on the laws of beauty, to further their aesthetic sensibilities and thus make the world their
own.[7]

Now, however, the superlatives and meretricious prose had reached a desperate
limit. The Berlin Wall—which could neither be photographed nor approached from
the east—loomed as a colossal monument to failure; it was ludicrous to pretend that
it doubled as the foundation for a perfect world. Beneath the facade of enlightenment
it remained a barbaric measure of control—a symbol of the abyss between the social-
ist dream and basic human desire. Undeterred, Ulbricht insisted that "thinking is the
first duty of the people. If only people would pause to reflect on their circumstances
and real interests," he said, "then they might easily make the transition from false to
true consciousness, and the foundation for a better world would be laid."[8]

It was indeed time for some serious thinking, but not necessarily as Ulbricht envi-
sioned. The new generation woke up to take stock of how low it had sunk: in the

75

name of freedom the people had literally landed themselves behind bars. Added to the climate of subtle but chronic discontent was a first waft of betrayal.

But Germans tend to adapt to their fate, while only dreaming about fighting subordination. For whatever reasons—the long tradition of authoritarian rule, a deeply ingrained idealism, or perhaps simply cowardice and opportunism—in the end artists eagerly accepted Ulbricht's offer to make socialism work. Of course, it was their best offer, their only hope to transform their prison and eliminate the need for a wall. Nonetheless, a wave of critical expression surfaced, mostly through serendipity.

In literature, a spearhead of this development was the novelist Christa Wolf, who followed the Bitterfeld Path to the letter by conscientiously exposing herself to the milieu of her working-class protagonists. She was clearly a part of the establishment, as evidenced by the revelation of her activities as a tentative Stasi informant between 1959 and 1962.[9] Her early novels superbly conform to Ulbricht's mandate of employing a bright literary style to make Marxist philosophy more exciting. And to lend some spice, certain of the government's shortcomings and society's nagging ills could now be addressed as well.[10]

In her second novel, *Divided Heaven* (*Der geteilte Himmel*), set shortly after the construction of the Berlin Wall and peppered with flashbacks to the time before the wall, Wolf—by criticizing aspects of the sluggish socialist bureaucracy—in effect reaffirmed the optimism for a socialist future. She invited the readers' involvement by pointing to certain problems that could be solved. The message was clear: we are not yet perfect, but with your help we will succeed. But when she also portrayed those who had escaped to the West not as traitors but as real people with tangible concerns, she was straying from safe shores. The conclusion of the novel predictably offered the "narrow path" toward "true" freedom that was secured by the wall, but Wolf, knowingly or not, had legitimized doubt. This move was unprecedented. Ulbricht's attempt to cement socialism through greater artistic freedom had already backfired, giving individualism a foot in the door.

Wolf recalled that Ulbricht had summoned writers and urged them to aim high. "We will create important works of lasting value," he said. "One day we will have a socialist Egmont and a socialist Faust." At that moment, a man sitting next to Wolf

wondered aloud if they would also have a socialist Mephistopheles.[11] His remark introduced a rather humorous but also profound, and ultimately fatal, dilemma. If evil could be conquered, how would the spectrum of human nature be defined? Wolf's stories, which were devoured by an audience starved for stimulation, initiated a dangerous dialogue that began to feed on itself. Still, for a number of years she was an elected member of the Central Commission of the SED, and thus she enjoyed a life of privilege.[12]

But while the intellectual liberties taken in *Divided Heaven* may have been permissible within the context of a novel, the film version by Konrad Wolf (who is not related to Christa) required major changes. Like photography, film is a visual medium. And visuals, as Susan Sontag reminds us, can only show what exists at any given moment. The characters in a novel, for example, may contemplate the function of the Berlin Wall and eventually come to the conclusion that it protects, that it secures social progress and so forth, but an actual image of the heinous barricade on a movie screen clearly shows it otherwise. Therefore, while the story of the film remains faithful to the novel, images of the wall itself are studiously avoided. Instead, the characters work out their conflicts in cozy pubs, at lively carnivals, and in romantic town squares bustling with well-dressed, cheerful people. Despite whatever problems they may discuss, they are ostensibly living in a happy place.

When the plot shifts to West Berlin, however, the visuals take on a colder hue. Active life is seen only on mammoth billboards glorifying banal consumer products, while the real people are glued to their blaring television sets, sitting alone with their backs to the camera. As the film subtly manipulates the viewer's outlook by showing the GDR as the better place—in spite of certain shortcomings—the audience is prepared to accept the conclusion.

Not everybody was duped by this kind of ruse, however. The singer-songwriter Wolf Biermann—often called the Bob Dylan of the GDR—remained a blunt critic of the real, existing socialism. Having moved to the GDR from his native Hamburg to work with Brecht in East Berlin, he had not been suitably conditioned and found it hard to hold his tongue. Frequently he was banned from performing.

In terms of challenging the status quo, photography lagged behind: the subliminal social criticism seen in the early work of Evelyn Richter—which centered on vague

77

feeling rather than identifiable fact—remained rather singular. For the most part, distracted by the recently imported role models, photographers became somewhat complacent, satisfied by the new possibilities of technique and style.

Evelyn Richter's formative influences had come from her studies with the traditionalist Pan Walther and her job as a photographer for an optical company. Although she was admitted to the HGB as an advanced student in the early fifties, her "bourgeois" background and her conflict with the rigid Stalinist curriculum—in which even a horizontal portrait risked being equated with formalism—led to her dismissal before she could graduate. It was then that she joined *action fotografie,* the Leipzig group bent on challenging the rules.

After the group disbanded in 1958, Richter supported herself through theater and commercial photography. With these routine assignments, in all their physical, material, and spiritual limitations, her artistic signature was forged. When she photographed displays at expositions that were meant to impress the neighbors to the west, she would also inadvertently train her eye on the tired women toiling with dangerously broken-down equipment, hardly befitting the socialist heroines of fiction. These portraits (among them *On the Linotype*; see fig. 22) almost became a book, but in the end they were rejected and relegated to Richter's private drawer, not to be published for more than twenty years.

During the 1960s Richter developed her style with an old 35-mm Leica, and she became a worker photographer in the classical sense, recording the new "injuries of time." She knew Otto Steinert's book *Subjektive Fotografie,* which had secretly made the rounds among the students at the HGB, and it gave her an inkling of the spirit of Neue Sachlichkeit photography of earlier days.[13] But without a meaningful international frame of reference and the feedback of an open art criticism, the subtle conceptual nature of her own documentary images remained opaque. Those who may have picked up on it wisely refrained from comment.

Richter's photograph of a housing development in Magdeburg (fig. 23) records the conventional subject of egalitarian life, but again, as in *On the Linotype,* another meaning seeps in. Something is amiss in this orderly scene. The repetitive geometry of the tiles and paving stones in the foreground accentuates the gray conformity of the con-

crete buildings in the background, revealing, once again, an oppressive air of endless repetition. Socialist aspiration and socialist reality continue to collide. In the 1960s new construction was generally viewed as admirable, even in West Germany; in the GDR, where many residents were assigned to decrepit or bombed-out structures, new projects were often the only ray of hope. Yet Richter appeared to be making a statement on the failure of the institutionalized environment, that symbol of the organized pursuit of happiness.

Equally ambiguous is a shot taken in 1972 from the shore of the Spree River in Berlin, affording a view of the Museum Island and the cathedral (fig. 24). It is a rather famous vantage point; countless photographers had stood there since the early nineteenth century, recording an ever more splendid architectural program, testifying to the dramatic displacement of the picturesque medieval city by the burgeoning glitter of German nationalism. But Richter shows an almost empty stage. Truncated and battle-scarred, the cathedral and part of the bridge remain as the only recognizable points of reference. There is no sign of life apart from two small figures—a father and son perhaps—who watch a passing barge. Painted on the bow, in large block letters, is the barge's name: *Traumland* (Dreamland).

Quite different are two of Richter's photographs made on assignment at a women's conference in Leipzig, which together illustrate what kind of performance was expected of artists. In the first, rejected, take (fig. 25), the woman's expression lacks emotion and her gesture is almost lost in the preponderance of Ulbricht. The children are almost lost too. But behold the wise woman in a later take (fig. 26)! Now she appears harmoniously supported by the father figure of Ulbricht in her symbolic role as mother and teacher. Her signaling finger helps articulate her piously surging gaze. Like an excerpt from Oscar Gustave Rejlander's nineteenth-century photographic allegory *The Two Ways of Life,* the scene portrays children harvesting the benefits of obedience, as the mother/teacher beckons those still astray to her fold. Thus, a purportedly unvarnished snippet from a factual event is fashioned into propaganda.

But routine assignments, no matter how trite, gave Richter the means to examine her own perception of life. The East German historian Karin Thomas called her a great moralist and a master at portraying emotional states, in the tradition of Albert Renger-Patzsch, Erich Solomon, Dorothea Lange, and Diane Arbus—a rather

79

Magdeburg, 1968

23

At the Museum Island,
East Berlin, 1972

24

25

Women's conference,
Leipzig, ca. 1962

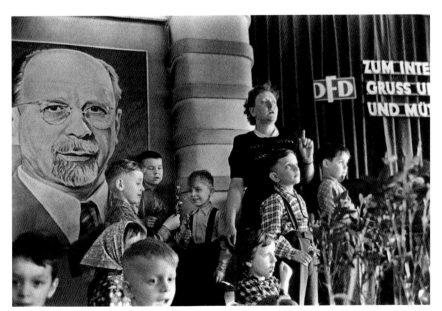

26

incongruous range that can indeed illuminate Richter's broad body of work.[14] By taking advantage of the conceptual potential of realistic images, Richter helped initiate a rescue of photography from literal, politically slanted communication. She explored the abstract relationship between the individual and society, the machine and the environment, and probed the myth of unconditional happiness.

By 1965 the tangential benefits of the wall had begun to pay dividends. Industrial production had risen at a rapid clip: 43 percent since 1958. Store windows were suddenly brimming with coveted consumer items, such as refrigerators and washing machines, and television sets were found in almost 48 percent of all households.[15] Salaries and vacation time had increased too, while the workweek had been shortened. West Germany, meanwhile, was plagued by labor problems and strikes. As the legendary *Wirtschaftswunder* was winding down, 1966 and 1967 brought a growth rate lower than that of the GDR.[16] The prophecy of waning capitalism seemed to be fulfilling itself, and for the first time true optimism was actually warranted. Proudly the wall was opened to West Berliners, and over one million came.[17] At the same time, East German pensioners were allowed to travel west in ever greater numbers. The GDR had become a model among socialist nations, prompting the Egyptian president Gamal Abdel Nasser to invite Ulbricht to visit him in Cairo. It was the first time a non-Communist country had extended such a gesture.[18]

But as hope for a more tempered socialism was nurtured once again, in the arts, new repression already loomed on the horizon. Triggered by Khrushchev's sudden removal from power in October 1964, a conservative mood fell over the Soviet Union, spreading its shadow over the East bloc.[19] Erich Honecker, who was becoming increasingly visible as Ulbricht's heir-apparent, struck a particularly somber chord, accusing artists of misusing their privilege. He lashed out at rock music and what he considered a growing preoccupation with sex and violence in art, which supposedly worked the nation's youth into a frenzy and robbed it of its ideals. This in turn threatened productivity and the standard of living.[20] By the end of 1965, the tentative period of cultural growth had come to a screeching halt.[21]

Honecker, who was impatiently awaiting the aging Ulbricht's retirement, had good reason to be concerned. West Germany was establishing diplomatic relations

with neighboring socialist countries—Rumania and Yugoslavia, among others—but showed no intention of recognizing the GDR. In the meantime the Soviet Union, whose strained relations with China had dangerously deteriorated, was seeking to improve its ties with West Germany. The GDR was left out in the cold again—still without official sovereignty and with no real allies. Then, without warning, the Prague Spring burst forth in Czechoslovakia under Dubček in 1968. Although it was crushed by Soviet-bloc forces—apparently with much support from the GDR—it set an unsavory precedent. Which country would be next to revolt?

That same year Christa Wolf published *The Quest for Christa T.* (*Nachdenken über Christa T.*), in which she examined the nature of "reality" in its relationship to conformity. She questioned the wisdom of prescribed roles in society and concluded that art could not flourish without freedom of expression. Wolf was harshly criticized and accused of being "overly pessimistic."

A deluge of articles in *Fotografie,* meanwhile, set out to rebuild a single-minded trust (if such ever existed) in the single-minded cause, and new curricula in photography at elementary levels and youth exchange programs with other socialist countries attempted to reach the very young before they might slip away. But the world was rapidly shrinking, and nothing could stop it. The late 1960s saw the strongest peace movement ever—on both sides of the iron curtain—as a response to the Vietnam War, where the two ideologies were pitched against each other in their last desperate stand for supremacy. It was also the first war to be televised live in many parts of the world, in gory color, piped directly into the homes of the people—over dinner. Suddenly it was no longer so easy to explain who was right and who was wrong. From either side, the situation seemed utterly senseless.

Although television lagged behind in the GDR, by the late sixties the number of sets had more than tripled from the approximately one million owned in 1960.[22] Physically the Berlin Wall was as strong as ever, but the cracks in its ideological foundation were widening. Nothing could be done to repair it; one could only pretend that it remained intact.

That is what many photographers chose to do. But at the same time, a growing number kept chipping away at the government's fiats in an attempt to reflect the changing world reality. Arno Hochmuth, for instance, the head of the Central Com-

83

Schöneweide,
East Berlin, 1966

27

28

May Day,
East Berlin, 1965

mission's Department of Culture in 1968, thought the time had come to allow photography to aim for a "new, more open, and looser expression," to address the arena of "leisure" more thoroughly.[23] He wanted, as he put it, a better balance of culture. It was a long shot, and Hochmuth received no encouragement. But it was a beginning.

Although the most dramatic changes were not to occur until the 1980s, Ulbricht's new art policy indirectly made it possible—and often unavoidable—for photographers to move toward an ever more subjective interpretation of "socialist truth." Ursula Arnold, for example, who had not been sufficiently discouraged by the experience of *action fotografie,* portrayed the subliminal fatigue of workers ejected from packed streetcars (fig. 27) or parading listlessly through the empty streets of a perpetually postwar Berlin (fig. 28). Like Evelyn Richter, she devalued ideal types by showing them as routine. Eventually she went to work for television, but others of her generation became the teachers of the next generation of photographers, who had never experienced life under a capitalist system.

Our youth does not fear the tomorrow. Filled with optimistic joy for life, they look to a happy future. But they also know that this is not a gift, and they are committed wholeheartedly to shape the life of society in their homeland, the GDR.

GERD NATSCHINSKI, composer

THE FORMATION OF THE SOCIALIST CONSCIENCE

Arno Fischer, a close contemporary of Evelyn Richter, also forged a visual metaphor of the zeitgeist that was less comforting than Ulbricht's official version. In one of his early photographs, taken during the height of social realism, in the 1950s, a lone man peers from a solitary, makeshift window in the fire wall of a dilapidated tenement building, seemingly unaware of the vertical crack in the masonry that runs above and below the window frame (fig. 29). The wall dominates the composition; it is the *studium.* The crack is the *punctum.* Although not very wide, it is a sign that the house is splitting apart. For the moment everything is tranquil, but an avalanche of bricks threatens to come crashing down sooner or later.

In the late 1940s Fischer studied sculpture, among other things, at the Kunsthochschule Berlin-Weißensee, where he also became Klaus Wittkugel's teaching assistant. Wittkugel was then making worker posters; his delicate, shadow-filled abstractions from an earlier time had been banned. Fischer developed a style marked by bold silhouettes and stark compositions, bursting with a gritty and raw immediacy that has led Karin Thomas to compare him to Alexander Rodchenko.[1] Fischer did not, however, deliberately explore disorienting low or high angles, as the Russian artist had done. Although some of his early work predates Robert Frank's sad soliloquy *The Americans,* it is with this Swiss photographer whom Fischer came to identify most. When he eventually discovered Frank, he felt validated for the first time.[2]

Untitled,
East Berlin, 1953

ARNO FISCHER

Consider an image titled *May 1, Unter den Linden,* in which a group of spectators observes the May Day worker parade (fig. 30). As in Ursula Arnold's unheroic depiction of the annual spectacle (see fig. 28), the mood is hardly celebratory. Here, instead of conveying the event with banners, flags, and giant portraits carried in procession, Fischer only mirrors it in the vacant expressions of seven people gathered among the ruins of Berlin's once grandest boulevard. Equally poignant is an image of four dark and seemingly disconnected figures seen stiffly staring into a foggy void (fig. 31), or another of four people waiting at an obliterated street corner in Berlin (fig. 32).

Typically Fischer's subjects were solitary or spaced far apart, against the grain of collective togetherness. Nonetheless, in 1961, when the worst of social realism had been overcome, the Berlin photographs were about to be published as a book titled *Situation Berlin.* Granted, most were less visceral, allowing for a more neutral interpretation, but after the printing plates had been made it was determined that Berlin was no longer a "situation." The wall had just been built, and the book was never published.[3]

During the 1960s Fischer continued to assimilate the best of imported realism, and although he could never quite equal the innocent power of his early work, he contributed significantly toward legitimizing a sensitivity to conscious image structure. He helped make East German photography more truly communicative as a medium and less myopic. But at the same time he helped free it from its specious obligation as an art. He built a road for photography on which others could travel, bringing to fruition the anti-aesthetic goals of the *Family of Man* exhibition—which, as a matter of fact, he helped install. It was said of him later that he followed "the magic of reality and its emblematic peculiarities."[4] In more politically correct terms, he won praise for his "memorable appreciation of people from different groups, different cultures, and different countries and a sense of the unique qualities of a certain time, what is noticed and what moves."[5]

But Fischer was more complex. He had moved to East Berlin in 1952 from West Berlin, yet apparently he never joined the SED.[6] Unlike Evelyn Richter, who for some time withdrew into the ephemeral uncertainty of her subliminal perception, Fischer, it seems, followed the trajectory of Ulbricht's new consummate photography, in which a certain degree of negativity was permitted in order to lure the viewer. As in Christa Wolf's novels, the goal was to make the narrow path glamorous and desirable

*May 1, Unter
den Linden,*
East Berlin, 1956

ARNO FISCHER

Untitled,
Müritz, 1956

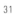31

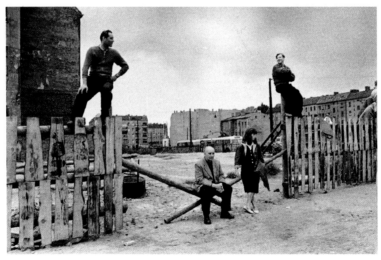

32

Untitled,
East Berlin, 1956

by contrast. The theme of isolation—treated in earnest in Fischer's early work—was therefore not necessarily a challenge to socialism; rather, it became an affirmation. If Richter embodied the intuitive, "feminine" aspects of East German photography, Fischer can be seen as an expressive "masculine" counterpart. Since both would teach at the HGB in the 1980s, where they nurtured the final group of photographers in the GDR, it is tempting to regard them as the parents of an indigenous East German photography.

Like others of his generation, Fischer made his living from official assignments, in which he opted for, as he put it, simple and easily read pictorial statements.[7] Thus, when he documented the building of a bridge on Fernando Po (Equatorial Guinea), the photograph published in *Fotografie* portrays the worker with the requisite socialist symbolism—shovel, tractor, and invincible demeanor—asserting once again human control over both the environment and destiny, and reducing the complex drama of life to a single upbeat object lesson (fig. 33).[8] Only a private outtake from the shoot allows the viewers to use their imaginations (fig. 34). As distinctly different attitudes are communicated by each of the workers, an individual moment in time has been skillfully rescued from oblivion.

93

Fischer became a founding member and spiritual leader of the photography association Direkt, established in the early 1960s and somewhat modeled after Magnum. Banding together in groups was encouraged by Ulbricht, as it demonstrated collectivity; and since one-person exhibitions were not allowed, it was also the only means for individual exposure. Direkt came together to participate in a specific contest, and the name was picked because someone had suggested their work seemed "direct."[9] Unlike the ill-fated *action fotografie* from the late 1950s, Direkt was permitted to widen the proletarian experience, creating a dignified platform for Ulbricht's ambitious art policy. Theirs was a vibrant visualization of the socialist workday—executed with capitalist flair.

It has been argued that the group challenged the political establishment and the status quo, but that was clearly not the case. They ventured farther than others, and they argued with the censors and bureaucrats who were mired in the 1950s, but they never transgressed Ulbricht's parameters of a tolerable unpredictability calculated to liven the otherwise dull experience of propaganda. Whether realists, idealists, or opportunists,

Untitled, Fernando
Po, 1972 (*Fotografie,*
September 1974)

ARNO FISCHER

33

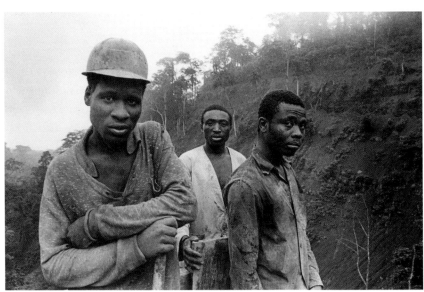

34

Untitled,
Fernando Po, 1972

the Direkt photographers were a product of the system. They knew what was ex-
pected of them—and they delivered.

That, however, does not necessarily diminish the value of their work. For example,
Sibylle Bergemann's thorough, sometimes confusing eclecticism captured details of
her country that other photographers still overlooked. Her images of storefront re-
flections (figs. 35 and 36), in the manner of the early twentieth-century French pho-
tographer Eugène Atget, not only abstracted the meager displays but also mirrored
the lugubrious cities of well-worn yet almost empty streets. Bergemann flowered un-
der Fischer's tutelage. They married, and they would work together on official as-
signments until the late 1980s.[10] Their varied portfolio—in which routine assignments
awkwardly overlapped (or collided) with private pleasure—became somewhat typi-
cal for many photographers. As they were doing their job as best as they could, news
filtered in about glamorous photographers who were given exhibitions in New York.
Such stories would arouse both ambition and anxiety: they wanted more, without
knowing precisely what. They increased their output to hone their skills, but creative
feedback still came from within the GDR—mostly through Berthold Beiler.

One of the most prominent members of Direkt was Fischer's protégé Roger Melis,
who, in spite of his early predilection for photojournalism, progressed toward a
stronger interest in the intimate portrait. He began to experiment with form and light
to give deeper psychological shading, at times even with a hint of multivalent ambi-
guity. He was also one of the first in the GDR to thoroughly analyze his own approach
to photography, explaining that although his shots were never planned, he learned to
anticipate them before even raising the camera to his eye. He conceded that he was
driven by a constant fear of not being able to capture the moment—of letting "real-
ity" get away from him—and for every shot he would enlarge the entire negative, be-
cause he believed all of it was important.[11] He had learned this from Cartier-Bresson,
undoubtedly via Berthold Beiler's second book, *The Power of the Moment.*

Melis's photograph *The Party Secretary,* from 1975, reveals his concern with good
timing, in terms not only of expression but also of balanced form (fig. 37). With the
secretary's head placed directly below a painting of Lenin, the frame can double as a
square nimbus, like those used in medieval icons to designate a living saint. The
solemn expression and the hand resting on a large book enhance the Byzantine mood,

95

35

Untitled, n.p.,
1960s (Ostkreuz)

36

Untitled, n.p.,
1960s (Ostkreuz)

ROGER MELIS

37

giving the subject weighty importance while hinting at the clandestine sanctimoniousness of party officials. But beneath the symbolic posturing lurks the real man—the browbeaten bureaucrat, slightly slumped and slightly bored—and more than slightly strained by the heavy burden over his head.

More traditional perhaps, but equally intriguing, is a photograph of the socialist novelist Anna Seghers from 1968 (fig. 38). Here the diagonal juxtaposition of the pale shapes (her face, hands, and necklace) with the nearly solid black of her dress startles with a stylized elegance that contradicts the stoic concentration of her gaze. Although Melis plainly intended this photograph as an official "heroic" portrait, he nonetheless managed to peel away some of the public layers to reveal an element of the subject's inner spirit.

Melis subtly contributed to the popularization of private portraits, which gradually began to liven up the steady display of worker photography. This development finally gave rise to the first official portrait show, held in Dresden and East Berlin in 1971, at which the "critics" were ready to be fascinated. The historian Heinz Hoffmann was prompted to concede that "the portrait is a mirror that not only reflects the individual but also shows the evolution of the citizens of our republic into socialist personalities."[12] Lest the private portrait be stripped of its didactic potential, the accompanying text included the subject's full name and profession or field of study. As in Victorian science, each "specimen" was carefully labeled with regard to its function and filed. It was an attempt, as the Marxist writer Walter Benjamin once put it, to "rescue it (the portrait) from the ravages of modishness and confer upon it a revolutionary use value."[13]

Predictably, the first portrait show featured no pictures of derelicts, criminals, religious leaders, or other socially unacceptable types. Still, endorsement of the new genre was not unanimous. "In observing recent photo shows," W. G. Heyde wrote three years later, "it appears that the subject of the working person is being replaced by others, such as the landscape or the portrait. Neglecting the most important theme constitutes a grave sin of omission. We call for an immediate return to work."[14]

Another group that originated in the 1960s called itself Signum. It was founded by Horst Sturm, together with Gerhard Kiesling, Alfred Paszkowiak, and others, photographers who pursued a more deliberate journalistic path, bent on eradicating the

ROGER MELIS

GERHARD KIESLING

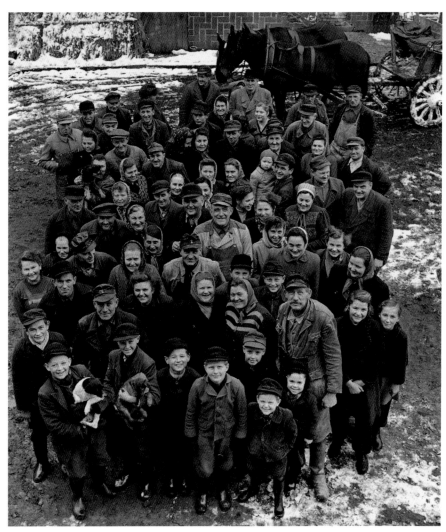

lingering phenomenon of social realism. They were less interested in portraiture than the photographers from Direkt; certainly they were less concerned with style. They also usually worked on assignment rather than selling their photographs to newspapers and magazines.[15]

The animosity between Direkt and Signum is exemplified in the works of Fischer and of Kiesling. In clear contrast to the former's solitary subjects is the latter's bird's-eye view of collective rural bliss, in which only a few persons, relegated to the back or the sidelines, appear to feel left out (fig. 39). In spite of the deliberate pose, the moment feels authentic, as the joy of sharing is demonstrated in a most elementary manner.

Horst Sturm was a worker photographer early on, and although his party loyalty was never questioned, his straight approach—which had remained consistent since the end of the war—was only fully appreciated again after the 1950s. The new preoccupation with so-called photographic objectivity favored his style, but while this attitude represented an advance over the flagrant fakery of an earlier time, it also damned nonjournalistic experimentation for years to come. Now that photographers were finally permitted to confront a more varied realm of life, anything tinged with fantasy was equated with social realism and "untruthfulness."

For Sturm—unlike Fischer or Melis—making a great photograph had nothing to do with either composition or concept. He had no patience for that. The point for him was to capture the moment in the clearest way possible; nothing else mattered. He once recalled how thrilled he was when he managed to catch Brecht with his actress wife, Helene Weigel, in the midst of a May Day demonstration. They were lost in the crowd, he explained, but his picture brought them back.[16]

Yet in spite of this lack of artistic pretense, Sturm created memorable images and contributed to the appreciation of photographic seeing. In *Out of the Box,* taken in 1955 (fig. 40), as Raphael's *Sistine Madonna* is lifted out of its shipping crate, an optical illusion of "false attachment" makes the workmen in the foreground seem to mingle with the worshipers in the painting: some heads are raised to the Madonna, others lowered in deep contemplation. Although we know the workmen's concerns are technical, they are nonetheless drawn into the composition, as a contemporary extension of Renaissance spirituality.

101

Out of the Box,
East Berlin, 1955
(Bundesarchiv
Bonn, 35 566/5N)

HORST STURM

Sturm had no ax to grind. Asked to contribute his comment to the *Eighth National Photo Show of the GDR (VIII. Fotoschau der DDR)* in 1976, he wrote that he would prefer experimentation to the lingering clichés of social realism, because it could at least provide a basis for discussion.[17] He was a man of fundamental convictions, but with an open mind. His images therefore remained alive, drawing in the viewer by their sheer presence.

A prominent follower of Sturm was Peter Leske, who worked for the women's magazine *Für Dich*. Like Sturm, he disliked manipulation and cropping, opting for a straight-on, no-nonsense approach, which he found consistently serviceable. But his tones were often dark, giving the subjects a brooding presence, in the newly discovered tradition of Lewis Hine. In a photograph of a mechanics brigade taking a break, the light favors the two women at the center of the group; perhaps one is consoling the other, or possibly they are involved in a standoff (fig. 41). With hues that seem borrowed from an Emile Zola novel, Leske caught everybody awkwardly looking about; one woman drops her jaw. Simmering impropriety subtly permeates the subject of workers as friends.

103

Leske had also learned to admire Cartier-Bresson, and the "decisive moment" he captured here can be seen as a rather ambiguous slice, skillfully lifted from its natural context and left dangling in suspense. But when he reasoned that he needed "the collective" because photojournalism was by nature "collective,"[18] he appeared to be mimicking the logical leaps of Berthold Beiler. That stance compromised the integrity of his hard-edged, high-speed, 35-mm Magnum-type realism, preventing him from becoming truly self-critical. Although unable to surpass Fischer, whom he accused of being too content with appearance, Leske nonetheless worked with a tireless determination that took him from assignment to assignment, event to event. Trusted with a visa, he covered peace marches in the East, protest marches in the West. His life became, as he put it, a constant search for "situations" in which human attitude was revealed.[19]

There had never been any real love lost between Ulbricht and Honecker, but by the late 1960s neither pretended to conceal their differences. A major source of conflict

Break,
Mechanics Brigade,
Potsdam, 1967

PETER LESKE

was Ulbricht's desire to intensify existing methods of control, while the younger Ho-
necker impatiently trumpeted novel and more persuasive ways to tie the people's
identity to the socialist state. He had been in radical politics since the age of ten, when
he joined a Communist youth group in his native Saarland, near the French border,
and at eighteen—during the final chaotic days of the Weimar Republic—he orga-
nized street demonstrations that all too often turned violent. When his incarceration
by the Nazis ended in 1945, his already extreme personality had been further defined
by the effects of prolonged suffering.

By the late 1960s he was known for his extremist anti-Western stance coupled
with an uncompromising dedication to socialism. Through what was later called his
Abgrenzungspolitik (politics of demarcation), he hoped to produce a singular national
culture that was distinctly set apart not only from West Germany but even from the
German character in general.[20] Seemingly oblivious to all social progress made in the
West, he insisted that there had always been two German cultures—one decadent
and bourgeois, the other healthy and proletarian.

Honecker's time finally came in 1971. Appointed as head of the SED, he became
the new spirit—the powerful wind that gathered all forces and carried them back to
the center, where he deployed an iron-fisted domination. Ulbricht, meanwhile, was
demoted to "honorary chairman," a strictly ceremonial position not even mentioned
in the constitution. He was still seen occasionally, giving out awards or cutting ribbons,
but by the time he died, in 1973, he was a broken and all but forgotten man. A pho-
tograph of his death mask, published on the front page of the August 7 *Berliner
Zeitung,* symbolized the official end of the Ulbricht era.

Honecker quickly established himself as a benefactor to those who complied and a
vengeful foe to those who resisted. He also developed a knack for veiling blunt threats
with terse promises, replacing terms such as "requirement" or "rule" with "artistic
commitment" or "honor." Such euphemisms could hardly disguise the fact that the
reins were pulled in more tightly than ever. There were to be no more taboos in art,
he alleged, but this freedom assumed that artists had acquired a solid socialist foun-
dation. Thus, artists could move in all directions as long as they stayed put. "In view
of the international conflict between socialism and imperialism," Honecker explained
at a political rally in 1973, "our art and our culture are privileged to develop person-

105

alities marked by an irrevocable commitment to socialism, inspired by the experience of our own revolutionary battle and the battles of other peoples."[21]

Honecker became notorious for holding the door open with one hand and slamming it shut with the other, giving rise to a national schizophrenia that persisted after the nation had perished. He also perfected the Stasi spy network, generating an awe-inspiring paper trail that filled warehouse after warehouse with information on just about anyone who displayed less than uncompromising devotion. He equipped the roofs of public buildings with surveillance cameras and created special archives to hold sweat samples of suspected dissidents, so they could later be tracked down with dogs. And because political prisoners were "sold" to West Germany for much-needed hard currency, judges were actually given quotas for convictions.[22]

In 1973 Honecker declared all private ownership "obsolete," and he immediately proceeded to nationalize the few remaining independent enterprises, thus paving the communist path and underscoring the permanence of the state.[23] In the new constitution, drafted the following year, the GDR was no longer a "socialist state of the German nation" but rather a "socialist state of workers and farmers." All references to a united Germany were stricken.[24] Asked to elaborate on his views on reunification, Honecker quipped that history had already shown West Germany to be a foreign nation.[25] A single nation had to have a single culture, he explained. As he saw it, there was no common cultural ground between imperialism and socialism.[26]

Ironically, Honecker's cantankerous stance is what finally brought him respect from the world community. On the urging of Chancellor Willy Brandt, even West Germany established diplomatic relations, which in 1972 led to the *Grundvertrag*, or basic treaty, guaranteeing "peaceful coexistence" for the two Germanys—henceforth described as two states with different social systems.[27] By 1976 the GDR was officially recognized by 121 nations, up from 26 in 1971.[28]

It was a major achievement, and the timing was superb. The Vietnam War—the longest conflict of the twentieth century—had just been brought to an end with a concession to communism. While the West was contending with rising crime and poverty, in the GDR the only thing rising was the standard of living. Everybody was truly equal, or so it seemed. The future seemed secure, as the "forward-moving march" of the "new humanity" took on a new sense of inevitability.

Some things that were still imaginable
yesterday are gone forever today.

CHRISTA WOLF, *Divided Heaven*

Chapter Seven

COLLECTIVE REALITY

108 The 1970s brought incisive changes for photography. Television, found in nearly 82 percent of all households by 1975, was clearly taking over the function of transmitting information.[1] With less pressure on photography as the major tool of communication, there was greater artistic latitude, even though censorship remained stringent. And as the emphasis shifted from male-oriented photojournalism, more women entered the field, creating a platform for feminist issues.

Television had also made the iron curtain increasingly transparent, perforating it with illegal airwaves from West Berlin that reached almost all areas where bootlegged antennas could be camouflaged as tomato plants or laundry racks. But anyone caught was subjected to public humiliation. "Frau Buchmann, your antenna was pointing in the wrong direction!" read the bold print of a flier distributed by the National Front for a Democratic Germany, Potsdam. "No—we will not stand for it! We will help you, Frau Buchmann at Eisenhartstraße 21, to think and act properly. Therefore your television set has been recalled."[2] Dresden was one of the few cities where reception was thwarted by low altitude and surrounding mountains, causing locals to nickname it "the valley of the unknown."

Another change was the boom for photography in the West, which stimulated serious marketing and collecting. The GDR, with no economic base for a true art mar-

ket, could only vicariously experience this trend, but it nonetheless fueled the aspirations of local photographers.

The death of Berthold Beiler in 1976 also had an impact on photography, as his peculiar art-parlance lost some of its punch. Although his books remained required reading, his credibility was fading in the information age. The future that Ulbricht had dreaded was drifting undeterred across the death zone of the iron curtain.

Although in terms of the economy the mission of socialism seemed to have been accomplished, collective consciousness limped a considerable distance behind. In fact, art was moving further and further from the political arena and toward private domesticity. The move was an inevitable repercussion of the cultural normalization that followed international recognition, but by the same token it was also the beginning of the end for socialism. Because political sovereignty and an independent national identity had finally been granted by the world community, the GDR was no longer able to remain sealed off from the Western world—no matter how hard Honecker tried. Inter-German detente became inevitable. In addition to the already existing inter-German loans and trade agreements, regular cultural exchange programs could now no longer be avoided.

Most important, in accord with the Helsinki Final Act of 1975, which Honecker signed, the GDR—as a sovereign nation—was obligated to accept requests for exit visas from its citizens. When they were routinely denied, and when border guards continued to shoot at escapees, there was a tangible grievance, a clear violation of the basic human rights that Honecker had vowed to honor. The gap between reality as depicted and reality as experienced was becoming more difficult to ignore, and the sense of betrayal was becoming more profound.

In his speeches Honecker hammered in the differences between the two Germanys; he also introduced compulsory military training in high schools to "defend Marxism against attacks and infiltration by imperialist forces." Arrests of suspected dissidents rose dramatically, while would-be emigrants were treated like pariahs, accused of "endangering the state with propaganda and agitation."[3] Even artist communities were infiltrated by Stasi informers, if not actually created to provide an arena for entrapping dissidents.[4]

In November 1976, Honecker barred the recalcitrant folksinger Wolf Biermann from returning to the GDR after a concert he had been permitted to give in West Germany. This move prompted the unprecedented protest of more than one hundred intellectuals in the GDR, including Christa Wolf, who signed an official letter. When *Neues Deutschland* refused to publish the letter, protest spread to Western Europe and the United States. But at home it resulted only in more bans and arrests. Christa Wolf was expelled from both the SED and the Berlin Committee of the Writers' Federation.[5] Anna Seghers, on the other hand, remained steadfast in her allegiance: "I never approved of the reprehensible letter," she wrote in a rebuttal that was published in *Neues Deutschland*. "Reports in Western newspapers that insist I approved of it after the fact are false, and they confuse matters. Since its inception, the GDR has been the country in which I want to live and work."[6]

110

But the more the differences between the two Germanys were stressed, the more similarities became apparent—in language, literature, music, art, and finally, history. Christa Wolf initiated an assessment of the countries' common Nazi past in her novel *Patterns of Childhood (Kindheitsmuster)*, where she dwelled on the day-to-day world of fascism rather than on Nazi violence, which was routinely associated only with West Germany. It became clear that the two countries remained inextricably linked by their shared experience. "Let that which belongs together come together," urged Willy Brandt, who for a time had single-handedly pursued his now famous *Ostpolitik*. More determined than ever, Honecker retorted that reunification was not an option.

Consequently, in the late 1970s—despite a seemingly satisfactory economy—an ever-increasing malaise and introspection made itself felt in East German art, as West German television became both a link to the world and an escape from reality. The people had done everything they were asked to do: they had given up their free will and worked; they had tried to remain optimistic against all odds, making sacrifices for the future. But they were still imprisoned. They were still democratic in name only. What had begun as a dilemma for intellectuals and artists in the early 1960s had now reached crisis proportions, trickling down through all segments of the population and creating an "anticivilization trend of melancholic weltschmerz" and "a spiritual ad-

diction to the experience of catastrophe."[7] Christa Wolf's question from *Kindheitsmuster* reverberated in the minds of the workers: "How did we become what we are today?"[8]

The general withdrawal into the intimate sphere did not necessarily engender a more individualistic approach in photography. For some of the younger artists, often the opposite was true. They forged a deliberate affront to both the introspection seen in Evelyn Richter and the aesthetic and compositional agenda introduced by Arno Fischer. Rather than a normal or long lens—which isolates the subject by throwing the background slightly out of focus—they preferred to use an extreme wide-angle lens, with its almost indiscriminate depth of field. Every iota of the image was important to them. They wanted to enter into the midst of life with absolute equanimity, eschewing all recognizable innuendos or personal preferences.

To some extent this tendency recalled Neue Sachlichkeit, which likewise was born of disillusionment. But at the same time it sought a unique photographic expression for the socialist worldview, as distinct from that of the West, and of West Germany in particular. No longer content to squeeze Western realism into the tight corset of socialism, these new artists instead used it as a mere ingredient for their own improved version of evidential "truth," which they unhesitatingly equated with activism and the mobilization of the people. The adroit desperation with which these photographers began compiling the advantages of their anachronistic no-man's-land produced the most vivid evocation of socialist life yet.

Typical of this trend was Gruppe Jugendfoto Berlin (Youth Photo Berlin Group), formed in 1968 to engage in what Peter Pachnicke described as "photographic research through the serial structure."[9] One of their prominent members, Christian Borchert, a native of Dresden, remained faithful to the worker theme, while consciously trying to avoid all subjective interpretation. In writing about Borchert's work, the historian and curator Klaus Werner contended that to the artist only the subject's "reality" mattered, and that in order to distance himself from the elitist concept of the creative process, he insisted that the subjects even choose the final print.[10]

Of course, Borchert was limited by his refusal to intervene. In the end it prevented

111

him from probing as deeply as his idol, August Sander, who—in spite of his asso-
ciation with Neue Sachlichkeit—managed to communicate a great measure of
voyeurism. Unwilling to strip away the mask of the subject's persona, Borchert tended
to linger in an exterior realm that was routinely defined by the vanity of the sitters. We
find them shoehorned into their tidy working-class milieu, where the obligatory
houseplants, an aquarium, and daisy-topped slippers are the only ornaments (fig. 42).
They are seen as one should expect to see them: devoid of all excess but comfortable,
with predictable values. They are the nucleus of the nation, the personification of the
ordinary good socialist life.

But Borchert could not always deny his artistic flair, which most often came
through when the subjects were unaware. A shot of three people ducking under an
umbrella next to a wall as a train roars by on the other side is rife with associations
(fig. 43): different tempos; different spaces; a different consciousness; separation; being
passed by; left out in the rain. But compartmentalized by the geometry of the wall, the
three figures are also protected from the rushing onslaught beyond. In a similar vein,
the shadowy figures weaving across the dance floor in an East Berlin ballroom suggest
the rewards of shared surrender (fig. 44).

Another prominent member of Gruppe Jugendfoto Berlin was Uwe Steinberg,
who had come to the GDR from West Germany in the 1950s with his parents and his
brother Detlev—in search of "a better life."[11] He had worked as a photojournalist
since the early 1960s, but he gained recognition only in the 1970s, for a series of pho-
tography books (some coauthored with his brother) on a variety of subjects, including
foreign countries such as Egypt. But the work closest to his heart was from the worker
milieu of East Berlin, where he felt safely at home. What he cared about most was the
perfectly ordinary, uneventful street life, at urban markets, playgrounds, public
squares, and parties (fig. 45).[12] But it was not uncommon for him also to enter the liv-
ing rooms of the workers to record a more intimate sphere.

Characteristic of this approach is Steinberg's series of photographs from 1971 titled
Elfriede Schilsky Departs (fig. 46). Here he documented in successive images the re-
tirement party of a woman who had worked eighteen years at a charcoal pencil fac-
tory: saying goodbye to her boss; wiping away tears; getting into a car; her former
coworkers waving goodbye. The individual shots become the equivalent of movie

*The N. Family
(Electrician,
Clerical Worker),*
East Berlin, 1983

CHRISTIAN BORCHERT

43

Nöldnerplatz Station,
East Berlin, 1971

44

*Dance at Clärchen's
Ballroom,* East
Berlin, 1981

Central Market,
East Berlin, 1963

UWE STEINBERG

UWE STEINBERG

Elfriede Schilsky
Departs, East
Berlin, 1971

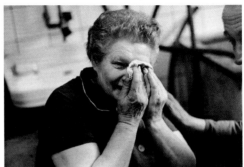

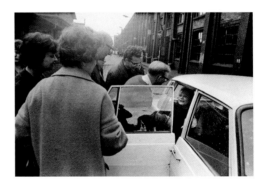

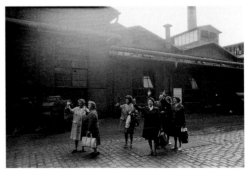

stills that can be studied for greater detail. For Steinberg the last image, with the remaining workers standing in the street waving, summed up the entire series, and he felt the others were unnecessary to tell the story.[13] This was in keeping with his continuous search for absolute clarity and simplicity. Like Borchert, he insisted on being nothing more than an objective extension of the camera, and if indeed the best of his work transcended what it showed to become universal,[14] that was perhaps not intentional. We will never know how he might have evolved as an artist, because his life was cut short. In 1983 he was killed in an automobile accident in Czechoslovakia. He was forty-one.

A more overtly political member of Gruppe Jugendfoto Berlin was Ulrich Burchert, a close contemporary of Steinberg's and like him a freelance photojournalist since the 1960s, who believed in the artists' responsibility to place their work in the service of the party and the collective experience.[15] Certainly in *Birthday Party at the Worker Brigade,* from 1973, the idea of socialist sharing could not have been more skillfully detailed (fig. 47). Far from the sullen ambiguity of Peter Leske's photograph on a similar theme (see fig. 41), here brightness and orderly camaraderie articulate the peaceful life. The seemingly casual grouping is firmly held together by the grid of the floor, which, however, fails to be softened by the strategically placed plant. The vantage point is raised, positioning the group below a higher unifying presence, as the ordinary socialist workday is transformed into a day of celebration.

Having participated in one of their exhibitions, Manfred Paul is sometimes associated with Gruppe Jugendfoto Berlin;[16] however, a look at his work should suffice to set the record straight. His images of shadowy corners and courtyards in East Berlin—where he seemed to be following in the footsteps of Heinrich Zille—are less about ordinary fact than about poetic form and visual drama (fig. 48). And despite the metaphorical associations of solitude and narrowness, the subjects breathe independently and without pain.

Paul was an odd trooper in the parade of East German photography, inasmuch as he attempted neither to support nor deride what he perceived around him. At times his style evokes the lyricism of Evelyn Richter, but the comparison does not hold up

47

Birthday Party at
the Worker Brigade,
Cottbus, 1973

Ackerstraße,
East Berlin, 1973

MANFRED PAUL

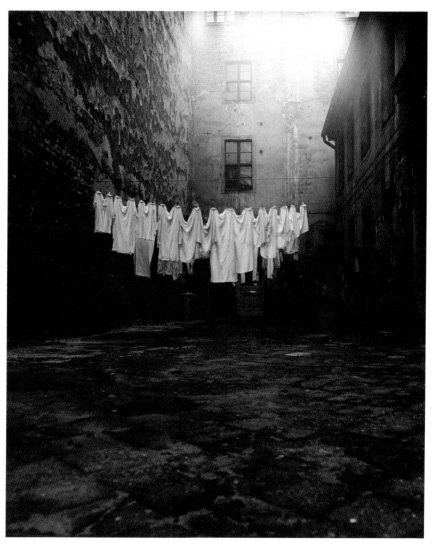

to scrutiny. For example, Richter's image of two flag-bearing boys (fig. 49), which dates from the same period as Paul's *Ackerstraße,* also draws on the loneliness of urban space. But once again, beneath the surface of harmony, Richter exposes a world literally torn in half, with contemporary and vintage architecture defining opposing camps. Even the pavement is taking sides. Puncturing conventional appearances, Richter typically focused on strangers in a strange land. By contrast, Paul's timeless, nonspecific universe—brought to shimmering life through Westonian tonal gradations, so out of context in the GDR—invoked a sense of elegant closure. The laundry billowing in its narrow space exists beyond arbitrary political boundaries. It is sustained by the power of beauty.

The work of Thomas Kläber, who touted the traditions of rural life, appears equally devoid of political innuendo. Of course, the scenes he portrayed only seemed traditional because development lagged even further behind in the countryside than in the cities; in reality farmers now worked as employees of the state on collective farms. There had been much resistance at first. But rural life is more communal than city life, so they soon adapted. In the end, the rent they paid the state in order to stay in their houses was far less than their property taxes would have been.

Beginning in the late 1970s, as part of his studies at the HGB under Helfried Strauß, Kläber set out to photograph in little out-of-the-way villages around his native Beyern, between the Schwarze Elster and Elbe rivers. There was nothing controversial in his approach to the subject—in the artist's own words, he was inspired by "engaging photographers whose work shows . . . that they consider social conditions and take a clear position."[17] Almost all the images illustrated the idea of sharing or working together, and thus they were frequently included in exhibitions, catalogues, and books. But as Strauß later pointed out, they could not be published as a complete body of work, since officially they were relegated to the sector of "peripheral" subject matter for failing to address "the new" and "the typical."[18]

This, however, could hardly have been an issue for the people whom Kläber befriended on the open country roads and in their homes (figs. 50 and 51). Flattered by the attention, they betray the innocence of those who live in close contact with the earth. Despite the political upheaval, their lives remained centered by the rhythms of planting and harvesting. Only occasionally would Kläber depart from this equilibrium, as

120

Music Quarter,
Leipzig, 1976

E V E L Y N R I C H T E R

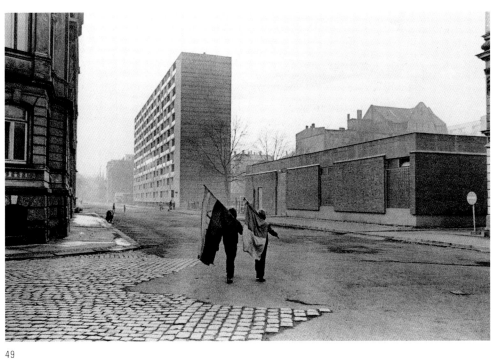

Untitled, from
Country Life,
Beyern region,
ca. 1980

THOMAS KLÄBER

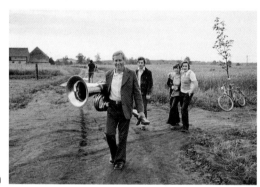

50

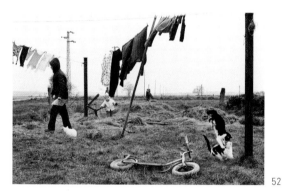

52

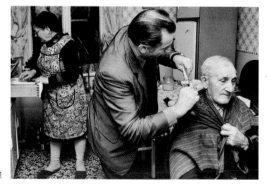

51

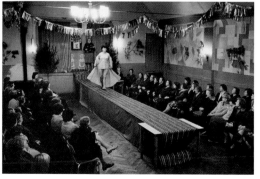

53

when an ordinary scene by the clothesline is littered with disconnected visual detail (fig. 52). Apart from the cats adroitly caught at the onset of a playful skirmish, everyone and everything here seems swept in different directions against this flat horizon. Inside, meanwhile, a makeshift fashion show may stretch the notion of glamour, but for the unspoiled audience huddled together on hard chairs, fantasy supplies what is lacking (fig. 53).

Professional socialist fashion photography became the territory of Günter Rössler, who had also studied at the HGB during the early 1950s. "The idea of fashion was something the government was not very thrilled about," he explained. "They would have preferred that everybody wear Mao suits, which of course was unrealistic."[19] Perhaps to be on the safe side, he echoed the austerity of Gruppe Jugendfoto Berlin, insisting that he was primarily interested in showing the cut and function of the clothes (fig. 54). Unlike Edward Steichen, Irvin Penn, or Richard Avedon, all of whom had abstracted femininity, Rössler wanted to comment on current styles in a simple yet informative manner. Helga Herzog further anchors his work within a socialist context by virtue of its "humane character": the clothes conform to the wearer rather than to the extremes of prescribed fashion.[20]

123

While on the whole Rössler's work offered welcome relief from the standard fare, the ideological goals proved limiting. "One needed to be on guard," he explained. He was once accused of having secret connections to the West because one of his models wore tight shorts. In another instance, Rössler recalled, a man with a Marx-style beard had to be cropped out of a picture for a knitting magazine, because any possible association between the fashion industry and the spiritual leader of communism was considered blasphemous.[21]

In the late sixties Rössler also initiated a respectable return to the female nude (fig. 55), a subject he had already experimented with in the 1950s, during his days with *action fotografie* (see fig. 16). Fashion, as he explained it, was a way to make a living, but the nudes became a "refuge from the grayness of ordinary days."[22] His approach to the classical subject was not revolutionary, but in the GDR—where erotic escapism was frowned upon—it took two years to find a gallery to show the work. That it was shown at all was at least partly thanks to a loophole in Honecker's new art policy,

Fashion, 1960s

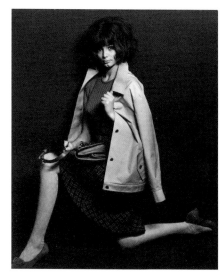

54

GÜNTER RÖSSLER

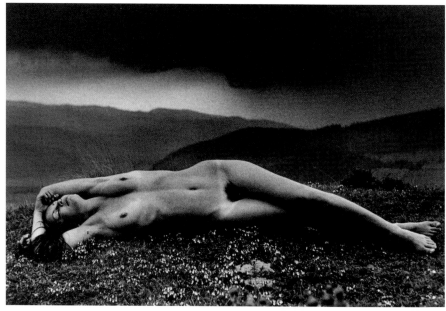

55

Nude, 1960s

which encouraged *Breite und Vielfalt*—"broad and varied subject matter" with regard to the socialist cause. Partly, too, the description of Rössler's nudes as "honest" and "unmanipulated" helped put them back on a virtuous track for the viewer.[23] With his irreverent sense of humor, Rössler apparently took it all with a grain of salt, playing the game in order to have his peace. But his heart was clearly in his work—not in politics. Regardless of how Rössler's work may weigh on an international scale, in the GDR it provided an unprecedented taste of luxury.

Throughout the 1970s much of West German photography remained under the interdisciplinary spell of conceptual and minimalist art, advanced by Joseph Beuys and the team of Bernd and Hilla Becher. But in the GDR, in spite of the growing shift toward television as the most vital instrument of communication, the political tightrope negated all significant exploration in photography. A 1987 anthology of East German photography from 1945 through the 1970s still brimmed with shopworn tributes to the success of the "new humanity": the proud father embracing his graduating daughter; ecstatic tenants moving their worldly possessions from one concrete housing project to another; victorious athletes, applauded orators, glorious actors, and confident teachers —all in didactic, active poses, as if they were saying, "Pay attention. Be like me."[24]

After fermenting for more than thirty years, the GDR had, for the most part, failed to turn vinegar into wine. "Progressive art" was still ideological conformity, and "progressive life" still meant getting married and having a baby right away in order to reduce the waiting period for a small, tinny Trabant (the only car made in the GDR) to about eight years. That is why the end of the decade experienced a new wave of disappearances. But this time not only those who had opposed the government but also those who had supported it were fleeing. Artists who had contributed to the independent cultural identity of the GDR now abandoned all hope and made a dash for the West, where their work could be published and exhibited without restrictions. What little cultural recognition the GDR had mustered since the building of the wall now quickly evaporated. What was Honecker to do?

On December 4, 1977, an exhibition opened at Galerie Roter Turm, in the heart of the old town in Halle, that was to shift the paradigm. Apart from the standard worker

themes, *Medium Fotografie* offered East Germans the first historical survey of photographers who, at one time or another, had worked in Germany, including many from the avant-garde, previously banned or at best ignored. Even Oskar Nerlinger's early abstractions were on view. There was, however, one significant exception to the scope of the exhibition—namely, the whole of West German developments since World War II. Thus local artists were made to appear the heirs of historical figures such as August Sander, Lyonel Feininger, Albert Renger-Patzsch, Heinrich Zille, and even László Moholy-Nagy—all of whom were represented in the show.[25] The inclusion of work by Hitler's favorite photographer, Erna Lendvai-Dircksen, further attests to the prevailing naïveté.

Why this offbeat show was launched remains a matter of debate, but more than likely it was meant to give artists an incentive to stay. Unfortunately, those who believed that freedom of expression had finally been granted were soon disappointed again; if any taboos had been broken, it was still only in terms of the viewing experience. Official policy on photography remained unaffected. As Hermann Raum, one of the organizers of the exhibition, noted, "We are not pitting Heartfield . . . , who placed experimentation in the service of content, against Moholy-Nagy, who did not. But neither do we consider them equals."[26]

Perhaps Honecker believed he could attenuate the growing discontent by creating an illusion of artistic choice. Indeed, the exhibition did appease photographers by allowing them to see themselves as part of the international artistic community, and the precarious flowering of creativity during the 1980s was undoubtedly triggered by this new awareness. But the illusion of freedom also accentuated the continued oppression and isolation that had become a paroxysmal nightmare. Once again Honecker had offered a taste of freedom in exchange for imprisonment, exacerbating the national schizophrenia. *Medium Fotografie* brought the issue to a head. It also delivered the inspirational tools to express it. Thus, as national differences in art were quickly evaporating throughout the world, in the GDR a rather indigenous expression began to take shape. It was not what Honecker had envisioned.

The photography that emerged in the 1980s was still ingrained with social con-

126

cerns, as a result of intense conditioning. But the tradition of socialist optimism gave way to a coded yet pervasive undercurrent of doubt, self-questioning, restless fear, longing, disillusionment—and finally, resignation. Indiscriminate fusing of individual human identities had failed to appease human consciousness. Quite to the contrary. "Collective reality" was discovered to be a lonely experience.

Sobered to the bones, we stand aghast before the actualized
dreams of our thinking, still called reason, but which has slipped
away from the enlightened beginning of our emancipation and
entered the Industrial Age as mad utilitarianism.

CHRISTA WOLF, acceptance speech for the Büchner Prize, 1980

Chapter Eight | **MILESTONES**

130 The protagonist of Christoph Hein's novel *The Tango Player,* who lives in Leipzig,
finds himself in a situation that sums up the dilemma of East Germany during the late
1970s: in spite of a deep longing for the outside, the idea of freedom had become alien,
and the lock on the door to the world had somehow become a pathological symbol of
security.[1] All that would change in the early 1980s.

As the superpowers were accelerating their nuclear missile deployment, Germans
on both sides of the iron curtain were beginning to realize just how vulnerable their
disunity had made them. Not only were they divided, but now they were confronting
each other on their own soil with the most deadly force imaginable. They had become
the pivot of a conflict the likes of which the world had never known. Christa Wolf, as
a kind of de facto mother confessor for East German readers, pressed the panic but-
ton in 1981 by predicting the end of all civilization within three or four years at best.[2]
While this perspective helped to sweep away all residue of false security, it also di-
minished the people's fear of the government. For artists, this attitude led to creative
avenues of defiance.

Honecker attempted to maintain order by stepping up the persecution of so-called
troublemakers, but before the bureaucrats could research the rules for closing down

an inappropriate exhibition in one place, a new one had already sprung up somewhere else.[3] Years of official bullying were foiled by a sense of private chaos. At times even official exhibitions doubled as platforms for defiance, although it remains somewhat unclear which instances constituted subordination by individual curators and which were a measure of official appeasement. Most were probably the latter, since curators were appointed on the basis of ideological conformity. Nothing was ever as it seemed or as it was stated, and reading between the lines remained an essential part of interpreting East German history—even after reunification, which brought an end to censorship but not to deception for political gain.

A case in point was Ullrich Wallenburg, who organized exhibitions from a collection of national photography that he had established in 1979 at Staatliche Kunstsammlung Cottbus. Wallenburg also edited the numbered catalogues, or "Fotoeditionen," whose essays he presented as the first platform in the GDR for serious art criticism on photography. For example, Fotoedition no. 7 is dedicated to the work of Manfred Paul, whose varied photographic interests included the study of light on small household objects such as a tea strainer, a dish rack, or a milk bottle.[4] Preoccupation with form verging on abstraction had not been rewarded in the GDR, and the inclusion of such images in the catalogue—though described as simple reflections of reality—seemed a breakthrough. In Fotoedition no. 5, however, hackneyed photographs of happy harvesters or of Soviet fighter planes taken with a starburst filter to make them appear ethereal were unabashedly presented as "the result of strenuous artistic activity" that mirrored "the concrete success of socialist cultural policy."[5]

In 1990, after the GDR had been eclipsed, Fotoedition no. 5 (and certain others in the series) was no longer available at the museum, whose name was changed to Brandenburgische Kunstsammlungen Cottbus. Wallenburg issued his eleventh and final Fotoedition that year: *Images of Time: Proto-GDR Photography* (*Zeitbilder: Wegbereiter der Fotografie in der DDR*). It was the most comprehensive project to date, attempting—as *Medium Fotografie* had done—to explain East German photography as the culmination of the avant-garde from the 1920s. This time, however, it was done without reference to socialist virtues. Was Wallenburg forging a new frontier of so-

131

cialist photography this late in the game, or was he whitewashing the past to secure his position under the next administration? He was eventually exposed as a major Stasi informer, but the whole truth may never be known.

Several definitive events helped to nurture the transhistorical climate of photography after *Medium Fotografie,* when speculations for the future were put on hold and all possible outcomes appeared to exist at once. One such event was the *Ninth National Art Exhibition of the GDR (IX. Kunstausstellung der DDR),* held in Dresden in 1982. This prestigious show had been presented every four years since 1950, but only now, for the first time, did it include photography. In fact there is no evidence that any of the more than seventy museums in the GDR had ever shown photography before. Whereas the medium had often been called an art, in reality it was considered a communications device for propaganda, valued for the graphic message and accompanying text but not the print itself.

132

If *Medium Fotografie* had created a historical framework for photography, the *Ninth National Art Exhibition* finally forced the issue of photography as a legitimate visual art, one worthy of display beside paintings on museum walls. More than one hundred photographs by old-timers—such as Arno Fischer, Sibylle Bergemann, Evelyn Richter, Roger Melis, Uwe Steinberg, Christian Borchert, Ulrich Burchert—were included, though none were reproduced in the catalogue. Also displayed were images by some rather unorthodox newcomers, such as Ralf-Rainer Wasse, Gundula Schulze, Rudolf Schäfer, and Ulrich Lindner, all destined for recognition.

So portentous was the inclusion of photography at this traditional art event that it warranted an excuse. In his article "Trust Your Own Eyes," Pachnicke—one of the organizers, who had also taught most of the photographers—urged viewers to give the work a chance. He assured them that it was carefully selected and by no means "merely" photography.[6] Why was it worthy? With one foot in the past and the other in the future of East German thinking, he alleged that the images revealed the self-confidence of the worker class but also conceded that they abstracted emotional issues, such as a need for security and unfulfilled longing. Most egregious was his admission that photography illustrates the impermanence of *all* ideas, since that would have to

include Marxism as well. While few had accepted the notion that socialism was the ultimate stage of human evolution, fewer still had considered its obsolescence. Now it was on everybody's mind.

Although the *Ninth National Art Exhibition* may have helped liberate photography, the ideological and political constraints persisted. A confidential government report on the concept of the exhibition affirmed that "the function of art as a weapon must be demonstrated. . . . The goal must be to allow works to come into existence that help forge the progress of socialist art by presenting new and valuable solutions for the central content of our art." Five million marks were spent on the show, of which only two million were likely to be recouped. Photography was included on account of a new decision to integrate all the arts, including architecture, book design, stage design, and fashion and jewelry design. The emphasis shifted from showing the worker to illustrating the idea and the tangible results of work, in order to promote "an artistic attitude marked by an advanced sense of socialist responsibility."[7] The same reasoning led to the eventual inclusion of photography in the Staatliche Kunsthandel (State Art Trade), an institution inaugurated in 1974 to raise government funds through the sale of art. It was a dubious victory, however, as it turned out to be nothing short of a ruse to confiscate 85 percent of the artists' profit.[8]

Another important precedent was established with the exhibition *Photography in Graphics (Fotografie in der Grafik),* held at the Kupferstich Kabinett in East Berlin, one year before the *Ninth National Art Exhibition*. Here, both international and local artists showed constructions and assemblages that utilized photography and photography-derived processes, thus acknowledging for the first time the validity of interdisciplinary art. The show passed censorship simply because it was presented as a graphic arts show, even though it drew unabashedly on West German developments in photography, which in turn harked back to the dadaist Raoul Hausmann and surrealist Max Ernst. Without making much of a fuss, artists and curators simply found indirect venues to transcend or circumnavigate the established boundaries. They learned to use their imagination. That is how the silent revolution took form in the 1980s.

The interdisciplinary exhibition *Workday and Epoch (Alltag und Epoche),* which opened in October 1984 at the prestigious Alte Museum in East Berlin, was as traditional as its title, but suddenly photography received almost a third of the exhibition space: seventy-five of the three hundred works were photographs.[9] In an interview with *Fotografie,* Pachnicke, one of the curators, recalled how in preparing this exhibition he found himself putting together a virtual retrospective of East German history.[10] It helped initiate a trend that gathered momentum toward the end of the decade, namely, to analyze the past through photographs.

Looking back was part and parcel of the postmodern climate everywhere during the 1980s, but in the GDR the motive was not so much nostalgia as the specific need to manufacture a memory of lost time. Throughout the fifties, sixties, and even the seventies, the GDR disparaged its past, and all momentary experience was invested in the future. But by the mid-1980s this future had moved farther into darkness. Honecker could no longer conceal the fact that the wobbly economy was kept afloat only through increasing loans and ransom money for political prisoners from the enemy to the west. The people were falling back on their Germanic penchant for brooding over their character and their destiny, and photographs became a visual aid. Thus, as the end of the nation neared, a tentative national consciousness—something the government had never managed to inspire—began to emerge all on its own. The long sleep had ended. Life was intensely felt.

The exhibition *Artists Photographing–Photographed Artists (Künstler fotografieren–fotografierte Künstler),* organized in 1984 by the art historian Klaus Werner at Galerie Oben in Karl-Marx-Stadt (Chemnitz) and Galerie Mitte in Dresden, also had a profound effect on the development of the medium.[11] One aspect of the exhibition focused on photographers, such as Evelyn Richter and Christian Borchert, who had photographed artists, but the other, more crucial, segment consisted of photographs taken by painters. Because painters enjoyed greater freedom from ideological encumbrances they could give photography new sensibilities. Very much like Moholy-Nagy in the 1920s, or Joseph Beuys after 1961 in the West, East German artists, such as Klaus Buchwald, Klaus Hähner-Springmühl, and Thomas Florschuetz, now began to lead photography away from its stolid past and the dominant tenets of verism.[12]

134

Censorship again was circumvented, quite possibly, as the historian Thomas Kum-lehn maintained, because the purported concern of the show was painting.[13]

A more traditional exhibition—missionary in its basic intent—was *Reality–Reason–Art (Realität–Vernunft–Kunst),* held in East Berlin in 1986 to demonstrate the preeminence of realistic art. In the foreword to the catalogue, Robert Weimann quotes Brecht saying that the victory of reason can only be the victory of those who are reasonable, and then asks: "What can art achieve here and today? To maintain peace, to create peace, to allow this country and its people to live—humanely, close to art?"[14] In the time-honored tradition of logical fallacies, he then concluded that realistic art—as the art of those who are reasonable—would guarantee peace. Nevertheless, by the 1980s such a shameless maneuver invited only contention, at least on a subliminal level. It contributed to the breaking down of unalterable convictions. In fact some artists used the reactionary platform to further their subjective interpretation of reality.

The title alone betrayed *Reality–Reason–Art* as a government-sponsored "official" exhibition, but in other cases it was more difficult to tell. The Kulturbund, with its in-finite subcategories of regional factions, youth groups, and amateur associations, achieved a Kafkaesque impenetrability, deliberate in its attempt to conceal the other-wise centralized organization. The idea was to make an art event look not like a government-sponsored program but rather like something produced directly by the people. It is safe to assume that lavish catalogues routinely accompanied politically cor-rect events, while shabby ones indicated a hurriedly produced, ephemeral under-ground endeavor. The paper was often a dead giveaway, as it was virtually impossible for the average person to obtain high-grade paper, even for stationery. A pale yellow-green stock that quickly faded to brown around the edges remained the norm.

The most infamous independent exhibition space was Galerie Clara Mosch in Karl-Marx-Stadt (Chemnitz), an industrial town where pollution was so noxious that the popular German saying *Rom sehen und sterben* (to see Rome and die happily) was facetiously adapted as *Karl-Marx-Stadt sehen heißt sterben* (beholding Karl-Marx-Stadt means death). But the city was no stranger to art. Karl Schmidt-Rottluff had survived in relative obscurity there well into the 1950s, and in the late 1970s his legacy was rediscovered.

The center of the burgeoning alternative art scene of the early 1980s, Galerie Clara

135

Mosch was an interdisciplinary space created by graduates from the HGB in 1977 to stage activist exhibitions, happenings, and dadaist noise concerts. It was a somewhat haphazard re-creation of Cabaret Voltaire in Zurich, where the original Dada artists had first mocked bourgeois tradition during World War I. Galerie Clara Mosch survived for almost five years before the government shut it down. The day after the official closing, in the autumn of 1982, gallery members took out a full-page ad in the local newspaper. "Clara Mosch is dead," it read. "The dead are not honored."[15] The real controversy surfaced only after reunification, when it was rumored that the gallery was actually created by the Stasi to spy on artists. That would certainly explain why it survived as long as it did.

Also in Karl-Marx-Stadt was the small but very active Galerie Oben, where *Artists Photographing–Photographed Artists* was shown in 1984. It normally did not feature photography, however. The first gallery exclusively dedicated to what was described as "progressive international photography" opened in 1986 in East Berlin. Called Galerie am Helsinger Tor, it was a comfortable space with all the trappings of a privately run commercial gallery. But the staff of four, headed by Heidrun Dauert, was "assisted" by a committee of representatives from the SED, the local Department of Culture, the Visual Arts Association, the Association of Journalists, and the Photography Society—formerly the Central Commission for Photography—under the direct jurisdiction of the Kulturbund.[16] Not surprisingly, at Galerie am Helsinger Tor "progressive international photography" still meant worker photography from socialist countries. The place became a community gallery with the same name in the 1990s.

Other photography galleries emerged, but most failed to have a lasting impact. Galerie Augenblick, in Leipzig—directly across from, and under the auspices of, the HGB—fared better. This small exhibition space and café, under the direction of Ute Schönherr, launched many different types of exhibitions, both traditional and experimental. It continued to operate after the demise of the GDR, as did Galerie Weißer Elefant, in Berlin.

Even though officially altruistic goals remained on the books, photography changed dramatically during the early 1980s, as artists developed an almost pathological preoccupation with the medium as a conceptual tool for personal expression.

This tendency resonated with artistic trends in other parts of the increasingly inter-
dependent world, except that in the GDR the idea of individualism did not rest on
consumerist notions of self-preoccupation and self-gratification. Rather, it represented
the arduous journey toward a fundamental sense of self-worth, counteracting the
Marxist-Leninist worldview that had elevated humanity as a whole while reducing
the individual to the equivalent of an engine part. The overriding difficulty of saying
"I"—an act that stands at the source of all human value, as Christa Wolf insisted[17]—
finally was addressed in photography. Even though Honecker set out to make the all-
around strengthening of the socialist state an official priority during the 1980s,[18] this
more urgent priority quickly eroded decades of collective indoctrination. It brought
new hope—but also new trepidation.

137

We live by the glimmer—
may it last as long as the earth turns.

CHRISTA WOLF, *Accident: A Day's News*

<div style="writing-mode: vertical">Chapter Nine</div>

DISSOLUTION

In spite of the tremendous surge in output, much of the photography produced during the 1980s remained radical in its ideological commitment. "Socialism is a public matter," wrote Karl Max Kober in 1987. "It is not a natural state, but rather it must be continually renewed for each generation."[1] Exhibitions with titles such as *Simple Peace (Der einfache Frieden)* marketed a carefully edited fantasy scenario of socialist life, oblivious to the cultural and economic climate of ennui.[2] Socialist photography, as a whole, was still stymied by definition: it precluded originality.

Ulrich Burchert, who had already made a name for himself in the 1970s as one of the most conservative photographers, weighed in as a notable representative of the 1980s. He continued to manufacture archtraditional worker portraits, exemplary of the prevailing faith in the power of appearances, but his artistic statements grew more deliberate and his concerns became more clearly articulated. Burchert now presented his work as an exploration of "simultaneous reality," by which he meant that each image could be read for both its ostensible content—the worker in the present—and its symbolic meaning—the worker as a signifier of the collective human potential (fig. 56). He called it "a new combination of artistic vision and Marxist methodology,"[3] but one might also argue that it was an old idea in a new intellectual mantle. Nonetheless, Burchert still held the formula for success.

The Physicist Dr. P.R.
Oranienburg, 1984

ULRICH BURCHERT

Artists who followed in his footsteps developed inventive explanations for their re-actionary style. Eberhard Klöppel, for example, called his photographs an appeal to "a worldwide coalition of reason"; Günter Krawutschke sought to translate his own so-cialist orientation into "images of societal interrelationships"; and Bernd Horst Sefzig simply aimed to "abstract the idea of work."[4] There were many others, but all of them more or less followed the official drummer. The work may be fascinating as a histor-ical curiosity, but it remains largely undistinctive.

Not all wholly ideological photographers created pat formulas, however. A few pen-etrated the human psyche more deeply than ever before, imbuing traditional themes with a new context and meaning. When Günter Bersch photographed the costumed worker actor Siegbert Richter against a wall filled with socialist memorabilia, he vi-olated no official rules, but the image is given a multivalent edge as the lachrymose clown poses directly below a "worker portrait" (fig. 57). Similarly, Bersch showed the worker veteran Robert Büchner not as a fulfilled citizen but as a woefully broken-down old man given to bitter introspection, with the blowing curtain a diaphanous evocation of life's memory at a time of impending death (fig. 58).

Although Bersch was quick to pledge his allegiance to the socialist mainstream—he was known for a self-portrait in which his face is superimposed on a newspaper headline that reads, "Socialism is for all and needs all"—his photographs often seem to isolate the dilemma it created for the individual. Was he feigning compliance in or-der to avoid being too closely watched, or was he seeking to improve socialist pho-tography? In any case, he was a man who had learned to survive.

Of equal acumen are the photographs by Hans-Wulf Kunze, intended as "vi-gnettes exemplifying the social issues that relate to the communal life of working people."[5] His photograph of a foundry worker resting on a lorry—taken as part of a graduate project at the HGB—contains all the regulation symbols of productive in-vincibility: helmet, goggles, overalls, and smudgy face (fig. 59). But even though the centrally placed worker dominates his environment, he remains oddly unheroic. His vulnerable eyes betray a reticence; he appears to be wearing a mask. Through a gentle yet persistent clarity of composition—reminiscent of August Sander, although Kunze denies that influence[6]—the artist managed to isolate the mournful face shining out

142

Siegbert Richter,
Worker Actor,
Tetlow, 1984

57

58

Robert Büchner,
Worker Veteran,
East Berlin, 1985

Foundry Worker,
Magdeburg, 1982

59

60

Induction,
Halberstadt, 1987

from darkness. We feel confronted by an authentic human being who, far from affirming the socialist work ethic, has been made into a powerless object against his will. Knowingly or not, Kunze used the traditional socialist subject and made it his own.

An equally felicitous photograph is *Induction,* where the tonal values are exactly reversed: instead of a light face against a dark background, we see a black figure against a predominantly light background (fig. 60). But the subject—a thin boy lost in a bulky army coat that he is trying on for size—is equally pathetic. We can taste the crisp morning air and sense the end of privacy; we vicariously experience the paradoxical relationship between personal need and history's authority to wage war in the name of peace. Kunze's later images were presented as mere abstractions of work. Yet the stooped bodies he shows grasping in the dark or perspiring in toil against a rigid grid of walls not only are stripped of all socialist glory, they seem transported back to the exploitation of nineteenth-century sweatshops (fig. 61).

It should come as no surprise that Kunze's teacher at the HGB, Helfried Strauß, also flouted the positivist mandate with his reconceived worker. Already in the 1970s he had depicted three women under an oversized portrait of Lenin in a manner that leaves the viewer with an undeniably Orwellian chill (fig. 62), and his 1984 photograph of a traditional May Day celebration goes even farther (fig. 63). Unlike Arno Fischer, who had shown May Day spectators as isolated entities (see fig. 30), or Ursula Arnolds, who had derided the participants as an odd little troupe (see fig. 28), Strauß holds the viewer safely above the turbulence. In the tradition of Alexander Rodchenko's high-elevation perspective, strong diagonals build tension, which is then balanced by the floating ovals of the umbrellas and faces. All flags but one are pointed in the same direction; all but one are stretched out in the breeze. The one exception forms a limp, dark, and soggy pinnacle over the worried man's head, like an arrow pointing to heaven. Detached from the main event, it seems to be going against the flow—but it cannot escape the current that carries it.

In the late 1960s and early 1970s Strauß had been a student at the HGB himself, and although he mostly photographed people, his subjects were wide-ranging. An ardent observer of Cartier-Bresson, he had learned that there are no tired themes in photography. Like Bersch and Kunze, he moved beyond the literal interpretation of the socialist workday, and in so doing helped forge a truly confrontational frontier.

145

Fish industry
workers,
Magdeburg, 1989

HANS-WULF KUNZE

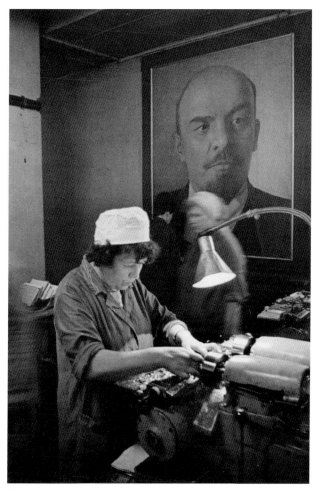

62

Untitled, from
People of Moscow,
1969–1973

May Day,
East Berlin, 1984

HELFRIED STRAUß

Not as probing, perhaps, but equally fascinating are the photographs of Wolfgang Gregor, who like Kunze graduated from the HGB in the early 1980s. His series on people from Berlin factories and garden clubs comprised worker portraits as dialectic expressions of work and pleasure.[7] The portrayal of those at work, however, evokes nothing short of exhaustion or, at best, deadly boredom (fig. 64). Gregor seems to imply that only on weekends—when the workers engage in their leisure—do they begin to live in earnest (fig. 65). Their clothes are neatly pressed, their hair is carefully styled—so it must be Sunday. The vintage commercial signs decorating the ramshackle restrooms that form the backdrop to a dance speak of "high quality." Ritualistic evocation of pleasure, we discover, is a tonic still capable of transcending all limitations.

Although on the whole the compositions of Kunze, Strauß, and Gregor are balanced, they also betray a more deliberate adaptation of Robert Frank's snapshot aesthetic, as it had been introduced by Arno Fischer. But Gregor, by simulating a more lighthearted, insiders' point of view, also imbued ordinary life with a candid immediacy that opened up entirely different possibilities of perception.

149

The same could be said of Harf Zimmermann when he immortalized the collective aura of a civilian defense team whose members had donned gas masks (fig. 66). Civilian defense was a very visible part of East German culture. Every factory had organized fighter groups culled from the worker brigades, and all university students were required to sign up for various civil training programs for a minimum of one year—in addition to their regular military duty. Even in elementary school, instruction in "defense" was mandatory.[8] By showing a civilian defense team in its ultimate state of conformity—where even sexual differences can be deduced only by a few joined hands—Zimmermann created an image of the collective that clearly goes beyond mere documentation into the realm of parody.

Equally deft, though without the same acid humor, are Erasmus Schröter's images taken with infrared film in the dark without flash, catching ordinary citizens floating off guard in their worried space like blurry fish in the deep sea (fig. 67). Man Ray once said that to master all the potentials of a medium, one had to learn to despise it a little. That is what happened here. As East German photographers learned to reject the camera as a rigid medium for perfecting society, they began to discover a world in flux.

64

Narva, from
Work and Leisure,
East Berlin, 1984

Garden Club, from
Work and Leisure,
East Berlin, 1980

Untitled,
from *Civil Defense,*
Glowe, Rügen,
1985 (Ostkreuz)

HARF ZIMMERMANN

67

Three Men,
Leipzig, 1981

What is it, this coming to oneself?

JOHANNES R. BECHER,
quoted by Christa Wolf,
The Quest for Christa T.

Chapter Ten

**BEYOND
IDEOLOGY**

156 Since 1958, when the Kulturbund officially espoused so-called objective realism in
photography, it had been acceptable to depict the disadvantaged. While such subjects
compromised socialist optimism, they asserted that the elimination of social injustice
was an ongoing process. But until the 1980s no one had ever portrayed weakness
merely for its own sake.

One of the artists who freed herself from the routine imperatives to venture into this
uncharted territory—almost to a point of obsession—was Karin Wieckhorst. She
photographed disabled people. Her style, her desire to transmit reality as accurately as
possible, and her preference for sequential images were firmly rooted in the anti-
aesthetic documentation of Gruppe Jugendfoto Berlin, but now the conceptual nature
was moving to the forefront, and the subjects were rendered with greater emotionality.

In a photo essay on a man named Siegmar Schulze, which was a part of a larger se-
ries titled *Disabled,* Wieckhorst captured vignettes from the life of a paraplegic who
was injured in a diving accident in 1964, monumentalizing otherwise banal activities
like sitting up, taking a bath, or getting down a flight of stairs (figs. 68 and 69).[1]
Wieckhorst allowed Schulze to write his own story to accompany the images, so that
he himself became directly involved in the creative process. This collaboration af-
forded an intimate dimension, giving the viewer the opportunity to see the world
through the victim's eyes and get inside his skin.

Untitled, from
Disabled, 1985

KARIN WIECKHORST

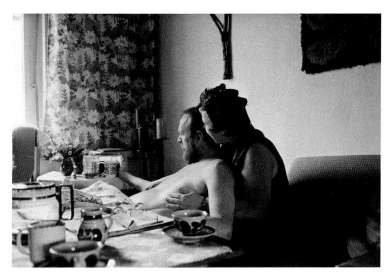

68

69

Untitled, from
Disabled, 1985

KARIN WIECKHORST

Schulze was an early manifestation of the antihero in East German photography: he is essentially unproductive and thus incapable of embodying the virtues of socialism. Struggling alongside the sterile backyard fence that separates him from the billowing wheat field beyond (fig. 70), he becomes a testament to an indifferent destiny—a completely unfamiliar worldview in the GDR. Still, Wieckhorst managed to buffer her painful observation with hope. At the end of the photo essay we learn that after almost twenty years of moving from one state hospital to another—which also demonstrates how the state cares for its people—Schulze has at last fallen in love. He and his nurse are about to get married and live happily ever after. Perseverance is shown to overcome all obstacles.

Renate Zeun took Wieckhorst's anti-ideological humanism all the way to its bitter and irrevocable conclusion. Here no redemption is offered. Her work explores sequentially the deteriorating health of terminal cancer patients at various state hospitals. The subject was important to Zeun for two reasons. More than sixty thousand new cases of cancer were reported in the GDR each year—one of the highest rates in all of Europe, considering the size of the population. But more important, the artist herself had suffered from this dread disease; she could speak with greater existential authority. In 1983, while studying at the HGB, she began to create a visual expression of her illness, and although the work was initially intended for other victims, it ended up as a book in 1986, titled *Afflicted* (fig. 71).[2] After that she began to explore the plight of others— women of all ages who were learning to exchange hope for a moment without pain.

159

Etherealized through the predominately white hospital environment, the carefully edited sequences focus on faces filled with anxiety and intermittent hope, interspersed with close-ups of the mutilations and personal details, such as reading glasses, a cup, family photos—items that make the patient at once specific and universal (fig. 72). Together with the artist the viewer descends deeper and deeper into the lonely realm of the dying, connected to life by the thin thread of the intravenous tube. Eventually we see only a clean white towel hanging from a heating pipe. The room feels intensely empty, as the viewer is left with the cold and savage pain of final solitude.[3]

Like Wieckhorst, Zeun was indebted to Uwe Steinberg's sequential model, but instead of recording the normalcy of life in a nonconfrontational manner, she ended up

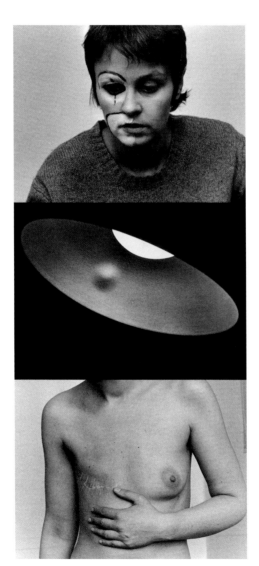

Untitled, from
*Afflicted: Pictures
from My Illness,*
ca. 1984

71

RENATE ZEUN

Untitled, from
Station Five,
ca. 1986

Untitled, from
Hospital Fragments,
1984

KLAUS ELLE

73

74

rattling all basic sense of security. While it is questionable if such images could live up to the artist's original intent of providing comfort to the dying, the very premise reveals a lingering need to justify creativity in terms of a greater purpose.

Such was clearly not the case with Klaus Elle, however. In 1984 he combined the socially conscious approaches of Wieckhorst and Zeun to portray impairment in yet another manner: he photographed his own stay at a hospital while recuperating from an undisclosed illness, capturing his experience from the bedside, literally (figs. 73 and 74).[4] Like Wieckhorst's, his images were augmented by text, but here the text was his own. The extreme autobiographical approach not only provides an intimate view of the hospital experience, it also creates a highly subjective worm's-eye view of the world as seen from a recumbent position.

Elle was a complex artist. In the late 1970s he had collaborated with others at the HGB on what came to be known as the country's first photographic process art.[5] In an attempt to explore the unconscious, he engaged in a kind of psychic automatism by painting over X-ray photos and photographic self-portraits, apparently eluding censorship by presenting the work as therapy rather than photographic art. The hospital series can be regarded in a similar light.

163

Intimacy also underlies the work of Ulrich Wüst, the bulk of which appears at first to be objective architectural documentation. Undoubtedly influenced by his studies of city planning in the early 1970s, this self-taught photographer began by simply recording buildings and streets—amassing a vast arsenal of factual information. But gradually he gravitated toward greater subjectivity, allowing his own sensibilities to come to the fore.[6] In the words of Ullrich Wallenburg, "his images were coined by a profound sense of seriousness and authenticity."[7]

Wüst wrote little about his work, but he explained that he wanted to trace the changing times and living conditions through the changing styles of architecture, in order to test, confirm, and question knowledge about the past and the present.[8] While this purpose again reflects a desire—or a need—to justify the work in terms of humanistic value, Wüst's images also came to epitomize the formal quality of socialist urbanity. Unlike Richter, who had put architectural repetition to a pugnacious end (see fig. 23), Wüst constructed modernist grids of the worker environment (figs. 75 and

76). But the most powerful of Wüst's images transcended formal issues to become hauntingly surreal, with the model socialist environment frozen under the lurking spell of an unseen presence (fig. 77). In a portrait permeated with a De Chirico–like stillness—in spite of the people seen walking in the distance—the stone figures grace a housing project in Rostock like guardians of the workers' temple, where stability is celebrated as the static antithesis to human nature and life.

More problematic is the work of Helga Paris, which at first glance simply affirms the old "worker-as-economic-unit" cliché, through interminable shots of women in factories and other productive environments. In the vein of Christian Borchert or Ulrich Burchert, the artist seems bent on recapitulating for the viewers—and the censors—what everybody has already been shown ad nauseam. But as Ulf Erdmann Ziegler points out, this may have been a deliberate strategy to make the unbearable even more unbearable, to invoke the conscious sensation of painful boredom.[9] In this light her work marks the beginning of turning the medium back on itself.

Most of Paris's photographic training came through her menial job at a photo lab and from taking pictures of her children—a background symptomatic of the break-down of barriers between institutionalized male-oriented journalistic photography and photography as a means for individual artistic expression. The portraits she made in her working-class neighborhood, Prenzlauer Berg, in Berlin—where many artists took advantage of inexpensive lodging—were undoubtedly influenced by Arno Fischer, who was a friend. But she preferred a more direct, frontal approach, in which technical finesse was subordinate to an atmosphere of trust, as she described it, between the subject and the artist.[10] Paris professed a dislike for using the camera as a tool for merciless probing, insisting that mutual respect and an engaging relationship between photographer and sitter can be the only possible basis for a meaningful transfer of vital personal information.

But even if photography were indeed mutual instead of voyeuristic, most of us, given the choice, would still prefer to be photographed in a flattering, and therefore dishonest and superficial, way—one that leaves out the hidden, and often more fascinating, contradictions. Those who believed Paris was emulating August Sander ignored the fact that his photographs were hardly the result of a gentle dialogue, that his eye was like a scalpel, prying from the sitters what they themselves often failed to realize.

164

Untitled, from
City Views, East
Berlin, 1982

ULRICH WÜST

75

76

Untitled, from *City
Views,* Rostock, 1982

ULRICH WÜST

More successful are Paris's candid images, where spontaneity saves the moment. There is a wonderful shot of three workmen, for example, caught sharing good laughs over a beer (fig. 78). Although one is barely in the frame and another is blurred, the image defines the very essence of their personalities. We have seen them before, with their obligatory beer mugs; we can almost smell the cozy tavern. Yet this kind of moment—which Robert Frank called the in-between moment, or disequilibrium—imparts fresh nuance.

The work for which Paris became best known in the 1980s is a series on the city of Halle, completed between 1983 and 1985, titled *Houses and Faces*. She wanted to photograph the city as though she had never been there, focusing arbitrarily on the ordinary conditions of life as she found it, with honesty and without personal judgment.[11] Like many of her predecessors since Arno Fischer, she sought "absolute truth."

A community of close to 230,000 inhabitants, Halle was described in an East German encyclopedia as the biggest industrial center of the country, noted for its progressive socialist urban planning. But Paris's attempt at an unbiased portrayal of this once-beautiful medieval town, where ruins were beginning to outnumber buildings—even though only two bombs had fallen there during the war—turned out to be as confrontational as it was unprecedented. Because of the scandal it created, her 1986 exhibition in Halle was canceled and the catalogue destroyed. Paris must be credited for her courage—for wanting to call the shots on the official definition of "objectivity." That was her strength.

In his foreword to the catalogue, Helmut Brade described a city that was gray, where the air was foul and the river dark, and where "the faces of the people have different furrows, different expressions."[12] As the GDR was palpably on the wane, many who wrote on photography joined the chorus praising Paris's courage to take on the sacred cow—to push the limits and open a compelling new window on reality. History was being made, or so it seemed. Soon others arrived in Halle, aspiring to similar achievements.

It is puzzling, then, that the actual images tell a rather different story. Yes, the city appears coated with a heavy patina of neglect, but no more so than the cities photographed by others—such as Ulrich Wüst—whose work passed the censors without a stir. And of the fifty-six reproductions in the catalogue, only one could be safely

167

Untitled,
n.p., ca. 1975

HELGA PARIS

categorized as a ruin. What the viewer beholds is not ubiquitous decay but a benign and rather picturesque oasis of enviable peace that has resisted the rush of the late twentieth century (figs. 79 and 80).

So perhaps it was the text to which the censors responded. Brade's words might have opened their eyes, by explaining unequivocally what they should see. It had become common knowledge by the 1980s that almost anything was acceptable in photography, as long as it could be placed within a constructive socialist context. Honecker's art policy with regard to broad and varied subject matter was precisely about context, and accompanying photographs with politically correct rhetoric had become routine since *Medium Fotografie*. Paris and Brade must have been aware of this too. The few positive statements in the catalogue—such as "one thing is certain, the standard of living has never been so high," and "her images are full of hope"—could hardly mitigate comments that seemed calculated to inflame.

In this light, Paris's images of a winding street with run-down but still delicately textured buildings are no longer merely routine; they become wrought with melancholy as a graphic metaphor for relentless loss. A portrait of a street becomes a portrait of a nation: scarred, used-up, at the brink of extinction. In another part of town, a woman dressed in black holds a small key as she poses expressionlessly in front of a parish door (fig. 81). There is still a trace of beauty in her eyes, but it is glazed over with chronic fatigue. Paris indeed addressed what everybody knew, only now it was being made into an issue. The affair was indicative of the attitude that marked the countdown.

169

Helga Paris warrants a comparison to Konstanze Göbel, who also photographed Halle. Having developed in the emerging field of commercial photography, where she specialized in graphic posters, she gained an appreciation for design, and even when she branched out into other directions her style remained simple yet powerfully direct in its ability to attract the eye. Her project on Halle, where she actually lived, was sponsored by the city council as a rebuttal to Paris's unappreciated oeuvre. She managed to get paid in advance to document tangible urban renewal but soon found herself caught up in an emotional quandary: urban renewal in Halle, she discovered,

79

Große Ulrichstraße,
from *Houses and
Faces,* Halle/Saale,
ca. 1984

Mühlberg, from
Houses and Faces,
Halle/Saale, ca. 1984

80

Untitled, from
Houses and Faces,
Halle/Saale, ca. 1984

Große Wallstraße,
Halle/Saale, 1987

82

Geiststraße,
Halle/Saale, 1988

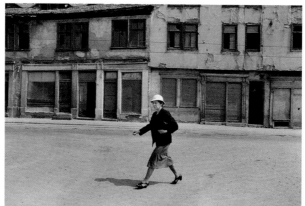

83

Geiststraße,
Halle/Saale, 1988

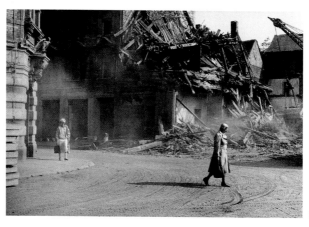

84

was a misnomer.[13] In the end, Göbel's images were far less sanguine than Paris's, and they spoke with greater force.

An old couple is seen walking away from their house of over thirty years, as it collapses under the wrecking ball (fig. 82). Only yesterday, the wife sobbed to Göbel, she was washing dishes in her kitchen sink. Nearby, a well-dressed woman's elegant stride is an anachronism on the stage of derelict facades, interminably lingering on the "slated for demolition" list (fig. 83). Everywhere Göbel turned she found crumbling architecture, groaning in its agony or succumbing with a roar (fig. 84). What the war had spared was now in the death-grip of socialist peace.

Whereas Paris maintained a polite and often generic distance, Göbel threw herself into her subject with a critical vengeance that was assured to set the record straight once and for all. She helped break the real taboos in photography, turning Honecker's politics of *Abgrenzung,* or "sealing off," into nothing short of *Entgrenzung,* or "breaking of all bounds." Intimidation had kindled imagination.

173

Least of all with my feet
do I walk this land.
With my fingertips
I brush along the sky
until I float, quietly, above everything
that still feels the cool wind.

SONJA SCHÜLER,
Zwischen Donnerstag und März

Chapter Eleven

PLURALISM

The 1980s brought profound compromises for the GDR, beginning with the historic meeting of Honecker with West German chancellor Helmut Schmidt in 1981, in an effort to block further covert deployment of U.S. and Soviet nuclear missiles on German soil. This meeting initiated an unprecedented involvement between the two Germanys in forging joint solutions, independent of the squabble between Washington and Moscow. With it came the inevitable need to officially acknowledge and reassess all of German history. Although Honecker continued to insist on an independent national identity for the GDR, the common roots of the two countries could no longer be denied.

Thus, in 1983 Martin Luther—who had been lambasted in the GDR as the first in a long line of German despots—was rehabilitated for the five hundredth anniversary of his birth. Bach and Händel were brought back as well. Even Karl May, the popular Saxon adventure writer who had been dismissed as a colonialist and a racist, was redeemed as a pacifist of proletarian birth.[1] The most stunning gesture, perhaps, was the restoration of the equestrian statue of the eighteenth-century Prussian soldier king, Frederick II, to its prominent position on Unter den Linden in East Berlin, facing the site of the Royal Palace, which had been razed by Ulbricht in the early 1950s. But apart from being a fierce imperialist, "der Alte Fritz" (Old Fritz)—as Frederick

came to be nicknamed—had also fostered the Enlightenment, with its emphasis on individual freedom. How could such a memory be reconciled with a country that continued to hold its own people hostage?

These changes preceded Gorbachev and *glasnost,* while Soviet influence remained unchallenged. They came suddenly, making it difficult to keep up. Heads were spinning. The possibilities seemed endless, but this also gave rise to an ever greater awareness of what was still out of reach. After decades of stagnation, time was beginning to speed up. Life in the GDR would never be simple again.

To varying degrees photographers broadened their elitist interpretation of the socialist conscience to include amorality. They began to address in earnest the dizzying complexity of existence, with little concern for any preconceived "higher meaning." Photography on the whole thus became more truly objective. But since all experience hinges on individual perception, it also became more truly subjective. Photographers reflected the change as much as they fueled it.

177

One of these artists who gave up judgment for the sheer joy of exploration was Tina Bara. She wanted to study the ordinary emotions of ordinary women and then record the various manifestations—tender, hopeful, timid, vulnerable, and so on.[2] Her nudes were consciously devoid of the prettiness seen in the work of Günter Rössler. Although she retained the standard socialist practice of titling each photograph by the name and profession of its subject—after 1989 she would refer to those works as "untitled"—she was less concerned with *what* they were than *who* they were. She wanted to address the intimate persona (fig. 85).

The subjects Bara probed were friends and acquaintances in Leipzig. She developed a style marked by forceful cropping, dramatic lighting, and sometimes even calculated backgrounds. Ulrike Stöhring saw Bara's work as a "visual portrayal of the association between face and body, spirit and flesh"; to Karin Thomas it was an expression of the artist's own feelings about life. Peter Lang, on the other hand, viewed it as a dialogue between the individual and society during the arduous process of personality development—as an attempt to "resolve the dissonance between the anonymous city and the human being."[3] But Lang also found the work tainted by

Untitled, West
Berlin, 1989

TINA BARA

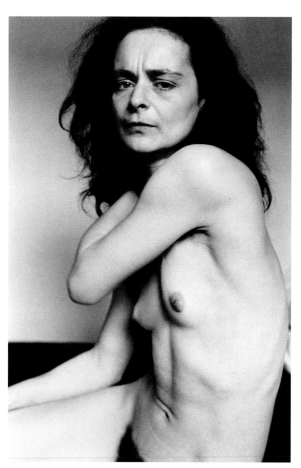

85

posed romanticism, which, he believed, ran the risk of stylization and thus loss of "reality." Although the 1980s saw the timid departure from advocacy in art interpretation, officially documentary realism remained the sole measure of value.

Bara's photographs were clearly intended to work on various levels, and, like Renate Zeun's, they can also be seen as feminist art. This is especially true of her series on women who, like herself, had resettled in West Berlin (figs. 86 and 87).[4] In photographs closely cropped to isolate the eyes, these women face the camera with a variety of sometimes contradictory emotions, but all of them, starting over again in an alien yet also strangely familiar culture, share an air of irrefutable determination to define themselves independently of society's expectations. They exist by themselves and by their own power—without men.

Eva Mahn was in a similar situation, although she remained in the east. In the deteriorating architecture of Halle—where she had lived since 1972—she discovered a means of transporting her desperate struggle into the visible world: architectural loss served as a backdrop for her own damaged psyche. Her images, many taken in the spring and summer of 1989, were staged with a deliberate sense of theatricality (fig. 88). But while the specific subject varied, in the end they are all about her own inability to reconcile herself to change.

The man with whom Mahn had shared twelve years had just escaped to the West, leaving everything and everyone behind. Her self-portrait, taken shortly thereafter on their disheveled bed—before a painting that doubles as a crown of thorns and sparks of fury—became the landscape of her heart (fig. 89). Less expressionist but equally succinct is a photograph of a brick fire wall that retains the mummified imprints of two former buildings: one is large and square, the other small and decoratively pointed—with a white patch of surrender remaining in an area that might be designated as the heart (fig. 90). An empty lot in Halle—where once two solid houses stood side by side—came to depict the homelessness of the artist's spirit and, on a larger scale, the impending death of the nation.

Ute Mahler never had to wrestle with such personal trauma. If anything, she was perhaps too securely married; she could afford the luxury of stepping away from herself. During the late 1970s, she had eked out a living as a fashion photographer for *Sibylle*

179

Untitled, West
Berlin, 1988

86

87

*Conni amid
Demolition,*
Halle/Saale, 1989

89

Self-Portrait,
Halle/Saale, 1989

magazine, and her idol, she said, was Irvin Penn.[5] In the early 1980s—with the encouragement of Arno Fischer, who was her mentor at the HGB—she began to photograph people in the privacy of their own homes, attempting to discover, as she put it, "the inner life of those only known by their faces."[6] The project, which spanned a number of years, evolved into a series titled *Living Together,* where she explored the relationships of married couples, mates, roommates, siblings, extended family, and even pets. It was a safe but also rather appropriate subject, as shared living quarters remained an omnipresent phenomenon. Despite the dwindling population, housing was disappearing through rampant neglect.

Mahler granted a fascinating unofficial glimpse into East German domesticity. Even though she tended to focus on harmonious group experiences, they often were removed from collective aspiration. Beyond the predictable model family unit portrayed by Christian Borchert (see fig. 42), Mahler's cohabitants remained intensely intimate, intriguingly enigmatic, and sometimes downright peculiar (figs. 91 and 92). Despite her traditional horizontal format, which allowed for emphasis on the subjects' surroundings, the guiding light of Irvin Penn (itself ignited by August Sander) was often evident in her formal distribution of the figures in space, against the simplified yet telling backgrounds that create a sense of reality intertwined with unreality. She cultivated an instinct for arresting a certain nuance, allowing each image—in spite of the serial format and strong documentary flavor—to stand on its own.[7] In a shot of four children, for example, a rope and one boy's arm make a tent shape over the other two (fig. 93). The image is an actual flicker in time, yet all the components meld together flawlessly. Regardless of whether these children are siblings or only sharing the same living space, the relationship of the four becomes magical, without appearing artificial.

In deference to Irvin Penn, perhaps, who was known for his lengthy preparatory exercises, Mahler tried to spend as much time as possible with her subjects prior to the shoot. She wanted to know them well.[8] This practice filled her work with an intimate tension and allowed her to penetrate the surface, to reveal, as Wolfgang Kil observed, both permanence and the fleeting moment.[9]

Whereas *Living Together* had a decidedly documentary component, a later series, titled *Men*, is more biased. Here Mahler deliberately manipulated the conventional perception of reality to make a rather unorthodox statement about masculinity

184

UTE MAHLER

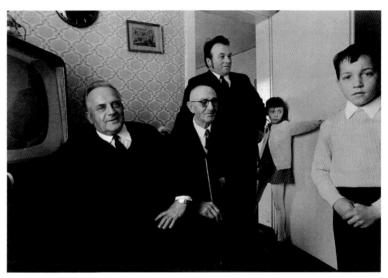

91

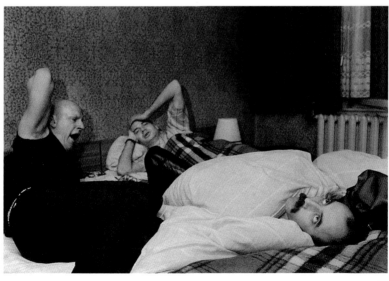

92

Untitled, from
Living Together, n.p.,
ca. 1981 (Ostkreuz)

UTE MAHLER

(figs. 94 and 95). The men she photographed are all very different from one another in both appearance and age, but somehow they share a common bond. They appear pensive, sensitive, and even vulnerable. All of them gaze deeply into the camera, with softly modeled faces and deemphasized physicality; only the architectural backgrounds—brick walls, square tiles—hint at the mathematical, gridlike hardness associated with "traditional maleness." But here, rather than augmenting the masculinity of the subjects, these forms only draw attention to their sensitivity. These men, it seems, are vulnerable not in spite of the fact that they are men but precisely because they are men.

Mahler had now come full circle, returning to what must be considered a somewhat idealized "higher reality," not exactly based on statistical fact. But now, as the nation was beginning to define itself in sexual terms (seduced, to a great extent, by the values of Western sitcoms), this reality was an expression of the artist's personal vision, divorced from all ideological polemics. It represented a startling departure from the sober lifestyle mandated by the politburo, but it also augmented the national schizophrenia. The GDR had been so excruciatingly homogeneous that there were jokes about the three classes: the lower-lower class, the middle-lower class, and the upper-lower class. But suddenly a massive tension was felt, pulling toward opposite extremes like a giant rubber band. Mahler, it must be remembered, was working at the same time as Ulrich Burchert, and both were cut from the same socialist cloth. Neither had ever experienced anything else.

Ute Mahler's husband, Werner Mahler, strove for a different yet equally unprecedented definition of gender. Undoubtedly inspired by his wife, he took the opposite approach, photographing beauty pageants and female bodybuilders. Both were a new phenomenon in the GDR as well. Werner Mahler had been a landscape photographer (by the 1980s the genre was respectable once again), producing images where the formal asymmetry of nature, at times juxtaposed with manmade objects, resonated with eternal harmony and poise (figs. 96 and 97). Only in 1986 did he begin to record public events—starting with the first beauty pageant held in Berlin-Mahrzahn. That occasion changed his life.

Werner Mahler's images communicated none of the frilly coyness associated with such pageants in the West; instead, he shows contestants strutting in an almost bawdy,

187

Untitled,
from *Men,* n.p.,
ca. 1986 (Ostkreuz)

94

95

*On the Way to
Hiddensee,* 1985
(Ostkreuz)

96

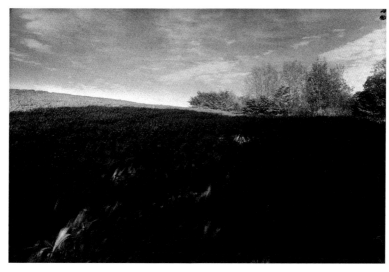

Baltic Coast,
1977 (Ostkreuz)

97

burlesque manner, prompting various responses from the audience (fig. 98). Wolfgang Kil believed that the artist wanted to capture the artificiality and self-exposure not only of the contestants but also of the audience.[10] The social conscience was perhaps still softly knocking on Mahler's door, but regardless of whether he was reacting, over-reacting, overcompensating, or merely trying to convey an indigenous flavor, his work opened new perspectives for consideration.

If Mahler's beauty pageant series seemed like a caricature of traditional femininity, his series on female bodybuilders reached another plateau (figs. 99 and 100). Homing in on sinuous muscles, straining veins, flexing abdomens, rippled breasts, and shaved crotches, he fabricated a tribute to self-centered determination that was not easily in-tegrated into the socialist maelstrom. An almost bitter rebuttal to the soft surrender elicited in his landscapes, Mahler's later work was symptomatic of the growing di-versity in society, emerging in tandem with a need for self-exposure. It was part of the multiperceptional pluralism of the postmodernist age drifting in through the iron curtain and made site-specific. Mahler's bodybuilder photographs resemble Robert Mapplethorpe's work in a similar vein, but for that very reason they also lack any sense of depravity. Mapplethorpe came from the extreme spectrum of the New York gay scene—the world of Andy Warhol and impersonal sex—but Mahler simply pre-sented a release from being deprived. His photographs emanated from an almost childlike curiosity and a desire to explore the world with wonder.

A similar innocence permeated the work of Christiane Eisler, which Gabriele Muschter described as marked by "longings, dreams, and private moments."[11] Like most photographers of the 1980s, Eisler worked in a serial format, and during the early part of the decade she focused on trains, fairgrounds, and what she called eco-logically oriented landscapes and portraits. But eventually she found multiplicity within single subjects. She became known for a series on young people close to her own age, whose lives she followed over a number of years in an attempt to explore how they changed—how their various conflicts were manifested and resolved. The series started as a graduation project at the HGB, where she had studied under Eve-lyn Richter. Inevitably, of course, it became a path for self-discovery.[12] Eisler explained

Beauty Pageant,
Berlin-Mahrzahn,
1986 (Ostkreuz)

WERNER MAHLER

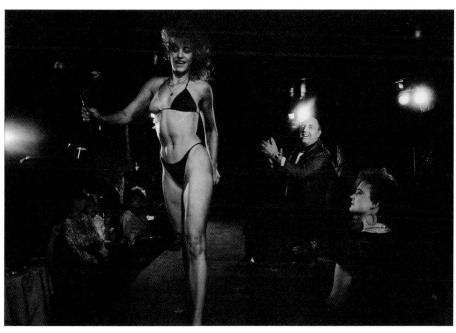

Untitled, from
*Female Body-Building
Contest,* East Berlin,
1988 (Ostkreuz)

WERNER MAHLER

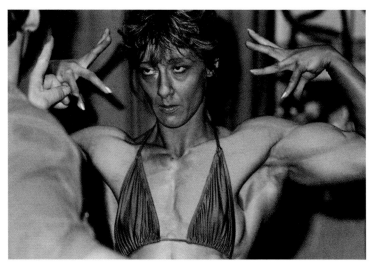

99

100

that she found herself confronting problems and situations close to her own realm of experience;[13] she came to view her subjects through the prism of her personal history.

One issue all young people grappled with—especially after the mid-1980s—was whether to stay in the GDR or make a run for it. Although the government had accepted applications for emigration since 1975—when Honecker signed the Helsinki Final Act—until the mid-eighties the requests were rarely granted, and border guards continued to shoot at those who attempted to escape. But early in 1984—yielding to pressure from West Germany, whose loans had become an indispensable fix—an estimated backlog of 500,000 applications was suddenly processed, prompting a sharp rise in departures.[14] Of course that only aggravated the economic problems, and consequently emigrants were treated like pariahs to be banished. New applicants were routinely made to wait—sometimes for years—and then forced to leave with no more than twenty-four hours' notice. This situation contributed to the unique flavor of the time and place. Who was waiting and wondering? Who would be left? Tina Bara had captured some of this sensation in the women she photographed in West Berlin, even though her portraits were after the fact. Eisler took the theme further. She used a "before and after" approach, illustrating the changes through diptychs.

A dreamy-eyed teenager named Chaos, for instance, is first shown in his cramped apartment in Leipzig in 1984, where a saying posted over the door behind him reads, "It is later than you think" (fig. 101). He is then photographed in 1989 in West Berlin, seated next to his new companion in his sleek apartment, exuding an aura of unmitigated self-confidence. He has even gained some weight. Eisler, it seems, was revealing the process of achievement, of becoming a person and making it on one's own and against all odds, yet those who stayed behind often saw it differently. Gabriele Muschter interpreted this sequence as a story of loss and compromise. She saw the coolness of the new environment as evidence of the high price paid for giving up a familiar lifestyle and friends.[15]

Similarly, images of leather-clad, wild-haired punkers, photographed later as doting, bourgeois parents, were seen by Muschter as a testament to the ultimate similarity between generations (fig. 102).[16] It was well known among artists, however, that photographs of punkers could not be shown at Galerie P in Leipzig—where Eisler

193

Chaos, Lead Singer
of Wutanfall
["Fit of Rage"],
Leipzig, 1984, and
West Berlin, 1989

Heike, Leipzig,
1983 and 1986

Stefan, Leipzig,
1983 and 1988

CHRISTIANE EISLER

had an exhibition in 1986—unless accompanied by an image of reform.[17] The growing visibility of the punk phenomenon—so out of context in the GDR—could no longer be ignored, but it would not be acknowledged either.

The most troubling diptych is of Stefan, who first held the viewer in his serious gaze, while he himself appeared to be holding on to a shadow on the wall (fig. 103). That was in 1983. Five years later a shimmering wreath marked the spot in the war memorial near Halle where Stefan had snuffed out his own life. There was nothing heroic about his death. It brought a senseless end to the promise of his youth.

The many changes that had swept over the country by the middle of the decade triggered not only tragic soul-searching but also mad abandon. In the late eighties the phrase "our times" came into use, reflecting a growing awareness of the impending end. Everything seemed to be happening at once; even ecological issues surfaced in no uncertain terms. Enter Manfred Butzmann.

While many photographers mined the labyrinths of their newly discovered egos, Butzmann had, since the late seventies, been using this energy to make poignant statements about environmental abuse that are easy to read without being simplistic, innovative without being contrived, and socially conscious without being moralistic. Known as a graphic artist—and thus less subject to scrutiny by the censors—Butzmann produced photographic postcards and posters that could then be mass-produced and widely distributed. Often he isolated specific concerns, and—like the "typologies" of Bernd and Hilla Becher in West Germany—he presented them in multiple images, in a gridlike arrangement that was deliberately redundant.

But whereas the Bechers made a statement about photographic perception and the mechanical nature of the medium, Butzmann used repetition to heighten the power of the individual images. Words and titles added a graphic dimension, allowing for quick recognition. For example, the words *Bürger schützt Eure Steige* (Citizens, Protect Your Sidewalks) fill the top tier of one of his posters, where twenty-eight photographs of different sidewalks show the various stages of decay caused by seemingly endless poorly planned sanitation projects (fig. 104). Anyone who ever attempted to navigate the perpetually torn-up streets of the GDR is struck by an immediate sense of déjà vu.

197

For a postcard the artist combined fifteen photographs of empty tree planters, some of them still containing sawed-off stumps, others partly covered by parked cars (fig. 105). Printed above the sequence are the words *Ein Platz für Bäume* (A Place for Trees). Again, by bringing all these diverse planters together, a disturbing pattern is revealed that surpasses the content of the individual images. In a related but different way, a series of postcards titled *Zum Beispiel* (For Example) addresses a variety of environmental aberrations that contribute to the steady decline of contemporary cities, such as graffiti, asphalting over ancient paving stones, and mutilation of architectural treasures through ruthless and mindless alterations (fig. 106).

Butzmann's art was message-oriented, something most photographers struggled to get away from. But as the medium was becoming more and more private, this artist articulated public concerns that truly served the interest of the common people. As the dream of socialism was fading, a beguiling socialist art emerged.

Citizens, Protect Your
Sidewalks, 1977

Ein Platz für Bäume

105

A Place for Trees,
1980s

zum Beispiel

1978

1980

Berlin-Pankow Schulstraße 6

For Example,
1978 and 1980

Then suddenly the years
passed, perished. My father
bought two dogs, they pushed me out
from the shelter of the kidney-shaped tabletop
over the carpet's edge.
One was victorious, one won. I saw myself,
match in hand, unlocking the garden of Eden.

SASCHA ANDERSON, "Woher, wohin"

Chapter Twelve

SECRETS AND
NATURAL STATES

204 Diane Arbus once said that a photograph is a secret about a secret.[1] But although her famous first book of photographs was known in the GDR by the 1980s, few could muster the courage or stamina to invite the same degree of contention. One who tried was Gundula Schulze. But whereas Arbus contented herself with compelling fragments of life, Schulze believed she could peel the human psyche bare and probe the meaning of human existence. This approach prompted Karin Thomas to describe her work as psychological X-rays of life.[2]

Schulze came on the scene in the late 1970s, when she was studying at the HGB. With Klaus Elle, she had participated in therapeutic art projects that turned into photographic process art,[3] but she became known through her straight photography, in which she mixed snapshot aesthetic with heroic gesture, giving her subjects importance without sacrificing spontaneity. In this she resembled Arbus, but unlike her, Schulze never progressed to a medium-size square format; in the manner of Cartier-Bresson, she stayed with 35 mm and printed full frame.

While Schulze may not have been able to explain human nature, her visceral snippets of humanity still drew notice. The series of nudes she made in the early eighties were much more confrontational than Tina Bara's from the late eighties; never ennobled through dramatic lighting or a somewhat staged sincerity, they resembled encased anthropological specimens, in which meticulous detail came to bear almost sci-

entific relevance. In the old socialist tradition the subjects were identified by name and profession, but these labels often seemed at odds with the individual depicted. Their use parodied simplistic categories.[4]

Consider the messenger, Lothar, an emaciated man sitting on the edge of his bed in his cluttered room, centrally placed to control the composition—and wearing nothing but his Scottish-plaid slippers (the *punctum;* fig. 107). Schulze recounted how this quiet little man, who worked for the Berlin subway, would show up at local pubs at lunchtime to barter old magazines for a beer.[5] Apparently he was seldom seen in anything but his mousy gray uniform, and Schulze recalled that it was rarely clean.[6] But now he is merely cloaked with the artifacts of his intimate sphere: a shelf brimming with liquor bottles, a big television set, a small picture of a nude woman, a photograph of a face curiously hung on its side, knotted extension cords draped from here to everywhere—tying all of it together into a confounding archaeological package.

We see an apparently lonely man with a far-off gaze, isolated in monotony, deluded about his physical appearance, given to alcoholism, and willing to do almost anything for attention and spare change. This interpretation was suggested by Karin Thomas, who wrote that Schulze's work was about the discrepancy between the realities of life and individual definitions of happiness.[7] She saw conflict. Schulze herself gave a similar interpretation: "Lothar imagined everything to be so simple he could not see the inequality between himself and other people."[8] But in another perspective, Lothar is an ordinary citizen with a perfectly satisfactory life. He likes booze, television, and women. His job is just a job, but at least he has one. His material needs are met. He is also willing to share a very private moment because he can accept himself. This frees him from all stifling social constraints. The only conflict is with the viewer who cannot respect him.

Equally devoid of conflict seems the luxuriously recumbent structural engineer, Regina, portrayed against a backdrop of upward mobility (fig. 108). Although her pose denotes flaunted sexuality, her gaze is not beckoning; instead it is filled with scrutinizing self-acceptance. Here, in the tradition of Manet's *Déjeuner sur l'herbe,* Schulze's nude photography again makes an intellectual statement. It defines a natural state that is misconstrued only through stereotypical modes of perception and the superficial trappings of culture. Despite its perhaps calculated shock appeal, her nude se-

205

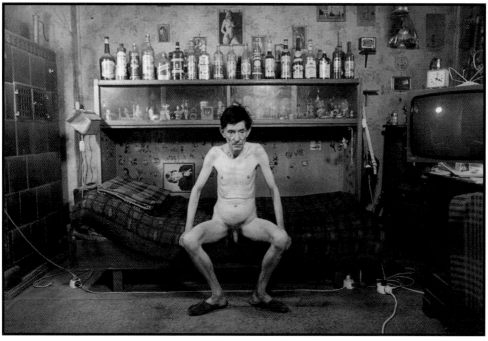

Lothar, Messenger,
East Berlin, 1983

Regina,
Structural Engineer,
Leipzig, 1984

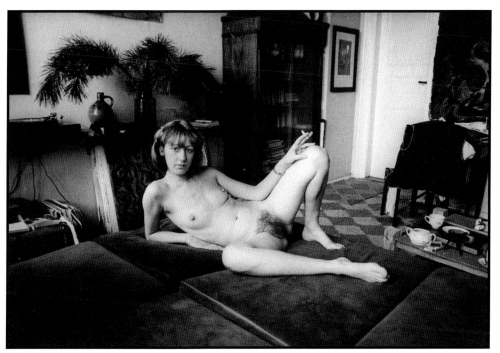

108

ries prevails as a socially conscious affirmation of life. In fact Schulze was not violating any official principles; her approach remained politically correct. She was simply updating the genre of worker portraits through ever greater directness.

Contrasting with these natural states are Schulze's color photographs of human-made "unnatural" states—scenes culled from Dresden's slaughterhouses. Schulze trained her camera on bloody animal heads and various body parts hanging on meat hooks or floating in pools of blood. Writing of the experience, she described the primordial stench of death, the screams echoing in the long, dark tunnels, the frenetic stampedes, the heavy metal doors slamming shut, the machines dragging and ripping the flesh, the bulls mounting each other, and the semen gushing at the moment of extinction.[9] But the most devastating photograph from this series is a quiet one. A fragile shorn lamb is seen waiting alone in a steel pen with its eyes closed (fig. 109). The impending death of the innocent becomes the *punctum*. We, the viewers, create the suffering and feel the mortal pain of our betrayal: a conflict indeed!

208

Schulze talked of life as endlessly moving colored dots that made up the rhythm of her pictures.[10] Although she insisted she was not an artist but a mere spectator of life,[11] at times she approached performance art, giving slide shows of her work with a pianist who played bawdy Berliner songs. She also wrote free verse for her catalogues and issued limited signed editions of her work, inaugurating the art of marketing artistic careers in East German photography. But with her slaughterhouse series she challenged the age-old presumption of human centrality in nature—an attitude she saw at the core of all oppression.[12] She made the viewer realize that only nature was real and that everything else was artificial. This notion was almost unfathomable in a culture ideologically preoccupied with machines in the service of humanity, where nature was viewed as an obstacle to be subdued and exploited.[13] Yet like Butzmann, Schulze created a truly egalitarian photography. She remained socially conscious by implicitly condemning a system that opposed all that was natural—including human idiosyncrasy.

Jörg Klaus, a protégé of Arno Fischer's, brought a different perspective to the subject of slaughterhouses when he photographed the butchers as well (figs. 110 and 111). Initially he regarded them as ordinary workers—part of the humming rhythm of productivity, in the traditional socialist view. But as he photographed them pressed

Slaughterhouse
(color photo); from
*The Little and the Big
Step,* Dresden, 1988

GUNDULA SCHULZE

Untitled, from
Slaughterhouse,
Halle/Saale, 1988

111

against the conveyor belts to keep pace with the carnage, it appeared to him that they too were transformed from living beings into inanimate objects. He decided to record the dehumanization of these blood-spattered workers who had let themselves become deadened to all pain.[14]

The subject of death fascinated Rudolf Schäfer as well, but he moved beyond notions of specific guilt or pain to evoke the ultimate fate of the viewers themselves: he photographed the dead. Schäfer was also one of the first to rediscover the large-format camera, used for greater print clarity, and he often made platinum prints, whose glowing low contrast allowed him to keep more of the mystery intact.[15]

East German photographers rarely discussed the making of a print. Although most knew how to work in a darkroom, that process was considered less critical than taking the picture. Only the content mattered. This attitude was part and parcel of the deeply rooted communication-oriented approach that took its cue from the *Family of Man* exhibition. Efforts were directed toward the most efficient representation of visual information, with the printed page as the final stage. But for Schäfer, taking and printing the photograph was one continuous process. The manipulated distribution of light and dark tones created imposing variations in the final prints, attesting to his preoccupation with mood and visual aesthetics. Although his work elicited a great measure of romanticist emotionalism, particularly in comparison with Schulze's classical tableaux, it also exuded control. And the large-format camera made it necessary for him to work slowly, with a sense of distance from the subject reminiscent of the work of nineteenth-century photographers, such as Nadar.[16]

Schäfer's fastidious printing method—which he described as a means of obtaining eternal permanence—may have been an anachronism in the GDR, yet it also reflected the government's goal to draw on the best qualities of Western culture without compromising a politically correct view of life and art. It is not surprising, therefore, that the artist spoke of wanting to defy what he called emerging consumerist attitudes, whereby art was both a deliberate and an accidental expression of glorified obsolescence. He voiced a disdain for contemporary moribund existentialism, in which vagueness and foreboding overshadowed all sensation. Through his art he wished to reestablish "traditional" values and hope.[17]

Schäfer's death portraits, *Visages de morts,* were first displayed in 1982 at the *Ninth National Art Exhibition* in Dresden (figs. 112, 113, and 114). Although short on hope, they were certainly his most sentient and thought-provoking body of work with regard to the "eternal." Schäfer's premise was that in the late twentieth century—as opposed to earlier times, when mourning was an organized and enriching ritual—nobody wants to look at the dead. They are discarded like consumer waste, he said.[18] This disturbed him, because he recognized death as the most permanent reality of human existence and believed that it should be observed with greater dignity. He wanted to rediscover death as a natural state and probe its secret anew through photography.

Voyeuristic to the core, the close-ups of old people, young people, and even children were assured to get the viewer's attention at once. Surrounded by white shrouds the faces gently glow, as though the bodies were weightless, yet the excruciating detail of the large-format camera causes them to remain firmly anchored in the realm of the living as well—with stains and strains, pores and pimples, plucked eyebrows, hairy necks, pierced ears, and freshly set curls. Although veiled by death, these faces retain a strong imprint of the individual persona.

Writing of a nineteenth-century photograph of a condemned assassin, taken shortly before his hanging, Roland Barthes commented: "He is dead and he is going to die." A photograph, he wrote, brings about "the return of the dead."[19] Like Christa Wolf's novel *The Quest for Christa T.,* Schäfer's images go back and forth between the realms of life and death. We cannot stop looking, wondering, empathizing, commiserating. "We want to know how death occurs," explained the clinical psychologist Chaytor Mason, "what would it feel like if it happened to me. . . . It's why crowds were attracted to public hangings, and why the Colosseums were built."[20] Schäfer's spiritual transfigurations become what the historian Wolfgang Kil called "challenging contemplations." External reality reveals the artist's internal vision of death.[21]

Schäfer's death portraits invite an intriguing comparison to a photograph by Helfried Strauß of a Moscow grave (fig. 115). Here the living presence of the deceased appears rising out of the earth, seemingly pondering inescapable fate, while we, the viewers, remain connected to her through our own power of thought. Schäfer's apotheosis of the worker, by contrast, comes from the actual realm of the dead, where even silence has been rendered obsolete. Despite these two distinct perspectives, each

213

Untitled, from *Visage
de mort,* early 1980s

113

114

Untitled, from
Graves, Moscow, 1987

HELFRIED STRAUß

photographer lifted the official veil of socialist hope to reveal existence as an abyss. Joining Germany's darkest romanticism with biological inevitability, these images leave us, the viewers, in the quicksand of time, the ultimate tyrant. Sacrifice and salvation become meaningless here. Collective "truth" inevitably vanishes with individual experience.

Schäfer did not think of himself as an East German artist but rather as an artist who happened to live in East Germany.[22] Nonetheless, in the 1980s his work was appreciated in the GDR for the message of social amelioration he provided by way of justification—not for its true significance. This tactic also enabled him to get away with producing catalogues of his work and archival print portfolios in leather-bound, gold-embossed cases that seduced the eye through sheer Byzantine opulence.

Another series by Schäfer, *Russian Night,* is an odd mélange of images joined for no apparent purpose, with a seemingly arbitrary selection of them tinted pink—because, as the artist later explained, Russia never turned totally red.[23] Toward the end of the decade, when critics could risk greater candor, Kil argued that the disjunctive flavor of the series should be seen not as an expression of tourist mania but as a reflection of Schäfer's extreme subjectivity and his refusal to serve the medium in the manner that East German photographers were admonished to. He saw the work as arguments, loosely presented as topics for discussion, rather than statements of opinion.[24] Indeed, since East German viewers were not expected to create their own interpretations, Schäfer's approach might be considered novel. It might also be argued, however, that the work contradicted the artist's avowed commitment to quality and eternal values and that it contributed precisely to the meaninglessness in art that he had so vehemently denounced.

217

More down-to-earth is the work of Bernd Lasdin. Having studied under Arno Fischer, Lasdin eschewed artistic grandiosity, and the secrets he wanted to explore related to the domestic life of ordinary working people. But in this modest endeavor he brought earlier objective tendencies, as manifested by photographers such as Christian Borchert, to a potent culmination. Although he used the traditional horizontal format for his series *This Is How We Are,* Lasdin departed from the precedent of Borchert and

others, whose subjects relaxed in their everyday surroundings. Instead, Lasdin's subjects pose self-consciously as they willfully act out their fantasies in a location of their choice, with their handwritten explanation appearing beneath the finished print. This last detail allows a comparison between how these people wished to be seen and how they actually appear, while also providing insight into their feelings. In the old socialist tradition the subjects are identified by name, age, and profession, a device intended to establish a common ground, as it does in Borchert's work; here, however, it tersely reveals just how different the social persona and the private person actually are.

The idea of using text to direct photography was already well established with Weimar worker photographers, and it remained an essential practice in the GDR. The specific concept for this series, too, had been explored by artists such as the American Jim Goldberg, who combined photographs with the handwritten wish lists of his subjects. But in the GDR this approach amounted to heresy. The historian Ulf Erdmann Ziegler lambasted Lasdin for a fictitious pursuit of reality, whereby "entire lives are compressed into subtitles," leaving "dollhouse models of the societal psyche."[25] Officially, so-called straight documentation remained the norm, because it could be used to demonstrate the collective similarity of society through its individual members. Even Schulze's or Schäfer's work could be fitted to this paradigm, as the subjects were all treated equally, shown either nude or dead. But Lasdin was now making statements about indomitable individual quirkiness that transcended all generic standards—those put in place by political despots.

One of Lasdin's photographs shows a group of bare-chested radicals soulfully posing in a bathroom (fig. 116). The one in the middle writes for all three: "You didn't ask us if we wanted to be born, so don't tell us how to live." In another image a sixty-three-year-old actress poses in the far corner of her frilly white living room and confides that going to the theater and acting have remained her "elixir of life" (fig. 117). Next we see two well-dressed young men—one seated, the other standing barefoot with a hand on his companion's shoulder—telling us how much work remains to be done in their new apartment and how much happiness they look forward to in life (fig. 118). We also meet the prominent and multi-titled party functionary with his tight-lipped wife, both seated before a wall dripping with hunting trophies, and we learn that

"good hunting is true happiness on earth" (fig. 119). There is even an almost ninety-year-old music teacher, who finds herself invigorated by her art, her memories, and her youthful pupils (fig. 120).

The similarities and dissimilarities between how these people appear and how they portray themselves contributes to the three-dimensional quality, often with a candid sense of humor, so sadly lacking in the angst-ridden climate of East German culture. It is refreshing, for instance, to see a family entertaining themselves with boa constrictors in their living room, an activity they present as a viable alternative to television (fig. 121).

Lasdin never attempted to edit his large body of work, as he wanted it to be seen the way it was created.[26] He became spellbound by his exploration, which knew no censorship beyond that imposed voluntarily by the subjects themselves. True, none of them are shown buffeted by misfortune, but the result is indeed a realistic reflection of a culture in which, despite the bitter limitations, it was difficult to feel left out.

Lasdin developed a distinctly focused artistic signature, yet like others he remained socially committed. With Schulze, Klaus, and Schäfer he shared a seethingly confrontational method and a clinical approach to deciphering the nature of things. All four presented a palpable "carbon copy" of life. But in the end, photography itself refuses to explain. As these artists could only reveal their own perception of the world, they raised more questions than they found answers. They discovered that, as Lisette Model once remarked, "The most mysterious thing is a fact clearly stated."[27]

219

Untitled, from
This Is How We Are,
n.p., 1986–89

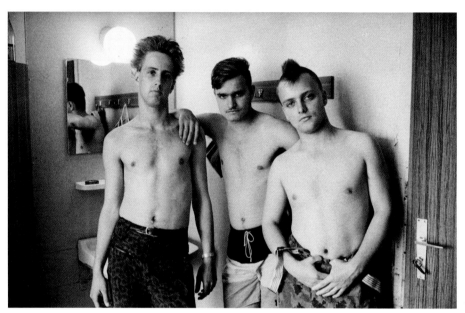

116

Ihr habt uns nicht gefragt, ob wir geboren werden wollen, also sagt uns auch nicht, wie wir leben sollen!

3. September 1987
Sven Stollo (Mitte)

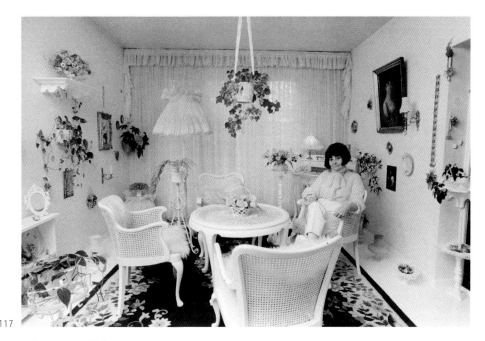

117

Gutes Theater sehen und Spielen ist für mich
wie ein Lebenselixier.

21. Mai 1987
Inge Göthel- Röder

Untitled, from
This Is How We Are,
n.p., 1986–89

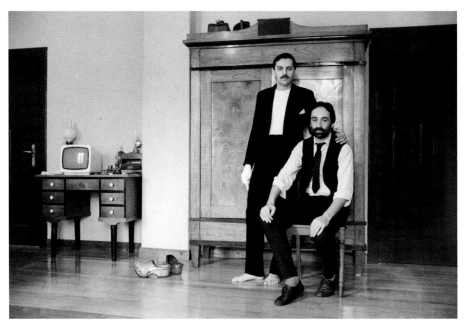

118

Wir und unsere neue Wohnung, das ist ständiges Tun, aber
ein tolles und schönes Lebensgefühl.
Wir erwarten noch viel vom Leben, weil es uns viel Freude
entdecken läßt.

25. Januar 1987
Willi Schmidt
Ulrich Landsberg.

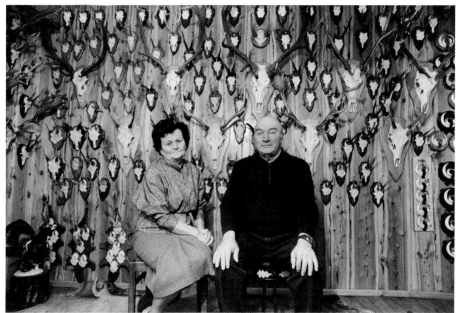

119

Ein Weidmanns Heil ist immer ein Glück auf Erden. Mein größtes
Glück fand ich in meiner Frau, meiner Weggefährtin, die mich auf
meinen steinigen und schönen Weg begleitet.
Die Jagd war immer ein Ausgleich zum anstrengenden Tagewerk.
Der Ansitz eine Ruhepunkt wo viele neue Ideen geboren werden.

27. Januar 1989

Fritz Gollmann

Untitled, from
This Is How We Are,
n.p., 1986–89

120

Wenn ich mir so mein Bild anschaue, in zwei Jahren 90 Jahre alt, ich kann es kaum glauben, aber
es stimmt! Ich fühle mich auch nicht so alt, bin immer froh und guter Dinge.
Meine Liebe gehört der Musik schon von Jugend an.
In meinem Elternhaus wurde viel musiziert, kein Wunder daß Musik mein Beruf wurde, den ich
heute noch mit Lust und Liebe ausübe.
Ich bin Musikpädagogin, meine Schüler verehren mich sehr und wie es immer heißt: „Jugend erhält
jung! Bin ich nicht ein Beweis dafür?

Lore Lamp
2. November 1986

121

Gemeinsame Interessen, Träume und Freuden bringen uns häufig auf neue Ideen. Wir wünschen uns für unser Familienleben, daß die Abende nicht vor einem Fernsehapparat enden.

25. Januar 1987
Roland Sternberg

To be above myself.
To experience the world
And stand next to myself.
Motionless relentless existence.
To understand
the elusive.
To feel
the incomprehensible.

JÖRG SONNTAG

MOVEMENT AND THE ORDER OF CHAOS

By the late eighties, Honecker realized that the prohibitions and incarcerations of artists could not weaken their defiance. In fact this oppression only empowered them to point a finger at "socialist truth," while the world watched. Thus, as the West abandoned modernist purism in art, in the GDR many artists found ways to express the futility of utopianism in society. Rejecting the socialist idea that reality could be defined and controlled, they focused on the transitory nature of all experience. They wanted to depict momentary sensation as they found it.

One such artist was Kurt Buchwald. He started out as a painter but soon moved to photography, as he considered the camera the fastest and most economical tool for recording the visual encounters randomly presented by life. And what he saw through the lens is what the viewer got! Although he made "straight" prints to be displayed in a conventional manner, they were intended as conceptual pieces. He wanted to comment on the ultimate meaninglessness of visual priorities and depict the chaotic sense of movement, which he identified with all existence.

Buchwald was an activist from the very beginning. He simply refused to accept limits. Once he staged a performance in which he set televisions on fire and then photographed the burning sets—while in the nude. Later he placed signs forbidding picture-taking at popular tourist spots in cities from Moscow to Berlin, prompting the unwitting police to confiscate cameras and even make arrests.[1] Yet his message ap-

parently was not about government censorship—or so he said at the time. He claimed that he merely wanted to acknowledge the phenomenon of contemporary visual overload, which was making inroads even in the GDR. Ironically, Buchwald himself contributed greatly to the glut. He became obsessed with capturing all of life on film, transfixing all experiences, sensations, and objects that came his way. For him there were no bad angles, no bad techniques, and no unacceptable subject matter; there were only images of life and movement. Although he denied political innuendo in his art, his nonpreferential approach still doubles as a visual metaphor for socialist democracy, whose purported equality neutralized life's onrush of sensations.

But even as he deconstructed existence through the lens of his camera, Buchwald—perhaps in an effort to avoid censorship—did not finally efface all meaning. "I am concerned with comparing various imaging techniques," the artist explained; "I want to open new systems of transportation."[2] Accordingly, his many shots of blurred landscapes or roads taken from fast-moving cars were explained as an expression of his own spiritual rhythm, whereby transportation routes symbolized the dissemination of his own ideas (fig. 122).[3] His series *Asphalt and Work,* meanwhile, passed government scrutiny because of the time-honored theme, yet far from vaunting human control, the workers it depicts often seem like vaporized emissions of the machines they operate (fig. 123).

Buchwald became especially well known through two projects: the coat photographs from *A Day in East Berlin,* which was based on the performance piece *Standing Room, Disturbing Room (Stehplätze–Störplätze),* and his series of out-of-focus portraits, *Berliner Dream.* Each presented a cultivated photographic accident that was then insistently repeated. In the coat photographs Buchwald placed a stand-in wearing his bulky dark coat between the camera and the view, blocking out most of what would otherwise have been ordinary sights of East Berlin (fig. 124). In 1988 Anna Lindenlaub called these images "provocative collisions in the net of reality," where vision is fragmented and reassembled.[4] Only after the demise of the GDR did Buchwald insist that he was trying to cover up socialist landmarks.[5] Still, nobody likes having their view blocked, not even by an artist—and especially not at an art gallery. It could easily be argued that Buchwald's "new systems of communication," as he called them, were designed to block all points of view but his own. The series becomes a neodadaist

229

Near Grausee,
from *Landscape and*
Movement, 1988

122

123

At the Boiler, from
Asphalt and Work,
East Berlin, 1986

annihilation of traditional values, with the artist as *Bürgerschreck,* thumbing his nose at those who have come to pay homage.

The same can be said of the out-of-focus portraits, equally deliberate in their irritating scrambling of perceptual logic (fig. 125). The sharply focused backgrounds in these shots—many of which were taken at night—appear as ordinary as those in the coat photographs, but now the view is blocked by blurry faces in the foreground. Jörg Wähner saw these pictures as a possible metaphor for the artist's personal distance— his admitted inability to clearly recall faces in the big city—but Gabriele Muschter may have come closer to the truth when she described them as a deliberate affront on the viewer. To Buchwald, she wrote, "activism and photography are one and the same."[6] After all, the artist had already learned that trying not to please was perhaps a better way to success.

It is tempting to see both works as a pregnant reflection on the East German zeitgeist, in which distant vision was blocked and close-up vision was blurred. At the same time, however, a gentle serenity emanates from the fuzzy faces in *Berliner Dream*. Made ephemeral by their obscurity, these individuals remain safe from the unscrupulous interrogation of the mechanical modernist tool; their fleeting presence in the empty streets is like an innocent breeze that gives no inkling of the gathering storm. By diffusing individuality, Buchwald was no longer evoking collectivity but rather, it seems, disconnecting himself from the physical space he had incessantly photographed and preparing his spiritual exodus from the responsibility of hope. The end seemed ever closer; indeed, the late years of the GDR were experienced with what has been described as a sensation of free-fall.[7]

Equally zealous in portraying the idea of movement was the versatile artist Ralf-Rainer Wasse, a former coal miner from Zwickau. Like many graduates of the HGB in the late seventies, he gravitated to Karl-Marx-Stadt (Chemnitz), the Manchester of Saxony, lured by the city's frontier spirit, which he hoped would stimulate new ideas. He became a founding member of Galerie Clara Mosch, where his work was primarily exhibited.

Wasse made photomontages, which he then crumpled into sculptures or combined with fabric or paint. He also made triangular and pyramid-shaped photographs, to be

KURT BUCHWALD

attached to ceilings or used as pillows (fig. 126), and one-of-a-kind landscape pho-
tographs that he painted over, such as that used as a New Year's card by Galerie
Oben—the name means "up high" or "upstairs"—in 1984, in which a man is seen
standing atop a ladder placed high in a tree (fig. 127). He would transform typical
landscapes into "verbal metaphors,"[8] in which style was never an issue but only a
means. His technique remained deliberately crude and his approach eclectic.

Wasse also became the chronicler of art happenings, creating a symbiosis between
performance artists who wanted a record of their event and the artist's interpretation
—thus twice removed from "reality." With an acute sense of theatricality, he stylized
what had already been stylized through the happening and presented it as a two-
dimensional phenomenon, as if to show the futility of all fixed meaning. A photo-
graph of the 1979 art happening *Stonelaying,* by Michael Morgner, shows the face of
a man partly covered by stones and pebbles (fig. 128). The event, which took place in
a park in Leipzig, was meant to symbolize the new oppression of artists by the emerg-
ing museum system, but Wasse's version brought art full circle—right back to the
museum wall, where the photograph was later exhibited. To Wasse, everything was
interchangeable; nothing was implausible.

In another image, the continuous action of the performance piece *Top to Bottom,* by
Thomas Ranft, Gregor-Torsten Kozik, Michael Morgner, and Wolfgang E. Bieder-
mann, is reduced to a specific isolated moment that expresses more about the pho-
tographer than it does about the performance (fig. 129). We see nude bodies distrib-
uted in a barren tree like a human chain, with the one on top comfortably resting, the
one in the middle climbing, and the one at the bottom struggling to get a foothold.
Without explaining what the performance was trying to accomplish, Wasse drew on
the enigmatic nature of photography to create an artificial context. The photograph
can be seen as a metaphor for the tree of life or a parable of the peculiarly human need
to succeed. Those are not the only meanings, of course. Wasse wanted the viewers to
participate and initiate their own process of discovery.

In the Harlass Project, a collaboration with the painter Gregor-Torsten Kozik,
Wasse used time exposure and darkroom manipulation to condense within single im-
ages the long process of factory production. Made into a portfolio edition of ten prints
and ten etchings titled *The Step,* the series infused new meaning in the old subject of

Triangular
postcard, 1980

126

New Year's card,
Galerie Oben,
Chemnitz, 1984

127

Stonelaying,
performance by
Michael Morgner,
Leipzig, 1984

129

Top to Bottom, performance
by Thomas Ranft, Gregor-
Torsten Kozik, Michael
Morgner, and Wolfgang E.
Biedermann, n.p., ca. 1981

Untitled, from
The Step (Harlass
Project), 1982

RALF-RAINER WASSE

work by eschewing all recognizable form. Wasse exploited the abstracting potential of molten steel to make luminous statements, evoking microscopic primordial life forms or gaseous galaxies (fig. 130). In this advanced rendition of "work," chaos became the reigning order, reflecting the instability of all existence.

A charismatic man, Wasse attracted a large following of artists who confided their innermost fears and conflicts. Buchwald was a close friend, and his letters to Wasse, some of which are preserved at the Getty Research Institute in Los Angeles, constitute a virtual outpouring of intimate artistic insights.[9] After reunification, however, tales of Wasse's rather extensive activities as a Stasi informer began to surface.[10] Everybody was in shock. Still, the news only confirmed what Wasse had maintained all along: nothing was stable; nothing could be relied upon—especially in the GDR. Perhaps it is to Wasse's credit that even though he engaged in deceit in the 1980s, through his art he spoke of truth.

239

No one can answer the question before the challenge
confronts him. No one knows if he is made of the
material that, at the critical moment, produces heroes.

ERICH KÄSTNER,
from a speech about book burning, Hamburg, 1958

Chapter Fourteen

MEMORY OBSERVED

242 With the GDR's reassessment of the past, its history remained systematically encumbered by fiction. The precedent had been established in 1945, when those who embraced socialism were classified as victims of fascism, in order to justify the persecution of those who did not. The intense soul-searching that went on in West Germany to comprehend and sort out responsibility for Nazi atrocities was thus totally circumvented. But memory is resilient. It is, after all, what all of life becomes; it defines our sanity. Recognizing that they could not confront history through open and earnest dialogue, some artists simply began to examine memory as an abstract idea. This process became a means for rebuilding the shattered soul.

One such artist was Klaus Hähner-Springmühl. Like Wasse, he photographed staged events, but they were ones of his own making. His work was directly autobiographical. And whereas Wasse's work reached some form of completion through limited editions and publications, Hähner-Springmühl's remained deliberately tentative and ephemeral. Like memory, his art was continuous and limitless, engaging both his conscious and unconscious energy.

Hähner-Springmühl quite literally lived in his art. The walls of his studio were like a seamless canvas dripping with paint; so were the floor, the ceiling, and sometimes even the clothes he wore. Everything he made he dearly owned, and photography be-

came a process of tangible recollection—the connective fiber and a point of departure for successive stages of experience. It was a means of creating a measure of time—of making what Barthes once described as "a clock for seeing."[1]

Hähner-Springmühl himself offered little in terms of an articulated philosophy, only that he wanted his art to be as close to life as possible and his artistic vocabulary to be simple. He was concerned not with the visual but with the sensation of the creative experience. His model was not nature but feeling. This approach is apparent in his manipulation of materials—the deliberate tears in the paper, the crinkles, the spots, anything that prevented sanitized completion and brought a sense of the open-ended emotional process of life.[2] But Hähner-Springmühl was not trying to illustrate the idea of chaos, as Wasse had done; for him, chaos simply existed on its own—like memory.

How did the artist work? Starting out with a photograph of himself, he would make a collage or a montage, which was then manipulated (painted over, dripped on, distressed, combined with other materials, soaked, and so on) before being rephotographed for the next step, where the process was repeated to create yet another level of consciousness. Objects are intertwined with images of images in a deliberate and relentless redundancy, reflecting the meaningless complexity of memory and life as perceived by the artist.

Like Joseph Beuys, Hähner-Springmühl forged symbolic associations through specific materials, such as bandages standing for injury, or food for sustenance. But since there was no end to Hähner-Springmühl's work, there was also no climax— only infinite associations, both mental and material. Reality was no longer depicted; it was revealed as an elusive fragment that exists only in the mind of the beholder. Predictably, Hähner-Springmühl's work was not appreciated by the censors in its rare appearances at galleries.[3]

The progression—or deterioration—of his memory is poignantly illustrated in three photographed phases. The first, from 1981, presents a surreal, mirrorlike confrontation: the artist, seen from above, is contemplating a self-portrait attached to his thigh (fig. 131). His leg doubles as a medieval helmet enclosing his image, restricting his movements and condemning him to silence. The number five is mysteriously

243

scribbled over the face. He is holding a crumpled fragment of the portrait or perhaps a rag or tissue with which to wipe the face before him—to rub it in or rub it out. He is stuck but resigned. The second phase, from 1987, conveys a similar feeling, albeit with a greater sense of urgency (fig. 132). Here his hand is clasped over his mouth, and a bold dash of black paint doubles as a blindfold. After six years, controlled fear has taken the place of resignation.

In the last phase, from later that year, a posted photograph of the artist's anguished face makes him seem encased in a dark, narrow recess that is framed by frenetically dripping graffiti (fig. 133). A crumpled copy of the same image appears below—falling, landing, discarded, caked with paint, which splatters from the mouth—convoluted and eerily reminiscent of Michelangelo's only self-portrait, which appears on the bare skin of St. Bartholomew in the Last Judgment fresco at the Sistine Chapel. The cross painted at the top of the assemblage, the bloodlike streams and gestural spasms, all enhance the aura of expressionist martyrdom, as an angst-ridden soul is seen shedding a layer of its anguished persona—only to discover the next layer to be identical. Some in the GDR lived like that until they died. Others died just at the moment of rescue.

Hähner-Springmühl's lunatic ravings combined an awe-inspiring range of sensibilities apart from process art and neo-expressionism: neo-dada, photomontage, collage, gestural painting, semiotics, and even West German Fluxus, as well as other approaches that have fertilized the multifaceted postmodern imagination.[4] His continual tearing down and rebuilding for new meaning also relates to deconstruction. It is ironic, however, that while the artist rejected the idea of the completed artwork, he is remembered today through vintage reproductions of his photographed phases. His prints have all but disappeared.

As the issue of recapturing memory became more critical, artists devised a variety of creative methods for coping. For Evelyn Richter, who was from a more stoic generation, the process was less threatening. She was already fifteen at the end of the last war—old enough to keep up with history firsthand. Her photograph of the entrance hall of a convalescent home in Leipzig, taken in 1986, conjures the heroic spirit of the past in a simple frame on a softly patterned wall (fig. 134). But beneath it, the prepared

Untitled, 1981
(Galerie Oben,
Chemnitz)

KLAUS HÄHNER-SPRINGMÜHL

132

Untitled, 1987
(Galerie Oben,
Chemnitz)

133

Entrance to a
Convalescent Home,
Leipzig, 1986

EVELYN RICHTER

stretcher remains empty. As in her early career, Richter could still find solace through intuition. For her, the end of the nation was nothing to fear.

Much younger than Richter, the multimedia artist and former photojournalist Thomas Florschuetz resembled Hähner-Springmühl in his need to retrieve memory. He considered photography a fast and effective tool for recording oblique fragments of his personal recollection, but unlike Hähner-Springmühl, he abhorred all cosmetic alteration of the image. He was concerned with authenticity and detail, and he strove for a sense of completion.[5]

At first glance some of Florschuetz's work begs for comparison with Richard Avedon's: the single head-shot aesthetic; the neutral white backgrounds with visible negative borders. But Florschuetz's photographs, often self-portraits, are not sharp and startling with nuance. They are deliberately flat or blurred like memory; they may be arranged in diptychs or triptychs. Muschter thought Florschuetz conceptualized his own reality in order to analyze his relationship to the world, thus revealing the dialectic between the conscious and the unconscious, between human being and primeval creature.[6] In another article she summed up his work as "parables of inner crisis and screamed-out aggressiveness."[7]

This assessment holds true in one of Florschuetz's diptychs, a self-portrait in which his profile is deformed and topped by an image of a raised fist holding a long, thin object (fig. 135). Although the fist evokes stock revolutionary poses, the meaning changes radically if the object it holds is seen not as a knife but as a rope. Is this image about aggression or simply about holding on? In another work, a triptych, we see an oddly wrapped tool placed against the artist's temple in the central panel (fig. 136). The right panel shows his featureless profile and the left is almost blank. Meanwhile, the enigmatic instrument seems to either push him over or suck him away. The featureless profile suggests the latter, and the viewer is left to wonder if this is how memory was lost.

Florschuetz was not always abrasive; in fact often he could be almost lyrical, even tender. A portrait of the controversial poet and Stasi informer Sascha Anderson challenges the viewer with its narrative inventiveness (fig. 137). The poet is seen wiping his eye beside an inset of an oddly bound fist that partly blocks out his face. Under-

249

Untitled, ca. 1987

Untitled, ca. 1987

Sascha Anderson, 1988

THOMAS FLORSCHUETZ

exposure creates a sense of fading away, and the uneconomical use of space denotes emptiness or waste. In effect we see "a fist that weeps," to borrow Heinrich Böll's characterization of Reiner Kunze's *Die Wunderbaren Jahre* (The Wonderful Years), an exposé of the daily petty repression in the GDR published in West Germany in 1976.[8] But Anderson offered his own interpretation of Florschuetz's work. "The nature of this photography is everything within everything," he wrote. It is, "for instance, the possibility for the hand to speak through the mouth and for the mouth to act."[9]

Florschuetz also made wall installations with photos of his own body parts, building large, often irregular grids of visual distortions (fig. 138). Straining under the extreme wide-angle lens, he appears pressed against the viewer, curiously writhing like an exotic sea mammal in a tank—half awake and half asleep, moving within and receding into another dimension. Suspended in the ether, he unites ancient and embryonic states of awareness.

253

Romanticism informs the recollection exercises of Ulrich Lindner, who attempted to transform his traumatic childhood memory of the Dresden bombing and grant it a new state of grace. He was six years old on that cold February night in 1945, and he remembered the fire arriving out of nowhere, pounding the city for two long days—until the air was so thick with smoke that the British bombers could no longer find their target. "The city was packed," Lindner recalled, "with refugees from everywhere: Pomerania, Bohemia, the Sudetenland. Dresden was a haven. Everybody knew it. There were no military installations, and the city was cherished the world over. Nobody worried, because not even Hitler had deliberately bombed architectural treasures."[10] What Lindner saw when the smoke had cleared he described as "the ultimate shock of the new." But it was also the genesis of his appreciation of the fate of all beauty.

His need to look back during the 1980s initially came out of a dire need to befriend history—to know it not just as a useless collection of past events but as part of a meaningful continuum. At a time when national identity was at stake, his roots became the only solid ground. By exploring and reconstructing the past in his own mind rather than judging it, he wanted to find redemption.

Untitled, 1985

THOMAS FLORSCHUETZ

Lindner's stunning series of photomontages titled *Death and the City* was made from photographs he had taken since his teens; he completed it in 1984, for the forti-eth anniversary of the bombing (figs. 139 and 140). Evoking Piranese's engravings from the eighteenth century, Caspar David Friedrich's paintings from the early nine-teenth, Jerry Uelsmann's photographs from the twentieth, and even Edmund Kesting's photomontages of Dresden after the fire, Lindner wove time and space into a symbolist magic realism that affirmed his own emotional wholeness. As he de-picted the fragments of once-famous stones serenely at rest below lugubrious skies and dark floating veils, beauty is revealed as a state of mind that can abide. Apocalyptic nightmare advances toward the arcadian dream.

The memory of Dresden was not Lindner's only subject, but his melancholic con-templation never wavered. In *The Sinking of the Romantic Sun,* two identical barri-cades face each other, each a solid slab of black impregnability, concealing from the other what lies behind (fig. 141). As the last glow of the sun fades behind the flat hori-zon, scattered sheets of white paper illuminate the emptiness in front of each slab. Each one is losing the light to face the night alone. *Miraculous Siege, or Pondering Carthage* shows a group of battered baroque statues pitched against a twentieth-century city (fig. 142). The barren ground is covered with brittle shards; thin poles di-vide the night. A heroic assembly has come to the limits of comprehension. Like the dead risen from the grave, they behold a dimension they cannot breach. They discover that only across the abyss lies reality; they themselves have become the mirage.

For Klaus Elle—the early process artist who had chronicled the experience of his hos-pital stay (see figs. 73 and 74)—memory was still more troubling. In a series with text titled *Fuzzy Heads* (*Wirre Köpfe*), he photographed himself in various emotional states, whether incensed and railing or sullen and death mask–like. The images were often overexposed, or they were vehemently painted over or even painted out. "Mother!" is hastily scribbled in the margin of one, "out of you crawled the unresolved question" (fig. 143).

Elle—like Hähner-Springmühl and Florschuetz—unabashedly put memory to an expressionist end. Micha Brendel, on the other hand, was an artist driven by what he described as "the opposing tendencies of intellectualism and sensuality."[11] Synthesis,

255

Untitled montages,
from *Death and the
City,* Dresden, 1984

140

141

*The Sinking
of the Romantic Sun,*
montage, 1986

Miraculous Siege, or
Pondering Carthage,
montage, 1983

Untitled, from
Fuzzy Heads, 1987

KLAUS ELLE

143

or Hegelian idealism, might be the first thing that comes to mind, were it not that Brendel's rationale finally justified nothing short of a reckless celebration of carnality. He let the jinni of intimacy out of the bottle as he addressed concepts of primordial memory with regard to procreation. *Protection of Lust* (*Lustschutz*) was the title of a series that Brendel completed in the late eighties. Manipulated through overexposure, multiple exposure, or sandwiched negatives, the photographs show the artist's face intertwined with body hair and other materials, all of it seemingly in motion or dripping with undefinable lubricious matter (figs. 144, 145, and 146).

Brendel had studied stage design and was a performance artist and a sculptor. His work, like that of Hähner-Springmühl, Florschuetz, and Elle, was autobiographical to such an extent that his own body became central to the composition. With the help of assorted pliable materials—such as cloth, sand, water, and even meat and bones— he created amalgamations of self-transformations, with the consistency of the materials varying to demonstrate impermanence: water might be liquid or frozen, sand might be either tossed or heaped into mounds.[12] Ulrike Stöhring saw these compositions as metaphors of physical states, where the different materials trigger existential memory of both origin and decay.[13]

Brendel tended to shoot from up close with a wide-angle lens, as did Florschuetz, to convey an exaggerated and confining libidinal intimacy. But for all his ectoplasmic manipulations, he remained committed to recognizable form. He wanted to melt the various elements into one another to make them inseparable but not indistinguishable.[14] In Brendel's own words, he strove to "transform reality into art and then bring it back to reality."[15]

Brendel's series works on many levels, but an inescapable sense of drowning, bleeding, or being buried alive permeates all the photographs—a sense that also comes through in the work of Hähner-Springmühl, Florschuetz, and Elle. As the decade was drawing to a close, some artists, such as Richter and Lindner, managed to retreat to higher ground, but most of them found themselves discarded, abandoned, and alone. Their extreme subjectivity mirrored the end of socialism. An idea had passed.

But although each became trapped in his own sensation, the loss of the country was experienced collectively. For all it was the end of being safely tucked away from the

261

Untitled, from
Protection of Lust, 1988

144

145

146

world and from global responsibility. It was the end of "our times" and of the many things that had been taken for granted: solidarity, job security, structured activities for the young, stable prices, low rents, virtually no crime, and a seemingly limitless array of free social services. But there was no turning back. The fixed star by which to sail was irrevocably fading, marking the end of the GDR as lived experience and the beginning of it as memory—through photography.

By May 1989, more than two hundred East Germans were escaping daily through Hungary, whose border with Austria had been opened. When Hungarian tourist visas were canceled, even greater numbers sought refuge at West German embassies in Poland and Czechoslovakia. Honecker responded by blocking all borders, but now he was without support. The Soviet Union had not intervened when Hungary demolished its iron curtain or when Poland held free elections; it did not respond to the East German exodus either.

By November—the fortieth anniversary of the GDR—massive protests demanding free elections, freedom of speech, and the freedom to travel had become routine in Leipzig, Halle, and East Berlin. Eva Mahn captured the apprehension, the furtive glances in the crowd where the will of a people was about to be reborn (fig. 147 . Gorbachev came to Berlin and warned Honecker about the inevitability of change, but Honecker ordered the police to open fire on the demonstrators. At the last minute, Security Chief Egon Krenz disobeyed Honecker's orders by withdrawing security forces, and bloodshed was avoided. When Honecker was ousted by the panicking politburo on November 8, he simply could not grasp what had happened.[1]

On November 9 the general spokesman of the Central Commission, Günter Schabowski, tentatively talked of travel to West Germany without special permit. When

*Monday
Demonstration,*
Halle/Saale, 1989

E V A M A H N

thousands of East Berliners gathered at the various checkpoints in the drizzling cold of the night to test that promise, the guards at one station mistakenly assumed that an order had already been passed down from the politburo. As they began letting people into West Berlin, guards at other crossings followed suit. The crowd became a flood. Those who could not pass through the checkpoints fast enough began scaling the wall—sometimes even with help from police. On the other side, West Berliners who had been roused from their sleep by the commotion rushed to the wall with musical bands, booze, and bouquets. For one brief moment of delirious celebration, "Germans were the happiest people in the world."[2]

Manfred Paul photographed one of the earliest breakthroughs into the death zone and the light beyond—before the wall was chipped into portable souvenirs (fig. 148). What a very thin wall it turned out to be! Yet its rupture brought the nation free elections—the first in fifty-six years—that resulted in reunification under the West German constitution on October 3, 1990. Many intellectuals on both sides, including Christa Wolf and Günter Grass, were against the idea of a united Germany.

The long postwar odyssey was over at last. In its wake a new uncertainty set in, summed up in a 1992 photograph by Klaus Elle, who now lived in Hamburg. No longer a "fuzzy head," he portrayed himself with his feet floating above the ground and the rest of his body going up in smoke (fig. 149). None of the young or even middle-aged generation of artists had ever known a competitive system, nor did they have any concept of democratic practices. Their history was pulled out from under them and turned inside out. Adding to their confusion was the general sense of letdown experienced after the rush. The Faustian moment of beholding nirvana had passed, and one major obstacle was replaced by seemingly endless smaller ones.

In time, however, their situations began to change. By 1996, some artists were still distraught, unable to secure a meaningful new footing for themselves, but most had made some kind of adjustment, and a few had even created wholly new lives for themselves. Those who had been opportunists under the old rule were still opportunists, with the only difference that instead of portraying workers they now milked the cash cow.

Many built on what they had been doing already by taking advantage of new technology and new opportunity. One of the most affirmative artists, Bernd Lasdin—who

Bernauer Straße,
East Berlin, 1990

MANFRED PAUL

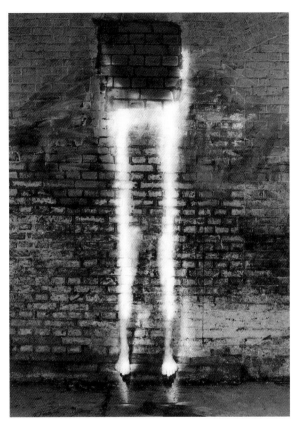

149

Self-portrait,
Hamburg, 1992

continued to identify with photo-graphics rather than photography—now directed his curiosity toward the people of the former West Germany: *This Is How We Are,* part two, presented new insights and universal dissimilarities. Konstanze Göbel still photographed Halle, but with a large-format camera for greater nuance, revealing that almost more was torn down since "the turn" than had crumbled before. Renate Zeun furthered her work on the terminally ill, but now she focused on children, encouraging them to participate by photographing their own fears and wishes. Hans-Wulf Kunze remained faithful to the worker theme but aimed for ever greater abstraction, whereas Ulrich Burchert went to photograph the horse cultures in the Asian steppes and Peter Leske turned to the subject of nudes. Eva Mahn finished her dissertation in art history and published two books of her photographs exploring her feelings and those of others at the onset of freedom.

Gundula Schulze, meanwhile, married an Egyptian and became known as Gundula Schulze el Dowy, meaning "the Light." She denounced her social consciousness as old-fashioned and succumbed to sheer revelry in "the cosmos" of color, light, and the music of form.[3] She also stopped making her own prints. Rudolf Schäfer received the patronage of Mercedes Benz to publish slick calendars of his color photographs, which at first look like large abstractions but turn out to be extreme close-ups of decorated female pubic areas.

In the early 1990s, to avoid having to investigate every person who held a teaching job, the government simply terminated everyone. Those who chose to reapply then underwent a background check. Both Arno Fischer and Evelyn Richter, who were already of retirement age, gave up teaching at the HGB. Younger artists, such as Tina Bara, took their place. Fischer moved to the country north of Berlin, where he amicably procrastinated with his new cellular phone in the cultivated wilderness of his garden. Richter gave up her studio in Dresden and returned to her birthplace, a little village in the Thüringer Wald where she had lived off and on for most of her life. Neither officially gave up photography. Both continued to have exhibitions, more perhaps than ever before, which yielded them glorious catalogues. But they were essentially commemorative shows, as neither had established a clearly defined new direction.

But while projections for the future of art in the new Germany lean toward capitalist concepts of personal sovereignty, the sudden infusion of artists with over forty years of rigorous socialist conditioning is bound to have an effect. As Germans will undoubtedly continue to ponder their identity and their fate, elements of the two belief systems may promote an artistic synthesis that addresses both individual and collective needs. Given a chance and a choice, photographers will show how they will manage freedom.

Unless a published translation is cited, all translations from the German are my own.

Prologue

1. Quoted in Susan Sontag, *On Photography* (New York, 1973), 69.

2. Peter Gay, *Weimar Culture: The Outsider as Insider* (New York, 1968), 13.

3. Gropius left the Bauhaus in 1928. The school moved to Berlin in 1932, only to be closed down two years later by the Nazis. See H. H. Arnason, *History of Modern Art: Painting, Sculpture, Architecture, Photography,* 3d ed. (New York, 1986), 312–19.

4. Moholy-Nagy and Renger-Patzsch discussed their new photography in *Das deutsche Lichtbild* 1 (1927), quoted by Van Deren Coke in his introduction to San Francisco Museum of Modern Art, *Avant-garde Photography in Germany, 1919–1939* (San Francisco, 1980). For further reading on the subject see also Herbert Molderings, *Fotografie in der Weimarer Republik* (Berlin, 1985), and Emilio Bertonati, *Das experimentelle Foto in Deutschland, 1918–1940* (Munich, 1978).

5. Zille used his photographs primarily as models for his drawings. The neighborhoods he photographed were described in a Berlin tourist prospectus as too dangerous to visit.

6. See Gorden A. Craig, *The Germans,* rev. ed. (New York, 1991), 30.

7. For further reading on this subject, see George L. Mosse, *The Crisis of German Ideology: Intellectual Origins of the Third Reich* (New York, 1964).

8. Friedrich Engels, "Three Constitutions," in *Deutsche Brüsseler Zeitung,* February 20, 1848, quoted in *Karl Marx and Frederick Engels, Reactionary Prussianism,* ed. Institute Marksizma-Leninizma (New York, 1944), 35.

9. David Blackbourn and Geoff Eley debunk the popular notion of German particularism, insisting that in nineteenth-century Europe, Germany "was much more the intensified version of the

norm than the exception" (*The Peculiarities of German History: Bourgeois Society and Politics in Nineteenth-Century Germany* [Oxford, 1984], 292).

10. Quoted by Craig, *Germans,* 11.

11. George L. Mosse, ed., *Nazi Culture: Intellectual, Cultural, and Social Life in the Third Reich* (New York, 1966), xxxviii.

12. In a radio broadcast heard all over Germany a few days before the "degenerate art" exhibition opened in Munich in 1937, Hitler insisted that the strength of a nation was not in army divisions and weapons but in the inner unity and the idealistic faith of the people. At the time arms production was already greatly accelerated, and concentration camps were under construction.

13. Lendvai-Dircksen died in obscurity in 1962. Some of her rare surviving prints were included in *Women on the Edge: Twenty Photographers in Europe, 1919–1939,* at the J. Paul Getty Museum in Malibu, California, August 24–November 28, 1993.

14. Craig, *Germans,* 32.

15. The Soviet zone comprised about one fifth of prewar Germany but over one third of Germany in 1945, when German territories in East Prussia, Silesia, Pomerania, and the port of Stettin were assigned to Poland and the USSR.

274

16. Wittkugel taught at the Hochschule für bildende und angewandte Kunst Berlin-Weißensee until 1952, when he was appointed professor at the Kunsthochschule in Berlin (Coke, *Avant-garde Photography,* 53). According to Ullrich Wallenburg, his work from the 1920s and 1930s was virtually unknown in the GDR for many years ("Fotografie und Museum," in *Fotografie in der Kunst der DDR,* ed. Ullrich Wallenburg, exhibition catalogue, Staatliche Kunstsammlungen Cottbus, Fotoedition no. 8 [Cottbus, 1986], 25). Well known in the GDR, however, were Wittkugel's socialist photo posters, such as "I Am a Coal Miner, Who Is More?" (the title is quoted by Volker Frank in "Lichtbild als Lichtkunst" in the same catalogue, 14). Edmund Kesting was also appointed to teach at the Kunsthochschule Berlin-Weißensee. Later he moved to the Deutsche Hochschule für Filmkunst in Dresden. Alice Nex-Nerlinger continued to work as a freelance photographer in Berlin. A monograph on Oskar Nerlinger by Kurt Liebmann, published in Dresden in 1956, fails to mention his experimental photography, instead associating him with realism.

17. Oscar Nerlinger, "Was will die Bildende Kunst?" *Bildende Kunst,* April 1947, 2; Carl Hofer, "Zum Geleit," ibid., 1. Nerlinger and Hofer were the two publishers of the magazine.

18. Sontag, *On Photography*, 116.

Chapter One

1. See Frank Gaudlitz and Thomas Kumlehn, *Die Russen gehen: Der Abzug einer Armee* (Berlin, 1993), 5.

2. Ibid., 6.

3. Quoted by Marianne Lange in *Prominente Fotogedanken,* ed. Lothar Klimter and Just Wagner (Leipzig, 1969), unpaginated.

4. See David Childs, *The GDR: Moscow's German Ally* (Boston, 1988), 195–97.

5. Karl Max Kober, "Die ersten Jahre (I)," *Bildende Kunst,* 1977, no. 5:218. Pieck had been exiled in the Soviet Union and molded by Stalinism. Kober refers to him as "president," which technically he became only in 1949, when the GDR was founded.

6. Childs lists, among others, the following as artists who came to East Germany: Bertolt Brecht, Lea Grundig, Horst Strempel, John Heartfield, Arnold Zweig, Anna Seghers, Ludwig Renn, Kurt Barthel, Erich Arendt, Stephan Hermlin, Hans Marchwitza, Jan Petersen, Bodo Uhse, Max Zimmermann, Johannes R. Becher, Willi Brendel, Eduard Levier, Erich Weinert, Gustav von Wangenheim, and Friedrich Wolf (*GDR,* 195–96).

7. The School for Graphics and Book Design was founded in Leipzig in 1764. Most photographers received their training here.

8. Peter Pachnicke, "Suche nach uns selbst," in *Symposium zu Aspekten der Fotoentwicklung in der DDR von 1945 bis 1965,* ed. Kulturbund der DDR, Gesellschaft für Fotografie (Leipzig, 1985), 10. Other worker photographers active at this time were Gerhard Kiesling, Erich and Wolfgang Krueger, Karl Heinz Mai, Alfred Paszkowiak, Abraham Pisarek, Willy Pritsche, Renate and Roger Rössing, Willi Rossner. See Wolfgang Kil, *Hinterlassenschaft und Neubeginn: Fotografien von Dresden, Leipzig und Berlin in den Jahren nach 1945* (Leipzig, 1989); also Petra Göllnitz and Wolfgang Kil, eds., *Frühe Jahre,* exhibition catalogue, Galerie Comenius (Dresden, 1985).

9. The Kulturbund was founded in July 1945 to aid "the process of democratization in Germany." Karl Schmidt-Rottluff—no longer active as an artist—became a regional delegate of the organization; see Karl Max Kober, *Die Kunst der frühen Jahre, 1945–1949* (Leipzig, 1989), 16, 18. An enormous bureaucracy with numerous subbranches, it established a Zentrale Kommission Fotografie (Central Commission for Photography) in 1959, reorganized in 1982 as the Gesellschaft für Fotografie (Society for Photography).

10. Pachnicke, "Suche nach uns selbst," 10.

11. Ibid., 12.

12. This idea originated during the 1930s, when Marxist aesthetic was defined by a number of left-wing intellectuals, including Brecht, Walter Benjamin, Hanns Eisler, and Georg Lukács. In his 1938 essay "Es geht um den Realismus" (The Issue of Realism), Lukács denounced montage, in particular, as "bourgeois decadent."

13. Pierre-Joseph Proudhon, *Du principe de l'art et de sa destination sociale,* quoted by Estelle Jussim, "Stieglitz and Hine," in *Photography: Current Perspectives,* ed. Jerome Liebling (Rochester, 1978), 57.

14. Kesting's series consisted of several versions of this image, which he created by placing the skeleton from the art academy across the street against the remains of the window. Some were straight photographs, while others were sandwiched and solarized.

15. This same view was also photographed by others. Richard Peter Sr., in spite of the emotional quality of his early work, remained one of the most respected photographers of socialism; he was one of its most vocal advocates as well. In 1969 he remarked that he had forgotten the tears he had shed

275

when he saw Dresden after its destruction and that he felt great joy for being a part of the battle for world peace (Klimter and Wagner, *Prominente Fotogedanken*, n.p.).

16. Both parties had existed during the Weimar years. The SPD ruled, but the KPD was the strongest Communist party outside the Soviet Union.

17. Childs, *GDR,* 196.

18. Günter Bernhardt et al., *Die Künste in der Deutschen Demokratischen Republik: Aus ihrer Geschichte in drei Jahrzehnten* (Berlin, 1979), 31. The other eight authors of this collective work on three decades of East German art are Hannelore Gärtner, Hans-Jürgen Geerdts, Horst Langer, Walter Pallus, Heinz Quitzsch, Eva Reissland, Manfred Vetter, and Nikolaus Zaske.

19. Henry Krisch, *The German Democratic Republic: The Search for Identity* (Boulder, 1985), 9.

20. Heinz Lüdecke, "Es kommt auf die Einstellung an," *Bildende Kunst,* July 1948, 12–15.

21. Ibid., 14.

22. Edith Lohmann, "Die Fotografie im Wandel des Zeitgeschmacks," *Fotografie,* November 1949, 135; Wolfgang Watteyne, "Fotografie und Psychologie," *Fotografie,* November 1949, 135.

23. See Ute Eskildsen, "*Subjektive Fotografie:* A Program of Non-functionalized Photography in Post-war Germany," in *Subjektive Fotografie: Bilder der 50er Jahre,* exhibition catalogue, San Francisco Museum of Art (San Francisco, 1984).

276

24. The Soviet Union formally recognized East German sovereignty only in 1954 and assumed full diplomatic relations the following year. A. James McAdams, *East Germany and Detente: Building Authority after the Wall* (Cambridge, 1985), 15.

25. Krisch, *German Democratic Republic,* 36.

26. Ulbricht became secretary general of the SED in 1950 and first secretary in 1953, positions that put him virtually in control of the party. After 1960 he also became head of the state council.

27. Ulbricht, representing the interests of Stalin, wanted a neutral Germany, so as to prevent Bonn from entering into a Western defense alliance; Konrad Adenauer, representing the interest of the Western allies, refused.

28. Wolfram von Hanstein, *Von Luther bis Hitler: Ein wichtiger Abriß deutscher Geschichte* (Dresden, 1948), 123–24, cited by George B. von der Lippe, "'Ich weiß jetzt wer ich bin': The Figure of Martin Luther as Presented in the Literature of the GDR," in *Studies in GDR Culture and Society 5: Selected Papers from the Tenth New Hampshire Symposium on the German Democratic Republic,* ed. Margy Gerber et al. (Lanham, Md., 1985), 341.

29. Martin Esslin, *Brecht: A Choice of Evils* (London, 1959), 182–83, quoted by Childs, *GDR,* 204.

30. Otto Steinert organized three exhibitions of Subjektive Fotografie (1951, 1958, 1959). In 1952 he wrote a book of the same name that defined photography in West Germany throughout the 1950s. See also Petra Benteler, ed., *Deutsche Fotografie nach 1945,* exhibition catalogue, Kasseler Kunstverein (Kassel, 1979).

31. It was a standard phrase, sprinkled throughout much of GDR literature.

32. *Fotografie,* June 1953, 171, 172.

Chapter Two

1. Specific guidelines for the "cleansing of art" were laid out during the Third Party Assembly of the SED, in July 1950. Another critical event was the Fifth Plenary Meeting of the Central Commission for Art, in March 1951, where an all-out war was declared on so-called bourgeois and opportunistic attitudes in art. Formalism, it was decided, was the main reason art had failed to live up to the requirements of society. See Heinz Hoffmann and Rainer Knapp, eds., *Fotografie in der DDR: Ein Beitrag zur Bildgeschichte* (Leipzig, 1987), 12.

2. Quoted by Craig, *Germans,* 50.

3. See Childs, *GDR,* 26.

4. Ibid., 28, 29.

5. For more on Ulbricht's art policy, see Ernst Hoffmann, "Die bildende Kunst im Kampf um die Einheit Deutschlands," *Bildende Kunst,* March 1953, 12; also Walter Ulbricht, "Worte zur Fotografie," *Fotografie,* June 1968, 8–9.

6. Childs, *GDR,* 31, 33; Craig, *Germans,* 51, 52.

7. "Die Lösung," quoted by Frederic Ewen, *Bertolt Brecht: His Life, His Art, and His Times* (New York, 1967), 454.

8. Bernhardt et al., *Künste in der DDR,* 100.

9. See Ernst Nitsche,"Realismus und Formalismus in der Fotografie," *Fotografie,* April 1953, 112–13.

10. Hoffmann, "Bildende Kunst im Kampf," 12.

11. Joachim Beyer, "Gespenst des fotografischen Formalismus?" *Fotografie,* November 1953, 304.

12. In 1995, Rössler was amused by my interpretation, but he did not disagree. Rössler, conversation with author, Markkleeberg, August 15, 1995.

13. Nitsche, "Realismus und Formalismus," 113.

14. Kurt Eggert, "Fotografie und Realismus," *Fotografie,* May 1953, 118.

15. Ibid., 117, 118. Perhaps it is no coincidence that the academic salon photographer Henry Peach Robinson had used a similar argument in Victorian England; he believed that realistic images should be staged or contrived to express a cultivated oneness of purpose and be made "by the mixture of the real and the artificial" to achieve "perfect truth" (quoted in Beaumont Newhall, *The History of Photography: From 1839 to the Present,* rev. ed. [New York, 1988], 78). Marx lived in England at that time and was undoubtedly exposed to Victorian morality; he may well have adapted certain aspects of it to his political program.

16. Quoted in Lachmann, "Kunstwerk und Lichtbild," *Fotografie,* November 1954, 306, 307.

17. Jaro Koupil, "Was ich über die fotografische Kunst denke," *Fotografie,* April 1955, 97.

18. Hoffmann, "Bildende Kunst im Kampf," 13, 19.

19. R. Tzschaschel, "Formalismus in der Fotografie—eine Diskussionsbemerkung," *Fotografie,* November 1953, 298.

20. Koupil, "Was ich über die fotografische Kunst denke," 84, 85.

21. Ibid., 85.

22. See Heinz Hoffmann, "Zur Förderung der Amateurfotografie durch den Kulturbund der DDR von 1945 bis 1965," in *Symposium zu Aspekten der Fotoentwicklung in der DDR von 1945 bis 1965,* ed. Kulturbund der DDR, Gesellschaft für Fotografie (Leipzig, 1985), 122.

23. Reprinted in "Bericht über die 1. Zentrale Tagung der Fotofreunde in Dresden," *Fotografie,* July 1954, 190.

Chapter Three

1. Wolfgang Hütt, "Gedanken und Andeutungen," *Fotografie,* January 1958, 11.

2. Ibid., 12.

3. Ibid., 14.

4. Engels, letter to Margaret Harkness, 1888, in Karl Marx and Friedrich Engels, *Über Kultur und Literatur,* vol. 1 (Berlin, 1967); quoted by Göllnitz and Kil, *Frühe Jahre,* introduction.

5. Members included Ursula Arnold, Friedrich Bernstein, Christian Diener, Rosel Eichhorn, Barbara Haller, Kurt Hartmann, Charlotte Heyde, Gerhard W. Heyde, Volkmar Jaeger, Heinz Müller, Evelyn Richter, Renate Rössing, Roger Rössing, Günter Rössler, Wolfgang E. Schröter, Lothar Vogel. See Ulrich Domröse, "*action fotografie*: Eine Gruppe sucht nach neuen Wegen in den 50er Jahren der DDR," *Bildende Kunst,* 1989, no. 10:36–39; see also Gosbert Adler and Wilmar Koenig, eds., *DDR Foto* (Berlin 1985), 8. According to Ursula Arnold, the group centered around Friedrich Bernstein (Arnold, conversation with author, Berlin, August 10, 1995).

6. See Kurt H. Hartmann,"*action fotografie* hat das Wort," *Fotografie,* April 1957, 112, 114.

7. Ibid., 112.

8. *Sächsisches Tagesblatt,* May 6, 1956. Quoted in Domröse, "*action fotografie,*" 38.

9. The catalogue (*action fotografie* [Leipzig, 1956]) could be sold only after the title page, showing one of the censored images, had been torn off. Posters of the same image, meanwhile, were displayed all over town. Domröse, "*action fotografie,*" 38.

10. Volkmar Jäger, "Ich suche den Menschen," interview, *Fotografie,* November 1956, 304, 306.

11. Quoted in Domröse, "*action fotografie.*"

12. Berthold Beiler, *Probleme über Fotografie: Parteilichkeit im Foto* (Halle/Saale, 1959), 58. Quoted by Göllnitz and Kil, *Frühe Jahre*, introduction.

13. Arnold's photograph, from a series documenting support of collective farming by city youth, won a gold medal in 1961 at the *Fourth German Photo Show (IV. deutsche Fotoschau)*.

14. Edmund Kesting inherited the rebellious spirit of Karl Schmidt-Rottluff and Max Pechstein, founders of Die Brücke in Dresden. His early photographs and photomontages thus showed an influence of expressionism, but also of cubism and surrealism (Coke, introduction to *Avant-garde Photography*).

15. David Childs, who lived in the GDR during the 1950s, witnessed many such incidents. See his *GDR,* 37.

16. Pachnicke, "Suche nach uns selbst," 19. The Photo League was a group of New York photographers that branched out of the Film and Photo League in 1936. Accused of being a Communist front organization during the late 1940s, they gradually disbanded, and by 1951 the movement was over.

17. Hoffmann, "Bildende Kunst im Kampf," 15.

Chapter Four

1. Already in October 1957, participants in a conference on culture had suggested that realism be regarded as something more changeable, in keeping with the original ideas of Marxist dialectic. The Fifth Party Assembly, in July 1958, determined that while painters should become even more directly involved with the ordinary reality of the working class, they should be allowed to adopt a more impressionistic style. For photographers, however, the rules for realistic portrayal were narrowed.

2. This series of exhibitions was called *Weltausstellungen der Fotografie.* See Benteler, *Deutsche Fotografie.*

3. On the impact of this exhibit in the GDR, see Wolfgang Kil, "Faszination des Beiläufigen," *Bildende Kunst,* 1987, no. 2:68–69. For a Western perspective, see Christopher Phillips, "The Judgment Seat of Photography," in *The Contest of Meaning: Critical Histories of Photography,* ed. Richard Bolton (Cambridge, Mass., 1989), 29–31.

4. See Wolfgang Hütt, "Gedanken zur Problematik einer Bildgeschichte der Fotografie," *Fotografie,* May 1960, 166, 168.

5. Friedrich Herneck, "Vor neuen Aufgaben," in *Fotografie und Gesellschaft: Beiträge zur Entwicklung einer sozial-realistischen Lichtbildkunst,* ed. Zentrale Kommission Fotografie (Halle/Saale, 1961), 14–17.

6. Friedrich Herneck, "Zu den grundsätzlichen Aufgaben der Fotogruppen der Deutschen Demokratischen Republik," *Fotografie,* December 1959, U3.

7. Klaus Fischer, *Das neue Porträt* (Halle/Saale, 1963), 47.

8. Quoted by Herneck, "Vor neuen Aufgaben," 15.

9. Alfred Neumann, "Bitterfeld: Die *VI. deutsche Fotoschau* und die Prognose," *Fotografie,* April 1969, 8.

10. Friedrich Herneck, "Vor neuen Aufgaben," *Fotografie,* January 1960, 8–16.

11. Fighter groups were civil reserve troops regularly present at factories and large industrial complexes to put down possible civil unrest.

12. Herneck, "Vor neuen Aufgaben," *Fotografie,* January 1960, 8.

13. See Gerhard Henniger, "Der Sozialismus siegt: Erste Gedanken über die 2. Bifota," in *Fotografie und Gesellschaft: Beiträge zur Entwicklung einer sozial-realistischen Lichtbildkunst,* ed. Zentrale Kommission Fotografie (Halle/Saale, 1961), 63–74.

14. Günter Blutke, "Suche nach Wahrheit," *Fotografie,* December 1959, 450, 452.

15. Zentrale Kommission Fotografie, ed., *Fotojahrbuch 1959* (Leipzig, 1959), 37, 41.

16. Gerhard Henniger, "Probleme einer sozialistischen Fotokunst, *Fotografie,* January 1961, 418.

17. John Mander, *Berlin: Hostage for the West* (Baltimore, 1962), 110.

18. McAdams, *East Germany and Detente,* 23.

19. Friedrich Herneck, "Zur Frage des sozialistischen Realismus in der Fotografie," *Fotografie,* August 1960, 296–99.

20. For a complete list of legal and illegal subjects, see Rudolf Wedler, "Fotografierverbote," *Fotografie,* March 1962, 82–83, 96.

21. Roland Brinsch, "Verlegerisches Engagement und gesellschaftlicher Auftrag," in *Symposium zu Aspekten der Fotoentwicklung in der DDR von 1945 bis 1965,* ed. Kulturbund der DDR, Gesellschaft für Fotografie (Leipzig 1985), 106.

22. Quoted by Domröse, *"action fotografie,"* 39.

23. Berthold Beiler, *Die Gewalt des Augenblicks* (Leipzig, 1967), 145.

24. Idem, "Vom Arbeiter-fotografen zum fotografierenden Arbeiter," *Fotografie,* April 1971, 25.

25. Idem, *Probleme über Fotografie,* 15.

26. Ibid., 34.

27. Quoted by Patricia Bosworth in *Diane Arbus: A Biography* (New York, 1985), 356.

28. When asked how the idea of competition in sports was reconciled with the idea of socialist sharing, the photographer Ulrich Burchert explained that even the losers were honored with a prize for participating in sports events, encouraging them to improve their performance. Burchert, conversation with author, Berlin, August 10, 1995.

29. Roland Barthes, *Camera Lucida: Reflections on Photography,* trans. Richard Howard (New York, 1981), 40–60.

30. Tyler Marshall, "Willy Brandt, Post–WW II German Statesman, Dies at 78," *Los Angeles Times,* October 9, 1992, sec. A, p. 35.

31. *Neues Deutschland,* September 16, 1961, quoted in McAdams, *East Germany and Detente,* 31.

Chapter Five

1. Martin McCauley, *The German Democratic Republic Since 1945* (New York, 1983), 145.

2. *Neues Deutschland,* August 26, 1961, quoted in McAdams, *East Germany and Detente,* 31.

3. Quoted in John Gunther, *Inside Russia Today* (New York, 1957), 475.

4. The photographs reproduced were unidentified, perhaps to avoid contributing to the notoriety of the artists.

5. August Sander was still blacklisted to some extent, as a "bourgeois" member of the old German avant-garde.

6. Manfred Paul, conversation with author, Berlin, August 11, 1995.

7. Gerhard Henniger, "Möglichkeiten und Maßstäbe fotokünstlerisches Schaffens," *Fotografie,* January 1963, 4, 5.

8. Quoted in McAdams, *East Germany and Detente,* 31.

9. For more on Wolf's Stasi connections, see Todd Gitlin, "I Did Not Imagine That I Lived in Truth," *New York Times Book Review,* April, 4, 1993, 1, 27–29.

10. See Childs, *GDR,* 210–12.

11. Christa Wolf, conversation with author, Los Angeles, December 20, 1992.

12. Childs, *GDR,* 211–12.

13. Evelyn Richter, conversation with author, Dresden, August 15, 1995.

14. Karin Thomas, "Vierzig Jahre Kunstfotografie in der DDR: Zwischen sozialistischem Realismus und Realität im Sozialismus," *Niemandsland* 2, no. 7 (1988): 14.

15. Childs, *GDR,* 70.

16. McAdams, *East Germany and Detente,* 57.

17. Between October 1964 and June 1965 the wall was opened seven times, for between fourteen and nineteen days each time. Childs, *GDR,* 70.

18. McAdams, *East Germany and Detente,* 59.

19. Childs, *GDR,* 72.

20. Honecker, *Bericht des Politbüros und die 11. Tagung des Zentralkomitees der SED* (East Berlin, 1966), 63, quoted in Childs, *GDR,* 74.

21. See McAdams, *East Germany and Detente,* 61.

22. Childs, *GDR,* 240.

23. Interview in *Sonntag* (a weekly paper published by the Kulturbund), December 29, 1968, quoted in Neumann, "Bitterfeld," 8.

Chapter Six

1. Thomas, "Vierzig Jahre Kunstfotografie," 13.

2. Fischer, conversation with author, Grausee, August 10, 1995.

3. Fischer later authored four books on other cities, including Leningrad and New York. Wolfgang Kil, "Damals in Berlin: Der Fotograf Arno Fischer," in *Kunst in der DDR,* ed. Eckhart Gillen and Rainer Haarmann (Berlin: 1990), 138–39.

4. Eugen Blume, "Einblicke in eine ungewöhnliche Fotografiesammlung," *Bildende Kunst,* 1990, no. 12:37–42.

5. From the notes of Gabriele Muschter. DDR Archives, The Getty Research Institute for the History of Art and the Humanities, Los Angeles, Muschter Archives, boxes 1.30, 1.31.

6. Fischer, conversation with author, Grausee, August 10, 1995.

7. Fischer, "Arno Fischer: Mit Kleinbild und schwarzweiß in Afrika," interview, *Fotografie,* September 1974, 4.

8. Ibid.

9. Fischer, conversation with author, Grausee, August 10, 1995.

281

10. Bergemann documented the construction of the Marx-Engels monument in East Berlin, while Fischer created an installation of socialist photographs on copper stelae surrounding the monument. Fischer received a national prize for this work.

11. Roger Melis, "Roger Melis" (remarks compiled by Peter Pachnicke), *Fotografie*, January 1983, 18–25.

12. Heinz Hoffmann, "Ergebnis erfolgreichen Zusammenwirkens," *Fotografie,* March 1972, 19.

13. Quoted in Sontag, *On Photography,* 107.

14. W. G. Heyde, "Arbeit, ein mühenswertes Motivbereich," *Fotografie,* May 1974, 25.

15. Thomas, "Vierzig Jahre Kunstfotografie," 13.

16. Sturm, "So wie ich sehe," interview, *Bildende Kunst,* 1984, no. 4:151.

17. Sturm et al., "Werden wir sie wiederfinden? Gedanken und Bilder zur VIII. Fotoschau der DDR," *Fotografie,* November 1976, 5.

18. Quoted in Konrad von Billerbeck, "Peter Leske, Im Sucher: Die Frau und ihre Welt," *Fotografie,* July 1968, 15.

19. Ibid.

20. Krisch, *German Democratic Republic,* 74.

21. Gerhard Mertink, "Über die Wurzeln unserer sozialistischen Fotografie," *Fotografie*, October 1973, 4–5.

22. Between the mid-1960s and 1989, West Germany apparently spent about $2 billion for the freedom of political prisoners in the GDR. See Tyler Marshall and William Long, "Erich Honecker, Mastermind of Berlin Wall, Dies," *Los Angeles Times,* May 30, 1994, sec. A, pp. 1, 10, 11.

23. McAdams, *East Germany and Detente,* 117.

24. Henry Ashby Turner, Jr., *The Two Germanies since 1945* (New Haven, Conn., 1987), 180.

25. McAdams, *East Germany and Detente,* 143, 144.

26. Albert Norden echoed Honecker's sentiment in a lecture given at the Parteihochschule Karl Marx in East Berlin on June 3, 1972, titled "Fragen des Kampfes gegen den Imperialismus." "There are not two states of one nation," he insisted, "but two nations in states of different societal orders." Quoted in Anneli Hartmann, "Was heißt heute überhaupt noch 'DDR Literatur'?" in *Studies in GDR Culture and Society 5: Selected Papers from the Tenth New Hampshire Symposium on the German Democratic Republic,* ed. Margy Gerber et al. (Lanham, Md., 1985), 266.

27. Krisch, *German Democratic Republic,* 75.

28. Childs, *GDR,* 88.

Chapter Seven

1. Childs, *GDR,* 240.

2. The flier is reproduced in Eugen Blume et al., eds., *Manfred Butzmanns Heimatkunde, in 24 Abteilungen* (Berlin, 1992), 141.

3. Childs, *GDR,* 91, 97, 221.

4. See Jane Kramer, "Letter from Europe," *New Yorker,* May 25, 1992, 43. Kramer believes that the activist art scene of Prenzlauer Berg in East Berlin was nurtured by the government in order to spy on artists.

5. Childs, *GDR,* 223, 224.

6. *Neues Deutschland,* November 22, 1976, 3.

7. Wilhelm Girnus to Günter Kunert in 1978, quoted in Wolfgang Emmerich, "Das Erbe des Odysseus: Der zivilisationskritische Rekurs auf den Mythos in der neueren DDR-Literatur," in *Studies in GDR Culture and Society 5: Selected Papers from the Tenth New Hampshire Symposium on the German Democratic Republic,* ed. Margy Gerber et al. (Lanham, Md., 1985), 185.

8. Christa Wolf, *Kindheitsmuster* (Darmstadt, 1976), 221, quoted in Emmerich, "Erbe," 185.

9. Peter Pachnicke, "Suche nach Individualität: Porträtfotografie der 80er Jahre," *Bildende Kunst,* 1987, no. 2:64.

10. Klaus Werner, "Ich stelle mich vor: Künstlerporträts von Christian Borchert," *Fotografie,* June 1985, 212–13.

11. Detlev Steinberg, conversation with author, Berlin, August 11, 1995.

12. Christian Borchert, "Foto: Uwe Steinberg," *Fotografie,* April 1984, 134.

13. Detlev Steinberg, conversation with author, Berlin, August 11, 1995.

14. The photographer Ulrich Burchert made this observation about Steinberg's work. Quoted in Stefan Orendt, "Zwei Generationen Berliner Stadtfotografie," in *Kunst in der DDR,* ed. Eckhart Gillen and Rainer Haarmann (Berlin, 1990), 205.

15. See Fred Cavon, "Ulrich Burchert: Beobachten und Geschichtenerzählen," *Fotografie,* May 1976, 15–17.

16. Manfred Paul, conversation with author, Berlin, August 11, 1995.

17. Ullrich Wallenburg, ed., *Fotografie im Bezirk Cottbus,* exhibition catalogue, Staatliche Kunstsammlungen Cottbus, Fotoedition no. 5 (Cottbus, 1983), 32.

18. Helfried Strauß, Foreword, in Thomas Kläber, *Landleben* (Erfurt, [1994]).

19. Rössler, conversation with author, Markkleeberg, August 15, 1995.

20. Helga Herzog, "Günter Rössler, immer wieder vor allem: Modefotografie," *Fotografie,* February 1969, 18.

21. Rössler, conversation with author, Markkleeberg, August 15, 1995.

22. Ibid.

23. Roger Rössing, "Gedanken zu Günter Rössler," in *Günter Rössler: Fotografien-Akt,* ed. Ullrich Wallenburg, exhibition catalogue, Staatliche Kunstsammlungen Cottbus, Fotoedition no. 2 (Cottbus, [1980]), 7.

24. Hoffmann and Knapp, *Fotografie in der DDR.*

25. Other early photographers in the exhibition were Walter Ballhause, Hermann Krone, and Hajo Rose. For a complete list, see Ullrich Wallenburg, ed., *Medium Fotografie: Resümee einer Ausstellung zur Kulturgeschichte der Fotografie,* exhibition catalogue (Halle, 1978).

26. Hermann Raum, "*Medium Fotografie* und Kunstwissenschaft," *Fotografie,* November 1977, 14.

283

Chapter Eight

1. See Jim Shepard, "Last Tango in Leipzig," *Los Angeles Times,* Book Review, January 12, 1992, pp. 3, 8.

2. Third Frankfurt lecture, "Ein Arbeitstagebuch über den Stoff, aus dem das Leben und die Träume sind," quoted in Nancy A. Lauckner, "Literature 'in der Dunkelheit': GDR Authors Address the Issues of War and Peace," in *Studies in GDR Culture and Society 5: Selected Papers from the Tenth New Hampshire Symposium on the German Democratic Republic,* ed. Margy Gerber et al. (Lanham, Md., 1985), 311.

3. Thomas Kumlehn, conversation with author, Potsdam, August 12, 1991.

4. Ullrich Wallenburg, ed., *Manfred Paul Fotografien,* exhibition catalogue, Staatliche Kunstsammlungen Cottbus, Fotoedition no. 7 (Cottbus, 1985).

5. Sebastian Zachow, "Sehen—Nachdenken," in *Fotografie im Bezirk Cottbus,* ed. Ullrich Wallenburg, exhibition catalogue, Staatliche Kunstsammlungen Cottbus, Fotoedition no. 5 (Cottbus, 1983), 6.

6. Peter Pachnicke, "Den eigenen Augen trauen: Fotografie auf der *IX. Kunstausstellung der DDR,*" *Fotografie,* January 1983, 4–17.

7. DDR Archives, The Getty Research Institute for the History of Art and the Humanities, Los Angeles, Department of Special Collections, box 60.

8. See Hartmut Pätzke, "Der Staatliche Kunsthandel der DDR," in *Kunst in der DDR,* ed. Eckhart Gillen and Rainer Haarmann (Berlin, 1990), 60.

9. Staatliche Museen zu Berlin, *Alltag und Epoche: Werke bildender Kunst der DDR aus 35 Jahren,* exhibition catalogue, Altes Museum (Berlin, 1984).

10. Peter Pachnicke, "Fotografie in einer Kunstausstellung," *Fotografie,* September 1985, 256–63.

11. Klaus Werner, ed., *Künstler fotografieren—fotografierte Künstler,* exhibition catalogue, Galerie Oben (Chemnitz, 1984).

12. Moholy-Nagy was actually included in this show, as were Raoul Hausmann and Man Ray.

13. Kumlehn, conversation with author, Potsdam, August 10, 1991.

14. In Ulrich Burchert et al., eds., *Realität–Vernunft–Kunst,* exhibition catalogue, Staatlicher Kunsthandel der DDR (Berlin, 1986).

15. See Olaf Thormann, "Clara Mosch: Zur Geschichte einer Chemnitzer Künstlergruppe und Produzentengalerie," *reiterin,* July 1991, 16–21.

16. Udo Rössling, "Fotogalerie Friedrichshain im zweiten Jahr," *Bildende Kunst,* 1987, no. 2:90.

17. Identification with the self is the basic theme of Christa Wolf's novel *Nachdenken über Christa T.* (Berlin, 1968).

18. *Neues Deutschland,* 20–21 June 1981, quoted in Krisch, *German Democratic Republic,* 35.

Chapter Nine

1. Karl Max Kober, "Kunst ist eine öffentliche Angelegenheit," *Bildende Kunst,* 1987, no. 2:50.

2. The exhibition named here as an example was held in conjunction with a song festival in 1983 in East Berlin. See Peter Schendel, "Junge Fotografen und der einfache Frieden," *Fotografie,* February 1985, 52.

3. Burchert, *Realität — Vernunft — Kunst,* 6.

4. Burchert, *Realität — Vernunft — Kunst.* For more on these photographers and others, see Peter Pachnicke, ed., *Was uns verbindet,* exhibition catalogue, Fotogalerie Berlin (Berlin, 1986).

5. Quoted in Helfried Strauß, "Hans-Wulf Kunze," *Bildende Kunst,* 1987, no. 2:75–76.

6. Kunze told me he preferred the more cluttered human configurations of Nicholas Nixon, Garry Winogrand, Bruce Davidson, and Robert Frank. Hans-Wulf Kunze, conversation with author, August 13, 1995.

7. Burchert, *Realität — Vernunft — Kunst,* 26; also Adler and Koenig, *DDR Foto,* 11–15.

8. Blume, *Butzmanns Heimatkunde,* 59.

Chapter Ten

1. Karin Wieckhorst and Siegmar Schulze, "Fotosequenz zu Siegmar Schulze," *Niemandsland* 2, no. 7 (1988): 36–39.

2. Renate Zeun, *Betroffen: Bilder meiner Krebserkrankung* (Leipzig, 1986).

3. For more on this series, see Stefan Orendt, "Renate Zeun," *Bildende Kunst,* 1987, no. 2:82–83.

4. Elle's idea was not entirely new. Peter Leske had done something similar slightly earlier, photographing a nude nurse from his bedside in a series titled *A Patient's Vision.* Those photos were included in the 1982 exhibition *Akt und Landschaft* (Nudes and Landscape) in Potsdam.

5. See Thomas, "Vierzig Jahre Kunstfotografie," 23.

6. Wolfgang Kil, "Zur Arbeit von Ulrich Wüst," in *DDR Foto,* ed. Gosbert Adler and Wilmar Koenig (Berlin, 1985), 84–85.

7. Ullrich Wallenburg, "Wirklichkeitsvermittlung und innovativer Anspruch," *foto-scene,* May 1990, 40.

8. Quoted in Burchert, *Realität — Vernunft — Kunst,* 76.

9. Ulf Erdmann Ziegler, "Bilder aus der Puppenstube," *Niemandsland* 2, no. 7 (1988): 103.

10. Quoted in Stefan Orendt, "Helga Paris: Fotografin," *Niemandsland* 2, no. 7 (1988): 70.

11. Jörg Kowalski, "Spuren: Häuser und Gesichter," *Fotografie,* August 1990, 282.

12. In Helga Paris, *Häuser und Gesichter, Halle 1983–85: Fotografien von Helga Paris,* exhibition catalogue, Verband Bildender Künstler (Halle/Saale, 1986), 3.

13. Konstanze Göbel, conversation with author, August 16, 1995.

Chapter Eleven

1. For an interesting account of Karl May's changing fortune in the GDR, see Margy Gerber, "Old Shatterhand Rides Again! The Rehabilitation of Karl May in the GDR," in *Studies in GDR Culture and Society 5: Selected Papers from the Tenth New Hampshire Symposium on the German Democratic Republic,* ed. Margy Gerber et al. (Lanham, Md., 1985), 237–50.

2. Petra Schink, "Zwischen Liebe und Zorn," *Fotografie,* February 1991, 84.

3. Stöhring, "Déjà-vu?" *Die Faszination des Gesichts: Aspekte der Portätfotografie,* ed. Ullrich Wallenburg, exhibition catalogue, Staatliche Kunstsammlungen Cottbus, Fotoedition no. 9 (Cottbus, 1988), 5; Thomas, "Vierzig Jahre Kunstfotografie," 22; Lang, "Tina Bara," *Bildende Kunst,* 1987, no. 2:70–71.

4. Photographs from this series were shown at an exhibition titled *Fotografie für die Stadt* (Photography for the City), at the Künstlerhaus am Marienplatz, October–December 1990.

5. Her fashion photography was exhibited with the work of her husband in 1989 in Chemnitz. Gabriele Muschter praised it for presenting a contrast to normal life and creating a new reality. "Mode als Erfahrungsmuster," in *Fotografie: Ute Mahler Mode, Werner Mahler Landschaft,* ed. Heidemarie Knott et al., exhibition catalogue, Galerie Schmidt-Rottluff (Chemnitz, 1989), 20.

6. Ute Mahler, conversation with author, Lehnitz, August 12, 1995.

7. Gerhard Ihrke, "Bilder vom Zusammenleben," *Fotografie,* November 1980, 429.

8. Ibid.

9. Wolfgang Kil, "Wunschmänner und Traumfrauen: Zu drei Fotoserien von Ute und Werner Mahler," *Bildende Kunst,* 1989, no. 5:35.

10. Ibid., 37.

11. Gabriele Muschter, "Chaos, Tümpel und die anderen: Zu Fotografien von Christiane Eisler," *Bildende Kunst,* 1990, no. 4:27.

12. The series was initially titled *Ich trage ein Herz mit mir herum* (I Carry a Heart around with Me), later retitled *Veränderungen* (Changes). See Theo O. Immisch, "Vision und Wirklichkeit: Zu einigen jungen Fotografen in Leipzig und Halle," *Bildende Kunst,* 1986, no. 9:423.

13. Roger Thielmann, ed., *Zehn Ausstellungen,* exhibition catalogue, Galerie P (Leipzig, 1986).

14. Mike Dennis, *German Democratic Republic: Politics, Economics, and Society* (London, 1988), 123.

15. Muschter, "Chaos," 28.

16. Ibid.

17. Thomas Kumlehn, interview by author, August 15, 1991. It is important to bear in mind, however, that in principle this censorship was no different from the motion picture and television codes in effect in the United States until the early seventies, whereby any depiction of crime had to be followed by appropriate retribution. In his long-running television series, Alfred Hitchcock would circumvent this restriction by adding a disclaimer at the end of the show, in which he himself simply announced that the culprits had later been apprehended.

Chapter Twelve

1. Arbus was inspired by her painter friend Richard Lindner, who had said that creative people must deal in secrets, and that if one's secrets disappear one is nothing. See Bosworth, *Diane Arbus,* 293.

2. Karin Thomas, "Fotografie als Kunst," in *Kunst in der DDR,* ed. Eckhart Gillen and Rainer Haarmann (Berlin, 1990), 119.

3. Although the main focus of this project was photography, it was initiated by the painting department (see Chapter 10).

4. Apparently the parody was unintentional, because after 1989, when such worker titles were no longer mandatory, Schulze deleted them.

5. Schulze, "Gundula Schulze und Gosbert Adler am 30. Mai 1985," interview, in *DDR Foto,* ed. Gosbert Adler and Wilmar Koenig (Berlin, 1985), 99.

6. This detail comes from "Lothar," an unpublished short story written by Schulze in 1987, sent to the author in October 1995.

7. Thomas, "Fotografie als Kunst," 119.

8. Schulze, "Lothar."

9. Gundula Schulze, "Kein fester Punkt," *Bildende Kunst,* 1990, no. 8:46.

10. Ibid.

11. Schulze, "Gundula Schulze und Gosbert Adler," 98.

12. Schulze, "Kein fester Punkt," 46.

13. Of course, the socialist attitude toward nature was not much different from the capitalist one: each used machines to exploit the environment. But in the West the myth of machines as the saviors of humanity was quickly fading after the 1950s.

14. Jörg Klaus, conversation with author, August 10, 1995.

15. Karl Steinorth, foreword to *Rudolf Schäfer,* catalogue raisonné (Stuttgart, 1989).

16. See Barbara Rüth, "Rudolf Schäfer," *Bildende Kunst,* 1987, no. 2:76.

17. Schäfer, "Rudi Schäfer und Gosbert Adler am 4. Juni 1985," interview, in *DDR Foto,* ed. Gosbert Adler and Wilmar Koenig (Berlin, 1985), 54–57.

18. Ibid.

19. Barthes, *Camera Lucida,* 95, 9.

20. Quoted Bettijane Levine, "Why We Hit the Brakes," *Los Angeles Times,* March 24, 1992, sec. E, pp. 1, 5.

21. Wolfgang Kil, "Die Produktivität der Distanz: Zur Fotoausstellung Rudolf Schäfer—drei Projekte," *Bildende Kunst,* 1989, no. 6:36.

22. Rudolf Schäfer, conversation with author, Berlin, August 12, 1995.

23. Ibid.

24. Kil, "Produktivität," 37, 38.

25. Erdmann Ziegler, "Bilder aus der Puppenstube," 103.

26. Bernd Lasdin, conversation with author, Grausee, August 10, 1995.

27. Quoted in Bosworth, *Diane Arbus,* 218.

Chapter Thirteen

1. See Jörg Wähner, "Prinzip Bildverneinung: Der Fotograf Kurt Buchwald," in *Kunst in der DDR,* ed. Eckhart Gillen and Rainer Haarmann (Berlin, 1990), 211. Buchwald also staged the happening in Paris after the fall of the Berlin Wall, and police reacted similarly there.

2. Gabriele Muschter, "Künstler als Fotografen—Fotografen als Künstler," in *Kunst in der DDR,* ed. Eckhart Gillen and Rainer Haarmann (Berlin, 1990), 124.

3. Jörg Wähner, "Vom Bilderstürmer zum Stöhrbildner," *foto-scene,* September/October 1990, 33.

4. Anna Lindenlaub, "Die Gegenläufigkeit der Bilder," *Niemandsland* 2, no. 7 (1988): 105.

5. Gunhild Brandler, ed., *Kurt Buchwald: Fotografie—in Aktion,* catalogue raisonné (Berlin, 1992), 82.

6. Muschter, "Künstler als Fotografen," 124.

7. Thomas Kumlehn, conversation with author, Potsdam, August 13, 1991.

8. Lutz Arnhold, "Ralf-Rainer Wasse," *Bildende Kunst,* 1987, no. 2:78–80.

9. Ralf-Rainer Wasse file, DDR Archives, The Getty Research Institute for the History of Art and the Humanities, Los Angeles, Department of Special Collections, box 7.2.

10. Gerhard Wolf, conversation with author, Los Angeles, January 12, 1993.

Chapter Fourteen

1. Barthes, *Camera Lucida,* 15.

2. See Gunar Barthel, "Klaus Hähner-Springmühl: Zeichnungen, Fotografien, Übermahlungen," in *Masse 80 kg,* exhibition catalogue, Galerie Oben (Chemnitz, 1987), [no pagination].

3. Ibid.

4. Fluxus (meaning "flow," or "change") was an international movement that began in West Germany in the 1960s, whose members were united less by style than by a quest for a new counterculture. Mixed-media events included concerts, street spectacles, and even demonstrations akin to the happenings that would later be staged. Robert Atkins, *Artspeak: A Guide to Contemporary Ideas, Movements, and Buzzwords* (New York, 1990).

5. See Gabriele Muschter, "Zur Arbeit von Thomas Florschuetz," in *DDR Foto,* ed. Gosbert Adler and Wilmar Koenig (Berlin, 1985), 70.

6. Ibid.

7. Muschter, "Künstler als Fotografen," 122.

8. Quoted in Childs, *GDR,* 224.

9. Sascha Anderson, "Woher, Wohin," *Niemandsland* 2, no. 7 (1988): 128.

10. Ulrich Lindner, conversation with author, August 14, 1995.

11. Quoted in Muschter, "Künstler als Fotografen," 122.

12. See Theo O. Immisch, "Andeutungen über Künstler als Fotografen," *Bildende Kunst,* 1989, no. 10:49.

13. Stöhring, "Déjà-vu?" 5.

14. Immisch, "Andeutungen," 49.

15. Quoted in Muschter, "Künstler als Fotografen," 122.

Epilogue

1. See Robert Darnton, *Berlin Journal, 1989–1990* (New York, 1991), 22; Tyler Marshall and William R. Long, "Erich Honecker, Mastermind of Berlin Wall, Dies," *Los Angeles Times,* May 30, 1994, sec. A, pp. 1, 10, 11.

2. Headline of the special edition of the *Berliner Morgenpost,* November 10, 1989.

3. See Gundula Schulze, "Gang im Licht: Gundula Schulze el Dowy im Gespräch mit Nike Bätzner," interview, in *Gundula Schulze el Dowy: Photographische Arbeiten, 1980 bis 1994,* exhibition catalogue, Kunstkreis Südliche Bergstraße Kraichgau E.V. (Berlin, 1994), 11.

Adler, Gosbert, and Wilmar Koenig, eds. *DDR Foto.* Berlin, 1985.

Anderson, Sascha. "Woher, wohin." *Niemandsland* 2, no. 7 (1988): 128.

Arnason, H. H. *History of Modern Art: Painting, Sculpture, Architecture.* 3d ed., rev. by Daniel Wheeler. New York, 1986.

Arnhold, Lutz. "Ralf-Rainer Wasse." *Bildende Kunst,* 1987, no. 2:78–80.

Atkins, Robert. *Artspeak: A Guide to Contemporary Ideas, Movements, and Buzzwords.* New York, 1990.

Barthel, Gunar. "Klaus Hähner-Springmühl: Zeichnungen, Fotografien, Übermahlungen." In *Masse 80 kg,* exhibition catalogue, Galerie Oben. Chemnitz, 1987.

Barthes, Roland. *Camera Lucida: Reflections on Photography.* Trans. Richard Howard. New York, 1981.

Beiler, Berthold. *Denken über Fotografie.* Leipzig, 1977.

———. *Die Gewalt des Augenblicks.* Leipzig, 1967.

———. *Probleme über Fotografie: Parteilichkeit im Foto.* Halle/Saale, 1959.

———. "Vom Arbeiter-Fotografen zum fotografierenden Arbeiter." *Fotografie,* April 1971, 24–27.

Benteler, Petra, ed. *Deutsche Fotografie nach 1945.* Exhibition catalogue, Kasseler Kunstverein. Kassel, 1979.

Berliner Morgenpost. Special ed., November 10, 1989; reissued August 11, 1991, in commemoration of the thirtieth anniversary of the Berlin Wall.

Bernhardt, Günter, et al. *Die Künste in der Deutschen Demokratischen Republik: Aus ihrer Geschichte in drei Jahrzehnten.* Berlin 1979.

Bertonati, Emilio. *Das experimentelle Foto in Deutschland, 1918–1940.* Munich, 1978.

Beyer, Joachim. "Gespenst des fotografischen Formalismus?" *Fotografie,* November 1953, 302, 304.

Billerbeck, Konrad von. "Peter Leske, Im Sucher: Die Frau und ihre Welt." *Fotografie,* July 1968, 15–23.

Blackbourn, David, and Geoff Eley. *The Peculiarities of German History: Bourgeois Society and Politics in Nineteenth-Century Germany.* Oxford, 1989.

Blume, Eugen. "Einblicke in eine ungewöhnliche Fotografiesammlung." *Bildende Kunst,* 1990, no. 12:37–43.

Blume, Eugen, et al., eds. *Manfred Butzmanns Heimatkunde, in 24 Abteilungen.* Berlin, 1992.

Blutke, Günter. "Suche nach Wahrheit." *Fotografie,* December 1959, 450–53.

Borchert, Christian. "Foto: Uwe Steinberg." *Fotografie,* April 1984, 132–37.

Bosworth, Patricia. *Diane Arbus: A Biography.* New York, 1985.

Brandler, Gunhild, ed. *Kurt Buchwald: Fotografie—in Aktion.* Catalogue raisonné. Berlin, 1992.

Brinsch, Roland. "Verlegerisches Engagement und gesellschaftlicher Auftrag." In *Symposium zu Aspekten der Fotoentwicklung in der DDR von 1946 bis 1965,* ed. Kulturbund der DDR, Gesellschaft für Fotografie, 105–9. Leipzig, 1985.

Burchert, Ulrich, et al., eds. *Realität—Vernunft—Kunst.* Exhibition catalogue, Staatlicher Kunsthandel der DDR. Berlin, 1986.

Cavon, Fred. "Ulrich Burchert: Beobachten und Geschichtenerzählen." *Fotografie,* May 1976, 15–17.

Childs, David. *The GDR: Moscow's German Ally.* Boston, 1988.

Coke, Van Deren. Introduction to San Francisco Museum of Modern Art, *Avant-garde Photography in Germany, 1919–1939.* San Francisco, 1980.

Craig, Gordon A. *The Germans.* Rev. ed. New York, 1991.

Darnton, Robert. *Berlin Journal, 1989–1990.* New York, 1991.

Dennis, Mike. *German Democratic Republic: Politics, Economics, and Society.* London, 1988.

Domröse, Ulrich. "*action fotografie*: Eine Gruppe sucht nach neuen Wegen in den 50er Jahren der DDR." *Bildende Kunst,* 1989, no. 10:36–39.

Eggert, Kurt. "Fotografie und Realismus." *Fotografie,* May 1953, 117–19.

Emmerich, Wolfgang. "Das Erbe des Odysseus: Der zivilisationskritische Rekurs auf den Mythos in der neueren DDR-Literatur." In *Studies in GDR Culture and Society 5: Selected Papers from the Tenth New Hampshire Symposium on the German Democratic Republic,* ed. Margy Gerber et al., 173–88. Lanham, Md., 1985.

Erdmann Ziegler, Ulf. "Bilder aus der Puppenstube." *Niemandsland* 2, no. 7 (1988): 103.

Eskildsen, Ute. "Subjective Fotografie: A Program of Non-functionalized Photography in Post-war Germany." In *Subjektive Fotografie: Bilder der 50er Jahre,* exhibition catalogue, San Francisco Museum of Art, 6–12. San Francisco, 1984.

Ewen, Frederic. *Bertolt Brecht: His Life, His Art, and His Times.* New York, 1967.

Fischer, Arno. "Arno Fischer: Mit Kleinbild und schwarzweiß in Afrika." Interview. *Fotografie,* September 1974, 4–5.

Fischer, Klaus. *Das neue Porträt.* Halle/Saale, 1963.

Fisher, Barbara. "A Slice of Photographic Time." *Artweek* 23, no. 7 (1992): 20.

Frank, Volker. "Lichtbild als Lichtkunst." In Ullrich Wallenburg, ed., *Fotografie in der Kunst der DDR,* exhibition catalogue, Staatliche Kunstsammlungen Cottbus, Fotoedition no. 8, 6–16. Cottbus, 1987.

Frommhold, Erich. *Paul Strand: Land der Gräser.* Leipzig, 1969.

Gaudlitz, Frank, and Thomas Kumlehn. *Die Russen gehen: Der Abzug einer Armee.* Berlin 1993.

Gay, Peter. *Weimar Culture: The Outsider as Insider.* New York, 1968.

Gerber, Margy. "Old Shatterhand Rides Again! The Rehabilitation of Karl May in the GDR." In *Studies in GDR Culture and Society 5: Selected Papers from the Tenth New Hampshire Symposium on the German Democratic Republic,* ed. Margy Gerber et al., 237–50. Lanham, Md., 1985.

Gitlin, Todd. "I Did Not Imagine That I Lived in Truth." *New York Times Book Review,* April 4, 1993, 1, 27–29.

Göllnitz, Petra, and Wolfgang Kil, eds. *Frühe Jahre.* Exhibition catalogue, Galerie Comenius. Dresden, 1985.

Gunther, John. *Inside Russia Today.* New York, 1957.

Hartmann, Anneli. "Was heißt heute überhaupt noch 'DDR Literatur'?" In *Studies in GDR Culture and Society 5: Selected Papers from the Tenth New Hampshire Symposium on the German Democratic Republic,* ed. Margy Gerber et al., 265–80. Lanham, Md., 1985.

Hartmann, Kurt H. "*action fotografie hat das Wort.*" *Fotografie,* April 1957, 112–14.

Henniger, Gerhard. "Möglichkeiten und Maßstäbe fotokünstlerisches Schaffens." *Fotografie,* January 1963, 4–6.

———. "Probleme einer sozialistischen Fotokunst." *Fotografie,* January 1961, 417–18.

———. "Der Sozialismus siegt: Erste Gedanken über die 2. Bifota." In *Fotografie und Gesellschaft: Beiträge zur Entwicklung einer sozial-realistischen deutschen Lichtbildkunst,* ed. Zentrale Kommission Fotografie, 63–74. Halle/Saale, 1961.

Herneck, Friedrich. "Vor neuen Aufgaben." In *Fotografie und Gesellschaft: Beiträge zur Entwicklung einer sozial-realistischer Lichtbildkunst,* ed. Zentrale Kommission Fotografie, 14–17. Halle/Saale, 1961. Published in a slighly different version in *Fotografie,* January 1960, 8–16.

———. "Zu den grundsätzlichen Aufgaben der Fotogruppen der Deutschen Demokratischen Republik." *Fotografie,* December 1959, U3.

———. "Zur Frage des sozialistischen Realismus in der Fotografie." *Fotografie,* August 1960, 296–99.

Herzog, Helga. "Günter Rössler, immer wieder und vor allem: Modefotografie." *Fotografie,* February 1969, 18–27.

Heyde, W. G. "Arbeit, ein mühenswertes Motivbereich." *Fotografie,* May 1974, 23–25.

293

Hofer, Carl. "Zum Geleit." *Bildende Kunst,* April 1947, 1.

Hoffmann, Ernst. "Die bildende Kunst im Kampf um die Einheit Deutschlands." *Bildende Kunst,* March 1953, 12–19.

Hoffmann, Heinz. "Ergebnis erfolgreichen Zusammenwirkens." *Fotografie,* March 1972, 16–23.

———. "Zur Förderung der Amateurfotografie durch den Kulturbund der DDR von 1945 bis 1965." In *Symposium zu Aspekten der Fotoentwicklung in der DDR von 1945 bis 1965,* ed. Kulturbund der DDR, Gesellschaft für Fotografie, 120–26. Leipzig, 1985.

Hoffmann, Heinz, and Rainer Knapp, eds. *Fotografie in der DDR: Ein Beitrag zur Bildgeschichte.* Leipzig, 1987.

Hütt, Wolfgang. "Gedanken und Andeutungen." *Fotografie,* January 1958, 11–15.

———. "Gedanken zur Problematik einer Bildgeschichte der Fotografie." *Fotografie*, May 1960, 166–68.

Ihrke, Gerhard. "Bilder vom Zusammenleben." *Fotografie,* November 1980, 429.

Immisch, Theo O. "Andeutungen über Künstler als Fotografen." *Bildende Kunst,* 1989, no. 10: 47–49.

———. "Vision und Wirklichkeit: Zu einigen jungen Fotografen in Leipzig und Halle." *Bildende Kunst,* 1986, no. 9:422–25.

Jäger, Volkmar. "Ich suche den Menschen." Interview. *Fotografie,* November 1956, 304, 306, 307.

Jussim, Estelle. "Stieglitz and Hine." In *Photography: Current Perspectives,* ed. Jerome Liebling, 46–64. Rochester, N.Y., 1978.

Kil, Wolfgang. "Damals in Berlin: Der Fotograf Arno Fischer." In *Kunst in der DDR,* ed. Eckhart Gillen and Rainer Haarmann, 138–39. Cologne, 1990.

———. "Faszination des Beiläufigen." *Bildende Kunst,* 1987, no. 2:68–69.

———. *Hinterlassenschaft und Neubeginn: Fotografien von Dresden, Leipzig und Berlin in den Jahren nach 1945.* Leipzig, 1989.

———. "Die Produktivität der Distanz: Zur Fotoausstellung Rudolf Schäfer—drei Projekte." *Bildende Kunst,* 1989, no. 6:36–39.

———. "Wunschmänner und Traumfrauen: Zu drei Fotoserien von Ute und Werner Mahler." *Bildende Kunst,* 1989, no. 5:35–37.

———. "Zur Arbeit von Ulrich Wüst." In *DDR Foto,* ed. Gosbert Adler and Wilmar Koenig, 84–85. Berlin, 1985.

Kläber, Thomas. *Landleben.* Erfurt, [1994].

Klimter, Lothar, and Just Wagner, eds. *Prominente Fotogedanken.* Leipzig, 1969.

Kober, Karl Max. "Die ersten Jahre (I)." *Bildende Kunst,* 1977, no. 5:218.

———. *Die Kunst der frühen Jahre, 1945–1949.* Leipzig, 1989.

———. "Kunst ist eine öffentliche Angelegenheit." *Bildende Kunst,* 1987, no. 2:50–51.

Koupil, Jaro. "Was ich über die fotografische Kunst denke." *Fotografie,* April 1955, 84, 85, 97.

Kowalski, Jörg. "Spuren: Häuser und Gesichter." *Fotografie,* August 1990, 282–89.

294

Kramer, Jane. "Letter from Europe." *New Yorker,* May 25, 1992, 40–64.

Krisch, Henry. *The German Democratic Republic: The Search for Identity.* Boulder, Colo., 1985.

Lachmann, Werner. "Kunstwerk und Lichtbild." *Fotografie,* November 1954, 302–7.

Lang, Peter. "Tina Bara." *Bildende Kunst,* 1987, no. 2:70–71.

Lauckner, Nancy A. "Literature 'in der Dunkelheit': GDR Authors Address the Issues of War and Peace." In *Studies in GDR Culture and Society 5: Selected Papers from the Tenth New Hampshire Symposium on the German Democratic Republic,* ed. Margy Gerber et al., 309–22. Lanham, Md., 1985.

Levine, Bettijane. "Why We Hit the Brakes." *Los Angeles Times,* March 24, 1992, sec. E, p. 1.

Lindenlaub, Anna. "Die Gegenläufigkeit der Bilder." *Niemandsland* 2, no. 7 (1988): 105.

Lippe, George B. von der. "'Ich weiß jetzt wer ich bin': The Figure of Martin Luther as Presented in the Literature of the GDR." In *Studies in GDR Culture and Society 5: Selected Papers from the Tenth New Hampshire Symposium on the German Democratic Republic,* ed. Margy Gerber et al., 339–55. Lanham, Md., 1985.

Lohmann, Edith. "Die Fotografie im Wandel des Zeitgeschmacks." *Fotografie,* November 1949, 134–35.

Lüdecke, Heinz. "Es kommt auf die Einstellung an." *Bildende Kunst,* July 1948, 12–15.

Mander, John. *Berlin: Hostage for the West.* Baltimore, 1962.

Marshall, Tyler. "Willy Brandt, Post–WW II German Statesman, Dies at 78." *Los Angeles Times,* October 9, 1992, sec. A, pp. 1, 35.

Marshall, Tyler, and William Long. "Erich Honecker, Mastermind of Berlin Wall, Dies." *Los Angeles Times,* May 30, 1994, sec. A, pp. 1, 10, 11.

Marx, Karl, and Friedrich Engels. *Karl Marx and Frederick Engels, Reactionary Prussianism.* Ed. Institute Marksizma-Leninizma. New York, 1944.

————. *Über Kultur und Literatur.* Vol. 1. Berlin, 1967.

McAdams, A. James. *East Germany and Detente: Building Authority after the Wall.* Cambridge, 1985.

McCauley, Martin. *The German Democratic Republic Since 1945.* New York, 1983.

Melis, Roger. "Roger Melis." Remarks compiled by Peter Pachnicke. *Fotografie,* January 1983, 18–25.

Mertink, Gerhard. "Über die Wurzeln unserer sozialistischen Fotografie." *Fotografie,* October 1973, 4–5.

Molderings, Herbert. *Fotografie in der Weimarer Republik.* Berlin, 1985.

Mosse, George L. *The Crisis of German Ideology: Intellectual Origins of the Third Reich.* New York, 1964.

————, ed. *Nazi Culture: Intellectual, Cultural, and Social Life in the Third Reich.* New York, 1966.

Muschter, Gabriele. "Chaos, Tümpel und die anderen: Zu Fotografien von Christiane Eisler." *Bildende Kunst,* 1990, no. 4:26–28.

————. "Künstler als Fotografen—Fotografen als Künstler." In *Kunst in der DDR,* ed. Eckhart Gillen and Rainer Haarmann, 122–24. Cologne, 1990.

295

———. "Mode als Erfahrungsmuster." In *Fotografie: Ute Mahler Mode, Werner Mahler Landschaft,* ed. Heidemarie Knott et al., exhibition catalogue, Galerie Schmidt-Rottluff, 20. Chemnitz, 1989.

———. Muschter Archive. DDR Archives, The Getty Research Institute for the History of Art and the Humanities, Los Angeles. Boxes 1.30, 1.31.

———. "Zur Arbeit von Thomas Florschuetz." In *DDR Foto,* ed. Gosbert Adler and Wilmar Koenig, 70–71. Berlin, 1985.

Nerlinger, Oskar. "Was will die bildende Kunst?" *Bildende Kunst,* April 1947, 2.

Neumann, Alfred. "Bitterfeld: Die *VI. deutsche Fotoschau* und die Prognose." *Fotografie,* April 1969, 6–13.

Newhall, Beaumont. *The History of Photography: From 1839 to the Present.* Rev. ed. New York, 1988.

Nitsche, Ernst. "Realismus und Formalismus in der Fotografie." *Fotografie,* April 1953, 112–13.

Oehlmann, Peter. "Glühlampenwerk, Narva, 1987." *Niemandsland* 2, no. 7 (1988): 112–18.

Orendt, Stefan. "Helga Paris: Fotografin." *Niemandsland* 2, no. 7 (1988): 68–71.

———. "Renate Zeun." *Bildende Kunst,* 1987, no. 2:82–83.

———. "Zwei Generationen Berliner Stadtfotografie." In *Kunst in der DDR,* ed. Eckhart Gillen and Rainer Haarmann, 205–8. Berlin, 1990.

Pachnicke, Peter. "Den eigenen Augen trauen: Fotografie auf der *IX. Kunstausstellung der DDR.*" *Fotografie,* January 1983, 4–17.

———. "Fotografie in einer Kunstausstellung." *Fotografie,* September 1985, 256–63.

———. "Suche nach Individualität." *Bildende Kunst,* 1987, no. 2:64.

———. "Suche nach uns selbst." In *Symposium zu Aspekten der Fotoentwicklung in der DDR von 1945 bis 1965,* ed. Kulturbund der DDR, Gesellschaft für Fotografie, 5–36. Leipzig, 1985.

———, ed. *Was uns verbindet.* Exhibition catalogue, Fotogalerie Berlin. Berlin, 1986.

Paris, Helga. *Häuser und Gesichter, Halle 1983–85: Fotografien von Helga Paris.* Exhibition catalogue, Verband Bildender Künstler. Halle/Saale, 1986.

Pätzke, Hartmut. "Der Staatliche Kunsthandel der DDR." In *Kunst in der DDR,* ed. Eckhart Gillen and Rainer Haarmann, 57–62. Cologne, 1990.

Phillips, Christopher. "The Judgment Seat of Photography." In *The Contest of Meaning: Critical Histories of Photography,* ed. Richard Bolton, 15–47. Cambridge, Mass., 1989.

Raum, Hermann. "*Medium Fotografie* und Kunstwissenschaft." *Fotografie,* November 1977, 2–15.

Rössing, Roger. "Gedanken zu Günter Rössler." In *Günter Rössler: Fotografien-Akt,* ed. Ullrich Wallenburg, exhibition catalogue, Staatliche Kunstsammlungen Cottbus, Fotoedition no. 2, 7. Cottbus, [1980].

Rössling, Udo. "Fotogalerie Friedrichshain im zweiten Jahr." *Bildende Kunst,* 1987, no. 2:90.

Rüth, Barbara. "Rudolf Schäfer." *Bildende Kunst,* 1987, no. 2:76–78.

Schendel, Peter. "Junge Fotografen und der einfache Frieden." *Fotografie,* 1985, no. 2:52–57.

Schink, Petra. "Zwischen Liebe und Zorn." *Fotografie,* February 1991, 84–87.

Schulze, Gundula. "Gang im Licht: Gundula Schulze el Dowy im Gespräch mit Nike Bätzner. In-

terview. In *Gundula Schulze el Dowy: Photographische Arbeiten, 1980 bis 1994.* Exhibition catalogue, Kunstkreis Südliche Bergstraße Kraichgau E.V. Berlin, 1994.

———. "Gundula Schulze und Gosbert Adler am 30. Mai 1985." Interview. In *DDR Foto,* ed. Gosbert Adler and Wilmar Koenig, 97–112. Berlin, 1985.

———. "Kein fester Punkt." *Bildende Kunst,* 1990, no. 8:46–48.

———. "Lothar" (1987). Unpublished.

Sontag, Susan. *On Photography.* New York, 1973.

Staatliche Museen zu Berlin. *Alltag und Epoche: Werke bildender Kunst der DDR aus 35 Jahren.* Exhibition catalogue, Altes Museum. Berlin, 1984.

Steinorth, Karl. Foreword. In *Rudolf Schäfer*, catalogue raisonné. Stuttgart, 1989.

Stöhring, Ulricke. "Déjà-vu?" In *Die Faszination des Gesichts: Aspekte der Porträtfotografie,* ed. Ullrich Wallenburg, exhibition catalogue, Staatliche Kunstsammlungen Cottbus, Fotoedition no. 9, 4–5. Cottbus, 1988.

Strauß, Helfried. "Hans-Wulf Kunze." *Bildende Kunst,* 1987, no. 2:75–76.

Sturm, Horst. "So wie ich sehe." Interview. *Bildende Kunst,* 1984, no. 4:151.

Sturm, Horst, et al. "Werden wir sie wiederfinden? Gedanken und Bilder zur *VIII. Fotoschau* der DDR." *Fotografie,* November 1976, 2–11.

Thielmann, Robert, ed. *Zehn Ausstellungen*. Exhibition catalogue, Galerie P. Leipzig, 1986.

Thomas, Karin. "Fotografie als Kunst." *Kunst in der DDR,* ed. Eckhart Gillen and Rainer Haarmann, 117–20. Cologne, 1990.

———. "Vierzig Jahre Kunstfotografie in der DDR: Zwischen sozialistischem Realismus und Realität im Sozialismus." *Niemandsland* 2, no. 7 (1988): 7–28.

Thormann, Olaf. "Clara Mosch: Zur Geschichte einer Chemnitzer Künstlergruppe und Produzentengalerie." *reiterin,* July 1991, 16–21.

Turner, Henry Ashby, Jr. *The Two Germanies Since 1945.* New Haven, Conn., 1987.

Tzschaschel, R. "Formalismus in der Fotografie: Eine Diskussionsbemerkung." *Fotografie,* November 1953, 298–302.

Ulbricht, Walter. "Worte zur Fotografie." *Fotografie,* June 1968, 8–9.

Wähner, Jörg. "Prinzip Bildverneinung: Der Fotograf Kurt Buchwald." In *Kunst in der DDR,* ed. Eckhart Gillen and Rainer Haarmann, 210–11. Cologne, 1990.

———. "Vom Bilderstürmer zum Störbildner." *foto-scene,* September/October 1990, 32–33.

Wallenburg, Ullrich. "Fotografie und Museum." In *Fotografie in der Kunst der DDR,* ed. Ullrich Wallenburg, exhibition catalogue, Staatliche Kunstsammlungen Cottbus, Fotoedition no. 8, 22–28. Cottbus, 1988.

———. "Wirklichkeitsvermittlung und innovativer Anspruch." *foto-scene,* May 1990, 40.

———, ed. *Fotografie im Bezirk Cottbus.* Exhibition catalogue, Staatliche Kunstsammlung Cottbus. Fotoedition no. 5. Cottbus, 1983.

———. *Manfred Paul Fotografien.* Exhibition catalogue, Staatliche Kunstsammlungen Cottbus.

Fotoedition no. 7. Cottbus, 1985.

————. *Medium Fotografie: Resümee einer Ausstellung zur Kulturgeschichte der Fotografie.* Exhibition catalogue. Halle, 1978.

————. *Zeitbilder: Wegbereiter der Fotografie in der DDR.* Exhibition catalogue, Staatliche Kunstsammlung Cottbus. Fotoedition no. 11. Cottbus, 1990.

Watteyne, Wolfgang. "Fotografie und Psychologie." *Fotografie,* November 1949, 135–36.

Wedler, Rudolf. "Fotografierverbote." *Fotografie,* March 1962, 82–83, 96.

Werner, Klaus. "Ich stelle mich vor: Künstlerporträts von Christian Borchert." *Fotografie,* June 1985, 212–13.

————, ed. *Künstler fotografieren–fotografierte Künstler.* Exhibition catalogue, Galerie Oben. Chemnitz, 1984.

Wieckhorst, Karin, and Siegmar Schulze. "Fotosequenz zu Siegmar Schulze." *Niemandsland* 2, no. 7 (1988): 36–39.

Wolf, Christa. *Die Dimension des Autors.* Vol. I. Berlin, 1986. Translated as *The Author's Dimension: Selected Essays.* New York, 1993.

————. *Der geteilte Himmel.* Halle/Saale, 1963. Translated as *Divided Heaven.* New ed. New York, 1979.

————. *Kindheitsmuster.* Darmstadt, 1976. Translated as *A Model Childhood.* New York, 1980.

————. *Nachdenken über Christa T.* Berlin, 1968. Translated as *The Quest for Christa T.* New York, 1971.

————. *Störfall: Nachrichten eines Tages.* 4th ed. Darmstadt, 1987. Translated as *Accident: A Day's News.* New York, 1989.

Zachow, Sebastian. "Sehen—Nachdenken." In *Fotografie im Bezirk Cottbus,* ed. Ullrich Wallenburg, exhibition catalogue, Staatliche Kunstsammlungen Cottbus, Fotoedition no. 5, 6. Cottbus, 1983.

Zentrale Kommission Fotografie, ed. *Fotojahrbuch 1959.* Leipzig, 1959.

Zeun, Renate. *Betroffen: Bilder meiner Krebserkrankung.* Leipzig, 1986.

Italic page references indicate illustrations.

305

Designer Nola Burger

Compositor Integrated Composition Systems

Text 11/15.5 Granjon

Display Univers Condensed

Printer Tien Wah Press

Binder Tien Wah Press